High Dynamic Range Digital Photography

FOR

DUMMIES®

D1254727

High Dynamic Range Digital Photography

FOR

DUMMIES®

by Robert Correll

WILEY

Wiley Publishing, Inc.

High Dynamic Range Digital Photography For Dummies®

Published by
Wiley Publishing, Inc.
111 River Street
Hoboken, NJ 07030-5774

www.wiley.com

For general information on our other products and services, please contact our Customer Care Department within the U.S. at 877-762-2974, outside the U.S. at 317-572-3993, or fax 317-572-4002.

For technical support, please visit www.wiley.com/techsupport.

Wiley also publishes its books in a variety of electronic formats. Some content that appears in print may not be available in electronic books.

Library of Congress Control Number: 2009940283

ISBN: 978-0-470-56092-1

Manufactured in the United States of America

10 9 8 7 6 5 4 3 2 1

WILEY

About the Author

Robert Correll is an author, photographer, and artist with a lifetime of film and digital photography experience. He is a longtime expert in image editing and graphics software such as Photoshop, Photoshop Elements, and Corel Paint Shop Pro Photo. He also retouches and restores photos. Robert currently provides professional software testing (Windows and Mac), tutorial and manual authoring, copywriting, and other services to HDRsoft, the makers of Photomatix Pro (the leading HDR application).

His latest published works include *HDR Photography Photo Workshop* (with Pete Carr; published by Wiley), *Your Pro Tools Studio,* and *Photo Restoration and Retouching Using Corel Paint Shop Pro Photo* (both published by Course Technology PTR). Robert also authors creative tutorials for the Virtual Training Company. His titles range from *MasterClass! — Adobe Photoshop CS4 HDRI* to subjects covering Corel Paint Shop Pro Photo, Adobe Photoshop Elements, Sony ACID Pro, and Cakewalk SONAR. He contributed to every issue of the *Official Corel Paint Shop Pro Photo Magazine* as the resident photo retouching expert.

Robert is also a music producer, audio engineer, and musician who makes his music on the electric guitar and bass. He graduated with a Bachelor of Science degree in History from the United States Air Force Academy and has worked in the publishing, education, and marketing and design industries.

Dedication

For my wife — Anne, and my kids — Ben, Jake, Grace, and Sam.

Author's Acknowledgments

Thank you to my agent, David Fugate, for your constant advocacy and support. You're the man, man. Thanks to all the wonderful people I've had the privilege and pleasure to work with at Wiley. Steve Hayes, Executive Editor, for having the vision to help get this book approved and published. Thanks for the opportunity to share my love for HDR photography. Jean Nelson, Project Editor, for your ever-present support and expert book shepherding and editing skills. Thank you for being such a pleasure to work with. Teresa Artman, Copy Editor, for your enthusiasm and copy editing skills. And Ron Rockwell, Technical Editor, for your effort and diligence.

Rick Hawks and Kathy Wagner of The Chapel, Michelle Gray and Amy Sipe of Tower Bank, Bob Krafft and Emily Fisher of the Kruse Automotive and Carriage Museum and the National Military History Center, and Bruce Gaylor and Mike Bergum of New Castle Chrysler High School. Thank you all for your permission to set up and shoot interior shots at your wonderful locations. This book would not have been the same without your cooperation.

Thanks to Nikon, Sony, Canon, Panasonic, Manfrotto, Sigma, Tamrac, and all the other manufacturers out there who make the gear I use. Thanks to the guys at Sunny Schick Camera Shop for your assistance and support, and to Katie of Best Buy. Very special thanks go to Pete Carr, and many thanks to Geraldine Joffre of HDRsoft.

Finally, thank you to my wife and children for your love, support, and encouragement. Thanks also to Dad and Lynda and Don and Mary Anne.

Publisher's Acknowledgments

We're proud of this book; please send us your comments at http://dummies.custhelp.com. For other comments, please contact our Customer Care Department within the U.S. at 877-762-2974, outside the U.S. at 317-572-3993, or fax 317-572-4002.

Some of the people who helped bring this book to market include the following:

Acquisitions and Editorial

Project Editor: Jean Nelson

Executive Editor: Steven Hayes

Senior Copy Editor: Teresa Artman

Technical Editor: Ron Rockwell

Editorial Manager: Kevin Kirschner

Media Development Project Manager:
Laura Moss-Hollister

Media Development Assistant Project Manager:
Jenny Swisher

Media Development Associate Producers:
Josh Frank, Marilyn Hummel, Douglas Kuhn,
and Shawn Patrick

Editorial Assistant: Amanda Graham

Sr. Editorial Assistant: Cherie Case

Cartoons: Rich Tennant
(www.the5thwave.com)

Composition Services

Project Coordinator: Katie Crocker

Layout and Graphics: Samantha K. Cherolis

Proofreaders: Laura Albert,
Melissa D. Buddendeck

Indexer: Becky Hornyak

Publishing and Editorial for Technology Dummies

Richard Swadley, Vice President and Executive Group Publisher

Andy Cummings, Vice President and Publisher

Mary Bednarek, Executive Acquisitions Director

Mary C. Corder, Editorial Director

Publishing for Consumer Dummies

Diane Graves Steele, Vice President and Publisher

Composition Services

Debbie Stailey, Director of Composition Services

Contents at a Glance

Table of Contents

Introduction

High dynamic range (HDR) digital photography is a technical and artistic leap forward from traditional photography. It has become so popular because it solves a lot of photographic exposure problems and, in the end, looks really cool. Images captured and processed with HDR techniques contain a much wider range of light than standard photos.

Normally, shadows and bright areas in a single photo are linked. For example, if you set your camera to lighten shadows in a landscape, the sky gets too bright. If you turn down the exposure so the sky looks good, details are lost in the darker areas of the photo. Although you can push and pull exposure in software, there is a practical limit to what looks good because you literally run out of data.

HDR increases the amount of data by using more than one source photo. You take the photos through a process called *bracketing*. Each photo in the bracketed set has a different brightness. Special software combines the photos and allows you to control how the end result looks. When it's all said and done, you have a lot of control over that look. You can choose to emphasize realism, details, contrast, artistry, drama, and more.

About This Book

Whether you're coming to HDR because you love photography and want to expand your skill set, you're taking a photography class and have to complete a project on HDR, you're trying to impress your girlfriend or boyfriend, or you have a new camera and want to do something special with it, this book is for you.

This book covers the big picture aspects, workflow suggestions, small picture items, tips, notes, steps, thoughts, photos, and more — all designed to show you how HDR works, and how to shoot it, process it, and finish your images.

Who This Book Is For

You're a perfect match for this book if you want information on HDR. The subject is HDR, from beginning to end. Topics include what HDR is, what you need, how to shoot it, how to process it, and how to edit and finish your images.

In terms of content, this book is for beginners to more advanced photographers — amateurs and professionals. I don't write from a scientific, technical, or otherwise overly nerdy perspective. Frankly, you don't need to know the exact dynamic range of your compact digital camera or dSLR to know that in practice, it isn't enough. You don't need to know how many bits you need or why 12-bit sensors have 4,096 steps of tonal discrimination. That said, I don't intend this book to be strictly for new and inexperienced users. There's room to grow and room to step in if you already know your way around a dSLR.

Although the content ranges from beginner to advanced material (I would call using a light meter to set the end points of a bracketed series of shots advanced material), the book is written so beginners don't get overwhelmed. I make it a point to explain and buffer the material so inexperienced photographers have a chance, but I don't alter the content unnecessarily to exclude more advanced photogs.

What You Need

If you want to dive in and start shooting HDR, you want to have a few things handy (see Chapters 2 and 3 for more details):

- ✓ **Camera:** If you have a compact digital camera with exposure control, you're set. It helps (although not required) to have a dSLR with a nice wide angle lens.

- ✓ **Tripod:** If you have a fast dSLR, you can get by without a tripod occasionally. Tripods are necessary, though, to stabilize your camera when you're shooting brackets.

- ✓ **Computer:** HDR requires that you have a computer. It can be Mac or Windows (or Unix, but I don't really go there), desktop or laptop.

- ✓ **Software:** The least you need is an HDR application. Go online and download a trial version to get started, and buy it if you like it. Other photo-editing software, such as Photoshop Elements, is invaluable when it comes to editing and publishing but not strictly required for HDR.

Foolish Assumptions

HDR pulls together a lot of different elements from photography and photo editing. That makes it impossible to cover every aspect of HDR from the ground up in this book — how to use a dSLR, photography, Raw conversion and editing, digital image manipulation in general (Photoshop Elements in particular), and participating in online photo forums like Flickr.

In writing this book, I made some assumptions about you, the reader:

✔ **You know how to use your camera.** You can enter different shooting modes, take photos, and download them to your computer. The more knowledge and practical experience you have (up to a point), the better.

✔ **You can do some basic tasks with photo editing software.** You've used a photo editor (such as Elements), and you're comfortable doing some basic editing: adjusting brightness/contrast, cropping, and resizing.

Whys and Wherefores

This is where I explain some of the hard decisions I made about the book and how I approached it:

✔ **Why Photomatix Pro?** It's the leading HDR application, and a very good one, which is why I chose it to show you how to generate HDR images and tone map them. (In Chapter 3, I provide reviews and links to many other HDR applications and encourage you to test them out for yourself.)

✔ **Why Photoshop Elements?** It's the leading consumer-level photo editing suite. It's good and gets the job done. It is more limited than Photoshop, but more accessible (and much less expensive).

For users of other products (such as Corel Paint Shop Pro Photo), the techniques I show are still valuable and as portable as I could make them. However, some tasks and tools might need a bit of translation.

✔ **Why dSLRs?** Gotcha. This is a trick question. I've gone out of my way to avoid assuming everyone who reads this book is using a dSLR. I use a dSLR most of the time, but I also use two compact digital cameras to show that if you can point and shoot with it, you can shoot HDR with it. So, everyone can play; just bring what you have.

How This Book Is Organized

HDR isn't rocket science. You take pictures. You transmogrify pictures. You edit and publish the pictures. That makes sense, so it's the order I chose to organize the information contained in this book. HDR jumps around a bit from photography to software, so knowing where you are in the book can also help you keep your bearings in the realm of HDR.

The book has lots of elements designed to help you navigate between parts, which contain information related to the same basic topic. Chapters deal with specific topics. You can also use the Table of Contents or Index to find exactly what you want.

Part I: The ABCs of HDR Photography

Part I is about getting started. If you know nothing about HDR, start here. If you already have some idea or have even started experimenting with HDR, this part gives you a lot of good information on workflow, cameras, gear, and software options. There's something for everyone.

Find out what HDR is, what it looks like, and how to go about it. Discover what photography gear you need and why. Find out what gear is beneficial but not required. Explore different software options for HDR, such as dedicated HDR software, image management, Raw conversion, and image editing applications.

Part II: Putting the Photography in HDR Photography

Part II is all about taking photos. Discover how to find the scenes to maximize the benefits of HDR and set up your camera to shoot HDR photos. Discover several different techniques to meter and shoot exposure bracketed photos. Find out when to break the rules and take single Raw photos to use as pseudo-HDR.

Part III: The Soft(er)ware Side of HDR

Part III turns to the software side of HDR, where the photos are turned into HDR images, tone mapped, edited, and published. These are technical and artistic processes that require specialized software — and guess who has to know how to use it. That's right: You. It goes beyond using it, of course, because you surely want to create something nice to look at.

This part is also about taking what comes out of the "tone mapper," making it look as good as it can, and finishing it. I show you layers; workflow; blending; correcting contrast, removing dust, distortion, noise, and other distractions; and more. You also discover the importance of consistency, sharpening, enhancing color, contrast, dodging and burning, recomposing, and finally, publishing your images. Pshew!

Part IV: Having Fun with HDR Images

And now for some fun! This part covers some interesting and potentially challenging ways to go even further with HDR photography. You find out how to photograph the pieces of a panorama, and then stitch them together to create a seamless composite. You also discover how to take color photos with a digital camera and turn them into black-and-white HDR images. (Black and white can be a great way to showcase some of your photos and create powerful, dramatic shots.)

Part V: The Part of Tens

Many *For Dummies* fans (myself included) eagerly look forward to leafing through the Part of Tens. That's why I held nothing back: no filler here. I strove for practical ideas that I expect to stimulate your thinking. This part is a resource you can turn to again and again for ideas on how to take better photos for HDR and how to avoid ruining them. Sounds like fun!

Icons Used in This Book

I use the following icons throughout the book to make certain information stand out from the rest. If you want a fun (and different) experience, leaf through the book and focus on one type of icon at a time.

Tips are fun. They're practical. They're helpful. I include as many as I can get away with to try and share my experiences with you. They normally contain what I think is the best way to do something, or perhaps a road to avoid. Tips — making your life easier, one step at a time (cue goofy music).

Remember icons highlight helpful bits of information — things for you to remember. It's sort of like a *Star Trek* mind meld from Spock in the *Wrath of Kahn. Remember.*

When I have to include some technical information, I warn you with these icons. You don't have to memorize them or understand what's going on to accomplish the task at hand, but they make interesting background reading.

If this were *Snake Charming For Dummies* or *Nitroglycerine For Dummies*, Warning icons would literally be life-preserving suggestions. As it is, you should pay attention to Warning icons because they will save you time and frustration if you heed them. I have tried to keep them to a minimum. When you see one, read it.

Where to Go from Here

You can read this book back to front, sideways, inside out, or from the first to the last page. If you're completely new to all aspects of HDR, I suggest you follow the basic order of the chapters, but feel free to jump around whenever you want to.

If you have questions about the book or HDR, you can contact me by one of the methods in the following list. Visit my Web site and Flickr photostream to see what I'm up to and get to know me. I can't guarantee immediate service or a 15-minute e-mail turnaround, but I will do what I can to answer your questions and make your experience with this book and HDR more enjoyable.

- **E-mail:** help@robertcorrell.com
- **Web site:** www.robertcorrell.com
- **Flickr:** www.flickr.com/photos/36292761@N03
- **Twitter:** http://twitter.com/RobertCorrell

Part I
The ABCs of HDR Photography

The 5th Wave By Rich Tennant

"I've told you a dozen times, stop showing him your HDR photos of pitchforks and torches!"

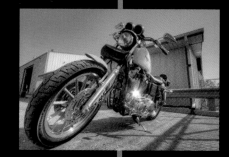

In this part . . .

Hey, you have to start somewhere. This is the place to find out what HDR is, how it differs from traditional photography, and what you need to get started.

Chapter 1 gets you started. You'll see HDR in action and look at several examples of "before and after" photos to see why there's such a fuss over HDR. I sneak in some macro-level HDR workflow on you, too. Chapter 2 is where you find out what you need to have in terms of photography gear (cameras, lenses, tripods, levels, plus a lot of other stuff), what each item brings to HDR, and why you should consider buying it. Chapter 3, being the third chapter, is the chapter that brings the software side of HDR into focus. I walk you through the different types of software that enable you to create HDR images on your computer and help you edit or manage them. I also review some HDR-specific applications.

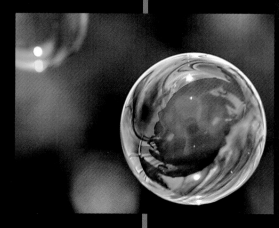

Shining a Light on HDR

*R*ather than start this book with a pedantic definition of high dynamic range (HDR) photography followed by a technical treatise on why digital camera sensors don't capture the actual range of light in most scenes, I want you to see it in action. After all, HDR photography is first and foremost about the photos.

Déjà vu alert: HDR photography is about the photos.

The technical information behind why HDR has been developed may or may not be meaningful to you down the road, but you can't be expected to make the decision to jump into HDR photography on the basis of bit depths, contrast ratios, and sensor noise. I haven't left you high and dry though. There are as many HDR images and examples throughout the book that I could fit in to help you see the HDR difference and decide whether or not you want to try it out.

You need to see HDR in action and examine the types of images you can create with it. Afterward, if you want to know why a 12-bit sensor can capture only 4,096 levels of gray and how that's insufficient for most scenes, you'll be able to put that into practical perspective.

This chapter, then, shines the light on HDR with a little bit of show and tell.

Peeking inside the HDR Process

HDR photography is an exercise in capturing more light than your camera wants to. As I show you throughout this chapter, today's digital cameras have a problem with dark darks and bright brights in the same scene. It throws them a bit wacky. "Traditional" pictures often don't tell the whole story.

HDR photography — also called HDR imaging (HDRI) — is a two-tiered process that attempts to

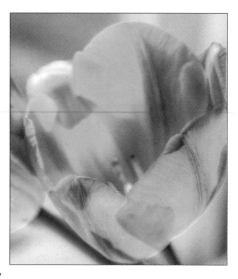

1. Capture as much of the true dynamic range of a scene as practical (or possible, or artistically desirable).

2. Process the result with specialized software to produce an image file that can be printed and viewed using standard graphics, Web, and publishing software.

Figure 1-1 is an example of what you can create with HDR.

HDR photography is not monolithic. A number of caveats, disclaimers, and personal preferences affect the process of HDR in all areas. However, certain established aspects of HDR make it HDR.

Figure 1-1: Turn mundane into amazing.

The twin peaks of HDR

As I just mentioned, HDR photography is a twofold process. You take pictures; you process pictures. Everything revolves around or is a part of these two activities. Each pillar (to continue mixing metaphors) builds a different part of the foundation:

- **Photography:** HDR photography isn't something you can do from the confines of your office chair or Barcalounger. It begins with photography. Without pictures, you don't have HDR. However, you don't have to

travel to exotic places to shoot. You can exploit HDR to its fullest with landscape, architecture, and everyday subjects easily found in your own backyard and local community.

For more information on setting up your camera and taking pictures, please see Chapters 4–6, plus Chapter 12.

✔ **Software processing:** HDR relies on a combination of software; some are specific to HDR, and some serve more general purposes as well as helping you create HDR. Without software processing, you don't have HDR.

For more information on the software aspects of HDR, please see Chapters 7–11.

Going with the (work)flow

HDR photography can be somewhat confusing if you aren't familiar with the basic flow of events. In general, here is what you dutifully do when you do the HDR you do and the order that you do it in.

1. Take the photos.

 This is the first, and arguably most important, step in HDR. Don't be content with average photos. Take good or even great photos.

 Much of the time, you'll set your camera on a tripod at the scene of your choice and take a series of exposure bracketed photos. *Bracketing* means you take a few pictures with different exposure values without moving the camera, resulting in a series of bracketed photos. The succession of Figure 1-2 shows an example of bracketing. You can see from these three brackets that each one preserves an important part of the overall dynamic range of the scene. This is pretty important. Although the under- and overexposed photos aren't pretty to look at, the HDR application uses the information from all the brackets to sense what each part of the scene actually looks like. HDR software works with all the information you can give it.

 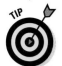

 If your camera is fast enough, you might be able to take bracketed photos without a tripod. This is called *hand-held HDR*.

 The exception to bracketing is when you take one Raw photo for use in single-exposure HDR. Raw photos are best to work with, but JPEGs can also produce good results.

2. Do Raw photo preprocessing.

 For the highest quality results, convert Raw photos to TIFFs before proceeding with HDR.

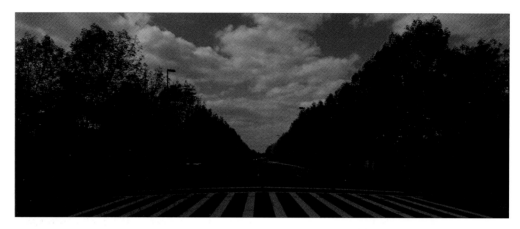

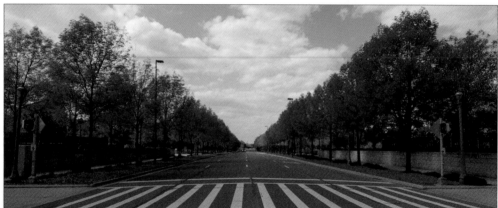

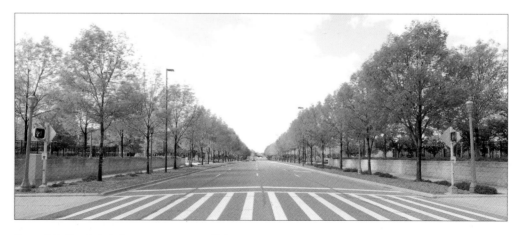

Figure 1-2: Bracketed photos capture more light.

3. Generate an HDR image in HDR software.

 HDR software merges the bracketed photos into a single HDR image that serves no practical purpose other than to turn into something else.

4. Tone map the HDR image in HDR software.

 By itself, the HDR image isn't worth much. Until everyone is using HDR monitors and printers, you have to *tone map* (the process of deciding what data from the original photos is kept in the final image and making sure it fits) the HDR image to convert HDR data into a low dynamic range space.

 Yes, you do all these steps to get back where you started — a low dynamic range image — kinda. The key difference is that this image was created from a much wider range of original data, making completely different and beautiful processing options available.

5. Finish with post-HDR processing.

 The image you just tone mapped often needs further attention. For example, it might have noise problems, or need straightened or cropped. You might also wish to convert your image to black and white, or otherwise embellish it by adjusting levels, tweaking the contrast, or dodging and burning.

6. Publish the image.

 You can see the result in Figure 1-3. The final product was a result of photography and software skills applied to capture and present an interesting view down a major street with traffic barreling down on me just like you were there with me.

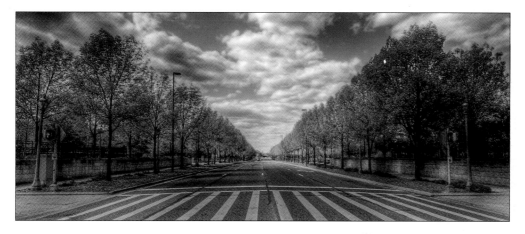

Figure 1-3: The final product.

HDR Show and Tell

The most effective way to show you the practical benefits of HDR digital photography is for you to see what photos look like before and after being processed as HDR. You'll discover a little bit of the why along the way, with the rest of the book completing the picture. I chose several types of scenes to illustrate the breadth and depth of HDR, ranging from interiors to sunsets to my son to a soap bubble. Here, let me show you.

Rescuing details from shadows

One of the things HDR is meant to do is bring details out of shadowy areas. The photo in Figure 1-4 looks west at sunset. The sky is reasonably light, and you can make out the clouds and the glow from the sun. These elements also reflect off the water of the river in the foreground.

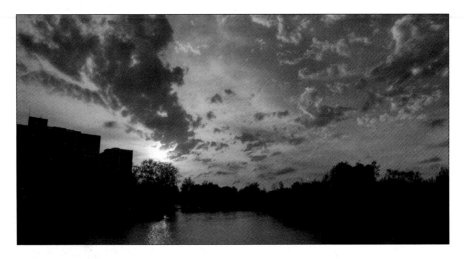

Figure 1-4: A sunset with a dark foreground.

Unfortunately, the trees, riverbank, and details of the building are all in shadow. The camera can't capture enough *dynamic range* — the total range of light in a scene — to accurately represent it. Standing there, the actual scene was much brighter. The disconnect between reality and the photograph is that digital still cameras do not see scenes the way our eyes do.

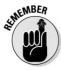

The reasons cameras have limited dynamic range are many. Camera manufacturers are currently unable (due to the fact that not everything is possible) or unwilling (they have to stay in business so not everything that is possible is practical) to cross scientific, technical, design, and manufacturing barriers, including

- The bit depth the sensor uses to store data
- The inherent noise level of the camera system and how it affects the sensor's ability to measure light
- How digital systems simply react to light differently than our eyes do

The effect, more often than not, is that a camera compromises when it measures the exposure of a scene. It has to. In this case, rather than make the sky too bright, the camera made it just bright enough and relegated the rest of the scene to the shadows.

Figure 1-5 shows the same scene in HDR. Notice the huge difference across the photo, particularly in the previously dark areas. The trees are now clearly green. The sky and clouds have more definition and the building has discernable details. Much better!

The secret to creating the new look is twofold. First, HDR photography captures a much wider range of exposure information using brackets. This gives the software much more information to use. Highlights that are normally too bright are captured so they aren't overblown. The same goes for shadows. In software, you tone map the source material (which has too wide a range of brightness to display or use as a standard image), squeeze it so it fits in a standard image, and make creative decisions that define the relative brightness of parts of the scene. After this, you can make other adjustments and enhancements (such as brightness, contrast, color, noise, sharpness, recomposing, cropping, and resizing) in a photo editor such as Photoshop Elements.

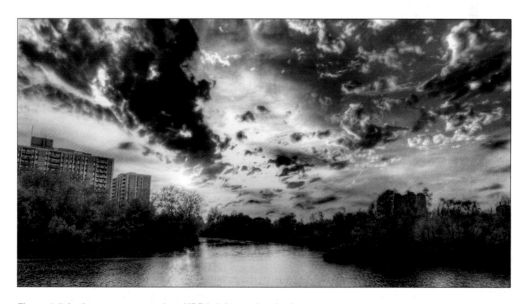

Figure 1-5: In the same sunset shot, HDR brightens the shadows.

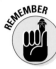

This example illustrates a few interesting points:

- **Losing the low end of dynamic range:** Digital cameras often lose details in shadows. This is caused by the camera's inability to capture the full range of light in a scene. This range is called *dynamic range*.

- **Compromises:** Cameras make compromises on what to expose well and what to let go. You can help the situation by metering the scene and subject correctly — but scenes with a wide dynamic range can't be faithfully captured by today's cameras.

- **Rescuing details from shadows:** HDR photography allows you to pull meaningful information out of shadows so the areas are brighter.

Taming highlights

Another strength of HDR is the ability to tame highlights, which are often *blown out* in traditional photos — that is, the camera ran out of room to store brightness information. When that happens, the camera sensor throws its hands up in the air and exclaims, "¡No más!" The blown areas have very little detail and may be completely white, as in the sky of the left image in Figure 1-6.

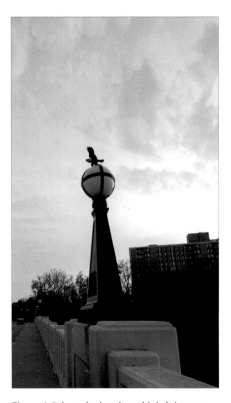
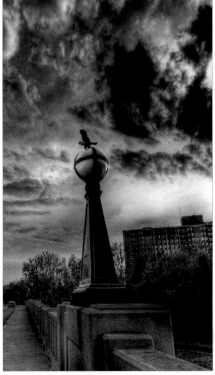

Figure 1-6: Lucy in the sky, with brightness.

In the left image, the street, bridge, and lamppost in the foreground are all decently exposed although not perfectly — they are, along with the trees, a bit dark. The sky is the bigger problem: It suffers from being mostly dead — that is, blown out. It's too light to see many details, especially over the building to the right.

The camera got caught in the middle. It ended up favoring the foreground (although imperfectly) and therefore blew out the sky.

However, the same scene shot and processed as HDR is shown on the right side of Figure 1-6. It is overwhelmingly better. In particular, the sky has many more details and is no longer washed out. The brackets provide the information and the HDR application uses them to access and manipulate the data. The clouds are dramatic, and the contrast between clouds and sky is much more interesting. This particular look — somewhat dramatic with plenty of surface details — was achieved during tone mapping, which is covered in Chapters 8 and 9. The trees are nice and bright, and the texture of the concrete bridge has been enhanced. The latter points used many of the editing techniques shown in Chapters 10 and 11. In particular, the tree line was dodged — a process that selectively lightens an area.

This shot reveals

 ✔ **The high end of dynamic range:** Normal photos often lose information to blown highlights. When the camera exposes the shadows brighter, highlights get blown out. It's a no-win situation.

 ✔ **Rescuing details from blown highlights:** HDR tames highlights and preserves important information. It allows you to emphasize details and contrast while preserving the entire scene. The entire photo looks better.

Making the most of interior spaces

HDR is perfectly suited for interior spaces — and the larger the better. Figure 1-7 illustrates the sanctuary of a large church lit with overhead room chandeliers, a few spots on the stage, and ambient light coming in from the windows.

This is a great example of a compromised exposure. The camera is doing the best it can, but it is stuck in the middle. The result is a dark looking room that should be brighter and bright areas around the lights and windows that should be the same or darker. It is the worst of both worlds.

And neither of the following two courses of action, illustrated in Figure 1-8, are attractive:

 ✔ **Dinged if you do:** Raising the ISO or slowing the shutter speed to make the room brighter (raising the exposure) only serves to blow out the highlights even more, as you can see in the left side of Figure 1-8. Rigging

additional lighting to brighten the room would either be too expensive or cumbersome, not to mention that you couldn't possibly hide the lighting gear from this vantage point.

✔ **Donked if you don't:** Protecting the highlights around the chandeliers and windows requires decreasing the exposure. The problem is that everything that already looks a bit on the dark side slides further into darkness if you do that. Check out the right side of Figure 1-8. You are left with a picture of a few bright spots in a dark room.

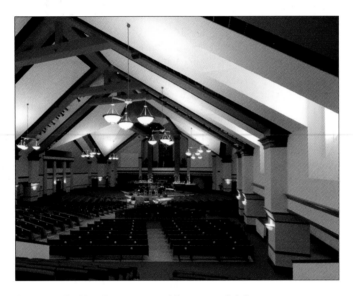

Figure 1-7: Inside a large space with no extra lighting.

Overexposed Underexposed

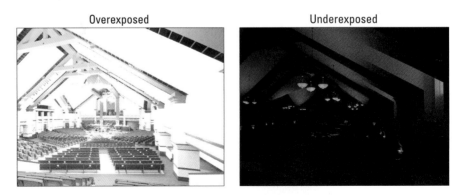

Figure 1-8: Two exposures show the horns of the dilemma.

Tone whating?

It's impossible to talk about HDR without touching on tone mapping, because that's what gives each HDR image a unique look. In HDR, you create an HDR image from bracketed photos first (see Chapter 7). Much more brightness data is stored (you know, what's in the shadows and what's in the highlights) in an HDR image than is possible in standard image formats like JPEG or TIFF (even a 16-bit per channel TIFF). That makes an HDR image impractical to use. You can't view it properly on your monitor or print it out. So, you have to tone map it (see Chapters 8 and 9).

Tone mapping occurs in HDR software. Different applications handle it differently, but the general principle is that you control how data from the HDR image gets put into a low dynamic range format. You get to choose specific tone mapping settings that can create entirely different looks in different images. The end result is a TIFF or JPEG — something you can continue to edit in a graphics program, publish, or print.

HDR solves both these problems nicely, as shown in Figure 1-9. The entire room looks brighter and more vibrant, and the light from the windows has not overpowered the photo. In other words, the best parts of each of the bracketed photos contributes to the final image. The decisions you make that control how this occurs is what tone mapping (Chapters 8 and 9) is all about. Although some post-HDR processing techniques helped achieve this effect, tone mapping is the single greatest contributor to the overall appearance of this image.

Figure 1-9: HDR solves this exposure problem.

This photo shows you

- **Flexibility:** HDR can work in situations where extra lighting is needed to achieve a better exposure. This is especially helpful for large buildings (which are impossible to light without owning a movie company), landscapes, cityscapes, and large interiors.

- **Color:** When more of the scene's dynamic range is present, brought to you by HDR, its true colors are free to come out. This is far preferable to the dull original.

- **Post-HDR processing:** It's often important to continue to edit a tone mapped HDR image to create a finished product. Even with bracketing and tone mapping, the windows were still a bit too bright. An underexposed bracket was used to tone down the windows even more. That option would not be available without the brackets.

Enhancing details

HDR works well for large scenes, but it also enhances smaller subjects that have lots of detail. Figure 1-10 shows the ceiling in the lobby of the historic Tower Bank in Fort Wayne, Indiana. You can see potential here. The top part of the figure hints that underneath the dullness, there promises to be an interesting work of art. Hints of color and detail are tantalizingly close to the surface, yet the local details are ill-defined, and the texture and colors are monotonous.

What often gets lost in the rush to say how much more dynamic range is captured by HDR is the fact that it accentuates textures so beautifully. You'll find it works wonders on wood, brick, stone, rust, gravel, and yes, even animal fur.

HDR brings out the subtlety and small nuances with a sledgehammer, as seen in the bottom part of Figure 1-10. It's fascinating, intriguing, compelling, and telling. It's shocking, I tell you. Shocking.

HDR uses exposure information gathered from a range of photos to enhance the local contrast so you can see the true details. These details aren't made up. This isn't a visual or processing trick. They are actually there, but traditional digital photography has a hard time finding them.

- **Details:** Poorly exposed photos lacking in dynamic range hide details that are often visible with the naked eye.

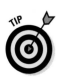

- **Details!:** HDR removes the "haze" from the original photo by capturing more light than the original. This brings out intricate and fascinating details. Contrast enhancements accentuate texture differences.

- **Details!!:** Colors shine when let loose by HDR. Tonal variations are much more visible.

Figure 1-10: Details explode out of HDR.

Working wonders with people

Most people think of landscapes, cityscapes, and other photos of inanimate objects when they think of HDR. I want to challenge you to try it with people as your subject(s).

It's not the same as traditional HDR because you don't capture a series of photos. You shoot a single Raw photo. This is because it is impractical or impossible to get people to sit motionless. My kids barely stay in one spot for 1/500 of a second without moving!

What makes this possible are Raw photos and a little bit of trickery. Take a good photo in Raw (not JPEG) and send that through your HDR software as if it were a bracketed set and then tone map the result. You can create

your own brackets from the single Raw photo and send those to your HDR application if you like. (Flip over to Chapters 6 and 7 for information on this.)

In the end, you're not increasing the dynamic range of your camera by shooting multiple shots. However, you do end up with something that looks very close to HDR.

This process has alternatively been called *pseudo-HDR, single-exposure HDR,* or simply *tone mapping a low dynamic range image.* Whatever you call it, here's an example. The left side of Figure 1-11 illustrates a reasonably good JPEG of one of my sons, straight out of the camera. It's a good portrait, but the sun is shining on his face from the left side. It's a classic case of the dreaded face shadow.

The original Raw exposure was processed through the Sony Image Data Converter five times to create five images with different exposures, from dark to light. This Raw converter enables you to save Sony Raw photos as JPEGs or TIFFs after you make adjustments to lighting, contrast, color, sharpness, and noise — see Chapter 7 for more information on Raw conversion. This process squeezes every bit of dynamic range in the photo to the surface.

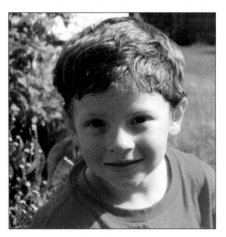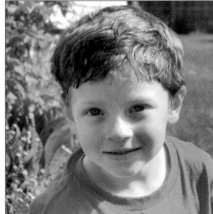

Figure 1-11: Harsh shadows often plague portraits.

Converting single exposures to brackets doesn't increase the dynamic range of the original, but it does bring out the entire range of exposure information more for you to see it better.

Those images were processed as HDR and tone mapped. The result is shown in the right side of Figure 1-11. Apart from the entire photo looking better and more vibrant, the shadows on the face are less distracting.

This example illustrates

- ✒ **People problems:** Cameras often have a hard time photographing people without a flash or additional lighting. This normally results in backlit subjects or shadows that cross the face. If you use a flash, you pay for it with harsh shadows and blazingly bright foreheads such as the nearby figure (and yes, I've got all sorts of bad shots in my photo archives waiting to be published).

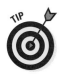

- ✒ **HDR and people:** HDR can work with people. If you let the tone mapping controls like Strength and Smoothing (you'll get to them in Chapters 8 and 9) get out of hand, the person may look horrible. A fine touch, however, will reward you with a more vibrant photo than the original.

- ✒ **Single-exposure HDR:** Although not technically HDR (because you're only shooting one limited dynamic range photo), you can use single Raw exposures as source images for pseudo-HDR.

Within and without

During a nice, brightly lit day, take your camera and go to a room where you work or live that has a window in it. Without using a flash or any other exposure aids, try to take a photograph where the inside and the outside are both properly exposed. Turn the inside lights off and on to see whether it makes a difference. Put the camera in Auto mode or use different metering and exposure strategies if you like.

You're not going to have much success, especially if you don't use some serious interior lighting to balance the brightness of the interior with the outside. The problem is again dynamic range, pure and simple. Today's digital cameras can't capture a dim interior and a bright exterior without messing something up, as shown in Figure 1-12.

In this case, both areas suffer. As you can see on the left side of Figure 1-12, the outside is blown out with details barely visible. The inside is completely dark. You would think I was standing in a dark room photographing the surface of the sun through the revolving door! Nothing could be further from the truth.

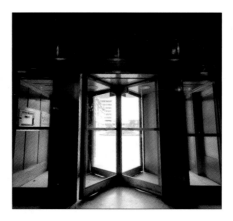 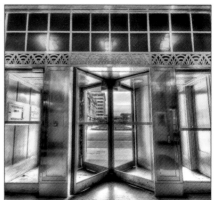

Figure 1-12: Seeing inside and out with HDR.

Your eyes don't see this, of course. What you see in person is a well-balanced scene with a high dynamic range. If you were standing there, the room would look normally lit. The outside would look normal. Or, to put it another way, you see something like the right side of Figure 1-12, which is the scene in HDR. (It is perhaps artistically embellished a smidgen, but not so much as to make it unrecognizable.)

I hope you can see that

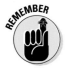

- ✔ **Cameras struggle with inside-out shots.** The dynamic range in this example, from a darker but well-lit interior to a very bright exterior, is huge. It's impossible to capture the entire range of this scene in one digital photograph.

- ✔ **Reality is not always well represented.** Traditional photographs aren't necessarily a good indicator of reality, despite what some people will tell you. If you doubt that, find a location like this and compare what you see with your eyes to a photograph.

Feeding your starving inner artist

HDR excels at many things and certainly solves a great number of common exposure and dynamic range problems. That satisfies those people who think with the right side of their brains. Another group (they often cross over), however, shoot HDR just because it looks cool. These people aren't constrained by a rigid set of rules or procedures: They're artists.

The left image in Figure 1-13 is a photograph of a bubble, floating in the breeze. The camera wasn't set up on a tripod, and bracketed exposures weren't taken. It's not necessarily the greatest scene for HDR.

What this base photo has going for it, though, is that it's an interesting picture. Even as a traditional photo, it pulls you in. The problem is, you want more.

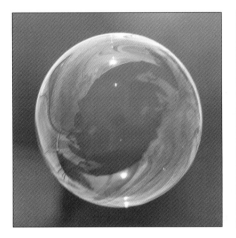 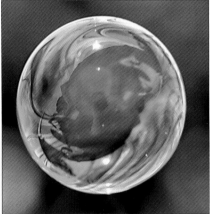

Figure 1-13: A bubble shot in Raw format and transformed.

The right image of Figure 1-13 is the "more." The result illustrates how captivating HDR can be — even when relying on a single exposure.

This photo benefits from parts of the HDR process just like the other examples in this chapter. The details of the bubble are clean and clear because the software accentuates the contrast between different bands of the bubble. In addition, the colors are much more vibrant.

This example shows

- ✓ **Left brain:** HDR doesn't always have to be the solution to a problem. Sometimes it can just be artistic.
- ✓ **Right brain:** There are important technical facets of HDR, and even an artistic expression can serve a logical purpose.
- ✓ **All skate:** There's room for us all. It's a big tent. Come on in!

Getting Excited about HDR Photography

There's a lot to HDR photography. One of the things that makes it most interesting is that it has elements that appeal to whatever side of your brain you use most, or both. If you're a technically minded photographer, HDR offers you a serious tool to pursue all the dynamic range you can shake a stick at. If you want to shoot HDR because it looks cool, you're in good company, too. HDR also has the depth to interest artists and craftsmen, dreamers and realists.

As you continue to discover HDR photography, consider where you want to take it and how to get there. These topics are a good place to start:

- **Deciding what you want to create:** Think about what you like to shoot, how much effort you want to put into it, and what generally floats your boat. Let your passion for photography guide you into HDR, and don't be afraid to diversify your interests.

- **Discovering your comfort level:** HDR photography should fit within the boundaries of your life. That doesn't mean you should take it easy and not push yourself. It means you don't have to let it take over your life.

 Given certain adjustments, HDR should fit within the time and money parameters that you set. Decide what level of effort makes you happy, and then get out there and do it!

- **Costing it out:** Taking digital photos costs very little. Compared with ye olden days, you don't have to buy rolls of film and pay to have the photos developed. That alone makes today's pursuit of photography very enjoyable. Take 2,000 photos over a weekend if you want to!

 You do, however, have to buy a camera, memory cards, batteries, other gear, and have a computer and the software to make HDR work.

- **Defining your workflow:** Workflow is a buzzword in the digital photo world, and for good reason. It just buzzes. Bzzzzz. Bzzzz. There is a distinct workflow to HDR (shown in this chapter and in the basic organization of this book), but within the overall framework, there are plenty of options (details of which are contained throughout). Find what is comfortable for you.

- **Experimenting:** Don't get yourself too tied down to a particular way of doing things to the exclusion of all others. Experiment. Try different lenses, approaches, techniques, styles. Stay fresh!

- **Growing:** Did you know that growth is a growth industry? Yeah, it's fun to grow. It exercises your brain and keeps you happy. Whether you're picking up HDR at 9 or 90, you can grow with HDR.

2

Gearing Up for HDR

*H*DR photography is easy to get into and fun to grow with. You don't need a whole lot to get started. In fact, the least you need is a digital camera that allows you to control the exposure and an inexpensive tripod. That's it!

And now for the fine print.

The catch is, not everything is equal. You can get started with a pretty inexpensive compact digital camera and a little tripod, but you won't have the same flexibility, nor will you be able to consistently achieve the same image quality as a more professional camera and accessories. (The consolation prize for being economical is saving from a few hundred to many thousands of dollars.)

More capable cameras can even shoot HDR without a tripod. There are a million-and-one camera and gear choices out there. If you're buying new, take the information in this chapter and use it to start off in the right direction. It's a very powerful feeling to stand in a camera shop, fully informed, knowing what you need while you test different cameras (that you have read up on beforehand).

If you already have a camera but don't shoot HDR, find out what your options are before running out to get a new model. Maybe you can use what you have and grow into HDR. You'll be better informed when you plan your next purchase.

Either way, it's time to explore all things gear, and gear is what you're going to hear here.

Knowledge Is Power: Researching and Shopping for the Right Equipment

Use every tool at your disposal to investigate the general types of gear you're interested in, and then zero in on specific makes and models. This chapter gives you a good start on choosing the types of gear you need, so I mention only a few specific models. Keep in mind, too, that because many products work differently, this book can't take the place of a manual dedicated to your specific equipment.

When you're shopping for equipment, use the Internet! Go to manufacturers' Web sites and look through their product lines to research camera specifications. Compare and contrast. Price your options. Shop for other gear, too, and read reviews.

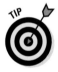

One word of caution on reviews: You don't know why a person might hate or love a piece of gear. Maybe the reviewer is an idiot, doesn't have any talent, didn't read the manual, or learn how to use the camera or gear effectively. Maybe the reviewer is a paid professional who gets a kickback. Maybe the review is a genuine, honest assessment of the gear. You never can tell, so always read more than one review before deciding whether a particular model is right for you.

If your camera has an online manual, download it and read it. **Hint:** You'll enjoy the ability to magnify it onscreen much larger than the tiny print in the one that comes with your camera.

Make friends at your local camera shop. Having a human connection can often make the difference between getting the right gear for you and wasting time and money on something that doesn't fit your needs. They don't expect you to buy everything from them, but they'll surely appreciate your business.

It's important to have a plan. To create that plan you need to know what HDR is (here and throughout the book), see different cameras, learn about optional gear, and know how each piece of gear will contribute to your ability to create HDR images.

Looking at Hand-Held Photon Capture Devices (Err, Cameras)

Choosing your camera is the best place to begin when you're buying equipment for HDR photography. The following sections look at the different camera types and what they bring to the table.

HDR is about controlling and manipulating exposure. You must control exposure to shoot bracketed photos of a scene, as shown in Figure 2-1. To complicate things, there are a number of different ways to control exposure. Some are obvious, and others are less so.

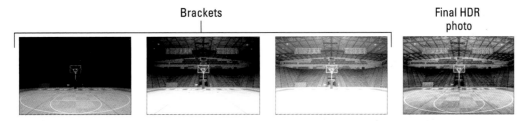

Brackets Final HDR
 photo

Figure 2-1: Control exposure to achieve bracketing.

Different cameras tend to have different methods and modes of exposure control. (If you aren't familiar with some of the camera or exposure terms in the following list, check out Chapter 4.) You need to investigate whether the camera you want to buy (or the camera you have) has at least one of the following exposure controls:

- **Manual exposure mode:** You won't necessarily be looking for a new camera with manual mode for HDR (look for a good AEB feature instead). If you're dusting off a camera you already have, manual mode makes it HDR-compatible. The only drawback is shooting speed.

- **Auto Exposure Bracketing (AEB):** Using AEB frees you from turning dials and changing the exposure in the middle of a bracketed set. The camera does all the work for you. (Cough: hence, the term *auto*.)

 This is what you want to look for in a camera to shoot HDR. AEB is the fastest way to shoot brackets. Not all AEB is created equal, however. Cameras with AEB that shoot a total range of at least +/– 5.0 EV for the bracketed set give you good exposure coverage. Some take more photos with a larger exposure difference between them and some take less.

 Bottom line: If you have AEB, you're in for faster, accurate, less stressful HDR photography than any other method.

✔ **Exposure compensation:** This method of shooting HDR turns virtually any camera into an HDR machine. In other words, you can take the inexpensive compact digital you already have and start shooting HDR with it right now — you don't have to run out and buy a new camera until you're ready.

You need only one of the features in the preceding list to shoot bracketed HDR. Some cameras have all three, and some have one or two. Others poorly implement some combination or another.

Notice something missing from the preceding list? How about the Raw file format? It's not the least you need to have, although it helps. Raw photos give you greater control, more dynamic range, and more upside. However, you can use plain ol' JPEGs for HDR. The only time you must have Raw photos is when you want to shoot single-shot HDR, which is covered more fully in Chapter 6.

Inexpensive compact cameras

Compact digital cameras (sometimes called digital *point-and-shoot* cameras) are the cheapest entry into HDR. You can buy one for about $100 and start your HDR career without having to get a second mortgage on your home.

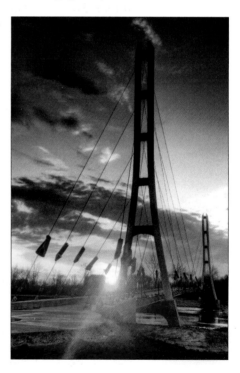

Figure 2-2: You can certainly get great shots with an inexpensive camera.

Here are some models that can fit the bill. The Nikon Coolpix S220 and Canon PowerShot A480 can shoot HDR by using exposure compensation. The Panasonic Lumix LZ8 is a little older, but it features manual mode and AEB. Figure 2-2 shows what you can achieve using this Panasonic model.

You can take great photos and have fun with HDR with any of these cameras. The key to buying a compact digital camera that can handle HDR photography is to know what you're getting and knowing the camera's limitations.

To repeat, with compacts that feature manual modes and even auto bracketing, you're set. You can't take action shots or hand-held HDR because the frame rate is too slow, and you won't have Raw photos to use for single-shot HDR.

If your camera doesn't have a manual mode or AEB, don't worry — all is not lost. The Exposure Compensation feature on most (if not all) digital cameras offers you a workaround for automatic controls to change shutter speed, which is how you shoot manual brackets.

The benefits you'll find if you use a compact digital camera:

- **Compact:** Compact digital cameras are easy to carry, hold, store, and shoot normal photos with "point and shoot" ease (HDR isn't quite so automatic with a compact camera). Their diminutive size can make a difference if you don't want to lug around a big digital single lens reflex (dSLR) with several lenses.

- **Inexpensive:** Not all compact digital cameras are easy on the wallet, of course, but this type of camera starts out inexpensively. You can find a good camera that fits your budget with little trouble.

- **Multi-purpose:** You can use a simple point-and-shoot for casual family photos during the day and HDR at sunset. These cameras are ideal to start your HDR career, and you can use them for many other purposes. They also make wonderful learning platforms to teach children about photography.

- **Results:** Purists and quality fanatics might cringe at the prospect of seeing HDR shot from compact digital cameras, but they work.

These are the tradeoffs you'll find if you use a compact digital camera:

- **Photo quality concerns:** Compact digital camera photo quality ranges from surprisingly good to downright abysmal. They tend to show more noise, and high-ISO performance trails far behind dSLRs. This degradation of quality happens primarily because these cameras have a much smaller sensor.

 Having said this, you can take (with a decent camera, the know-how to use it, and good software processing skills) beautiful pictures. Paradoxically, without those skills, you will find it very challenging to take decent pictures even if you have a very high-quality, expensive camera.

- **Small or no optical viewfinder:** Many new compact digital cameras have no optical viewfinder. You are forced to frame and compose your shot on the LCD screen. Although this is fine sometimes, it's harder to see what you're doing outside in the sun. And even if your model does have a viewfinder, as in Figure 2-3, it's often microscopically small — and, to make matters worse, it's not a faithful representation of what you're photographing. This is one reason why dSLRs are so popular among professionals — because you look through the lens when you look through the viewfinder, seeing what the camera sees.

✓ **Small controls:** Although these cameras are designed to be easy to use, they are often harder to use if you want to do anything other than put the camera on Auto and start taking pictures. Control knobs and buttons are tiny or nonexistent. This can make it hard to change shooting modes, aperture, focus, and exposure compensation.

✓ **Restricted flexibility:** One of the biggest strikes against compact digitals is the lack of flexibility compared with dSLRs. This has an effect on where and how you can shoot good HDR:

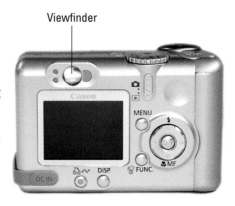

Viewfinder

Figure 2-3: This camera's viewfinder is but a tiny porthole above the LCD screen.

- *Limited shooting modes:* You will often be limited to preset scenes and auto modes, which restrict your ability to be in control of the camera.

- *Limited focus modes:* You often have no manual focus — and even if you do, it's pretty hard to focus a compact digital camera on anything other than the side of a barn. Too, depending on the shooting mode you are in, you might have a limited ability to control focus points. Shooting sweeping landscapes might not be a problem, but focusing on a small detail for HDR might be.

- *Limited metering modes:* You might be limited to one or two metering modes (multiple, which you should always have; center weighted; and possibly, spot), which can restrict your ability to set the best overall exposure.

- *Single lens:* This could be a pro or a con, depending on who you are. You can save yourself a lot of money because you won't be tempted to buy new lenses. On the other hand, you can't upgrade your camera with a better or different lens. **Hint:** If you aren't happy with the angle of view (it may be too "zoomy," or not wide enough), you'll have to get another camera.

- *No growth:* These cameras are great at what they do, but when you master them and want to continue to grow, there is no alternative but to get another camera.

✓ **JPEGs:** Budget compact digital cameras do not offer Raw support. The only file format available is JPEG, which limits your ability to make pre-HDR processing decisions. This limitation can also affect photo quality. This is not an insurmountable problem, but realize that the upper level of quality you can achieve is limited.

Touch-screen controls

New Nikons have moved to a touch-screen paradigm, which isn't the best for HDR when you want to keep the camera steady. Ideally, you should touch the camera as little as possible. When you must, it helps to have controls at your fingertips instead of having to poke the screen several times.

High-end compact and super-zoom cameras

Taking a step up from the budget range, you will find a wide variety of more expensive compact digital cameras, high-end compacts, super-zooms, and dSLR look-alikes. There are so many often-overlapping categories that it makes your head spin.

The two things this range of cameras have in common are their increased cost, and better or more features. Figure 2-4 shows an older Kodak EasyShare Z740 super-zoom. Despite its age and being only a 5 megapixel (MP) camera, it sports a manual mode and can help you take fantastic pictures. Notice at this point you get an upgraded grip. Woohoo! That makes the camera easier to hold and use without getting your fingers in the way of the lens. Speaking of lenses, super-zoom lenses tend to be much larger than budget compact digital cameras. Part of the reason is marketing (a larger lens looks more impressive) but part is functional — these lenses have to be better in order to make zooming in by a factor of 20x practical.

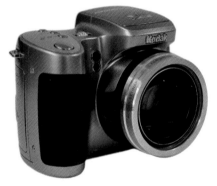
Figure 2-4: Look for more features with a midrange camera.

Other candidates in this category are the premium compacts Panasonic Lumix DMC-LX3, Canon PowerShot G10, and Nikon Coolpix 6000; super-zooms Canon PowerShot SX1 and SX10, Panasonic Lumix DMC-FZ28, and the Sony Cyber-shot DSC-HX1.

Super-zooms are basically compact cameras (all but the beefiest are smaller than a dSLR) with an impressive zoom capability that generally cost much less than a dSLR. The Canon PowerShot SX-20 IS, for example, puts 20x optical zoom at your fingertips for about $400. This is equivalent to a 560mm lens on a full-frame (35mm) camera. To put that into perspective, the Canon EF 600mm f/4L IS USM super telephoto lens costs just under $10,000. The SX-IS 20 also features a reasonable wide-angle capability, starting out at 28mm (35mm equivalent).

Here are the pros of spending more money to get a more capable camera:

- **Higher picture quality:** Although sensor sizes are still small, the image quality you can get from a more expensive camera tends to be better than the budget line because of image stabilization and additional processing oomph in the camera. Too, this class offers better or larger lenses. High-ISO performance still lags behind dSLRs, however.

- **Comparable megapixels:** These cameras compete well in this category. High-end models generally top out at 12 megapixels while more inexpensive and older cameras have between 8 and 10.

- **Still relatively compact:** Even at this level, you can still carry around an amazingly small camera. For example, at only the size of a box of animal crackers, the Canon G10 is a serious camera with a lot of power. You can easily fit it in a purse or a manly European carryall (think Seinfeld).

- **More controls:** High-end digital compacts and the more expensive super-zooms offer more controls than a budget camera. Look for handy knobs and switches on the camera body, which make changing shooting modes, aperture, and shutter speed much easier.

- **More manual control:** You tend to garner a greater ability to manually control the camera as you spend more money. This makes manual bracketing (assuming no AEB mode) easier than having to resort to exposure compensation.

- **Raw file format:** At this level, the Raw file format is sometimes — albeit not always — an option. This is a significant reason to step up to the next level and purchase a more expensive camera. Although you might be happy with JPEGs for casual shooting, Raw photos can give you a boost in HDR quality. In addition, you can shoot single-exposure HDR using Raw photos. That opens up a whole new and exciting world.

Here are the cons of spending more money to get a more capable camera:

- **Not a dSLR:** As the cost rises, you approach the price of budget dSLRs but don't get the same benefits. If you're considering upgrading to a dSLR, seriously consider the two types of cameras and whether you need the super-zoom.

 No matter how expensive a super-zoom camera is, the camera and lens combined often cost less than a professional quality zoom or telephoto lens for a dSLR.

- **Flexibility:** Super-zooms tend to be single-purpose cameras. Sure, you can stand on the sidelines of the soccer game taking photos of little Timmy across the way competing his heart out. However, wide-angle capability is limited, which can restrict your ability to shoot certain scenes in HDR. High-end compacts are much more versatile.

✔ **Noise:** Compared with dSLRs, these cameras have more noise, especially at higher ISOs. Shooting at ISO 100 can negate this problem. See what I mean in Figure 2-5.

dSLR

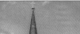
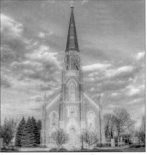

Super-zoom

dSLR cameras

If you're serious about HDR, you will eventually come face to face with the dSLR. Or rather, face to lens. Although it's not the only game in town, the dSLR is a big-league camera. Figure 2-6 shows an entry-level Sony Alpha 300 dSLR with a Sigma 10-20mm F4-5.5 ultra wide angle lens mounted on a tripod. Makes my heart go all pitter-patter seeing it there.

Here are the benefits to getting a dSLR for HDR photography:

✔ **Highest quality:** Although dSLRs range from basic entry-level models to the full-frame, super-professional, complicated-as-a-nuclear-reactor variety, they are the pinnacle in rea-sonably affordable (from a few hundred to several thousand dollars) quality.

Compact

✔ **Total control:** dSLRs don't skimp on control. You decide what you want to do and choose how to do it. This helps when shooting manual HDR brackets.

Beginning photographers might find con-trolling such a complex piece of equipment a bit overwhelming at first (I did), but entry-level dSLRs offer a good mix of features that combine automated photography and dSLR power.

Figure 2-5: Smaller sensors, lenses, and fewer megapixels equal more noise.

✔ **Shooting flexibility:** Better dSLRs offer you the flexibility to shoot in tough conditions that push the camera to its limits. With a fast frame rate, you can take bracketed shots of moving clouds without worrying that they will smear. Lenses are interchangeable — and with the right lens, you can shoot darker scenes without having to lengthen shutter speed too much. And although I'd avoid this, you can also raise the ISO to moder-ate levels without paying too much of a noise penalty. (You'll certainly get less noise with a dSLR than with other types of cameras.)

✔ **Growth:** dSLRs offer tremendous growth potential. You can upgrade camera bodies and keep the lenses you've invested in over the years as long as you stay within the same system.

✔ **Raw+JPEG:** Virtually all dSLRs allow you to save photos in the Raw file format, and most allow you to simultaneously store Raw+JPEG, which means the camera stores two files (one Raw, one JPEG) for every photo you take. This is the best of both worlds. You can quickly view the JPEGs and put extra time into processing the Raw photos you want to keep.

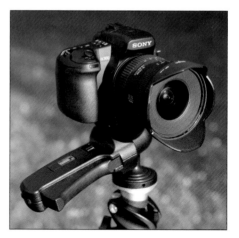

Figure 2-6: Even an entry-level dSLR looks mighty impressive.

✔ **Bracketing:** dSLRs are the kings of bracketing. Many have an auto bracketing feature, and all dSLRs should have a manual shooting mode, which opens up manual bracketing. Not all bracketing capabilities are equal, however, so carefully research the specific camera you have or plan to purchase.

✔ **Reduced noise:** Compared to compact digital cameras and super-zooms, dSLRs take photos that have much less noise, especially at higher ISOs. This is due to a variety of reasons. dSLRs have larger sensors, more powerful in-camera data processors, Raw photos with a greater bit-depth, and tighter design and manufacturing tolerances for noise (especially as you ascend into the professional range).

dSLRs with sensors smaller than a 35mm film frame are called *cropped bodies* (FX if you're a Nikon user). They perform better than cameras with smaller sensors but not as well as full-framed dSLRs (which cost a lot more).

Here are the tradeoffs to getting a dSLR for HDR photography:

✔ **Wide range of different capabilities and formats:** Just because the box touts the camera model as dSLR doesn't mean that it will have the capabilities you need. Even more expensive dSLRs are not guaranteed to be your cup of tea.

It is easy to see that an $8,000 camera is a professional piece of equipment. However, entry-level and amateur dSLRs (some costing upward of $2,000) can have very different capabilities.

✏ **More complicated:** You can't deny the learning curve for operating a dSLR, especially if you've never used one. It's a complicated piece of equipment that requires a dedicated artist-engineer to wring all the goodness out of it. Read the manual. Take your time. Practice. The payoff is greater.

✏ **Cost:** dSLRs cost plenty, as do lenses, memory cards, additional batteries, remote shutter releases, bags, and the other gear that goes with the territory. This isn't something most people can decide get into on the spur of the moment, go down to the local camera store, and come back fully equipped. It takes time.

Thankfully, you don't need ten lenses to shoot HDR. You can make do with a good kit lens to start with, especially if it has a decent wide-angle capability. (dSLRs are sold as camera bodies with no lens or as part of a kit, which usually features a popular and inexpensive zoom lens such as an 18-35mm, called a kit lens.) A wide angle lens is probably your next big investment.

✏ **Hard to switch brands:** After you commit to a particular brand of camera and compatible lenses, it's hard to switch to another brand because you have to reinvest in all new lenses. It's not impossible, mind you, but it does discourage experimenting with alternative systems.

✏ **Bulk:** dSLRs are good-sized cameras that take up space and can weigh you down. On the flip side, though, your wallet or purse will be lighter. (Think about it.)

Looking through Lenses

Although the camera body plays a significant role in determining whether the camera is suitable for HDR, lenses play an equally important role in steering you toward, or away from, your favorite subjects. In addition, lenses play a critical role in photo quality.

Budget compact camera lenses

Budget cameras have budget lenses. If you're starting out with an inexpensive compact digital camera, don't expect the best image quality in the world.

The point that can't be repeated enough, however, is that if you apply yourself, you can shoot great HDR with inexpensive, entry-level gear.

Figure 2-7 shows the lens on the Panasonic Lumix LZ8 (the camera that shot the sunset in Figure 2-2). It's t-i-n-y compared with other available lenses.

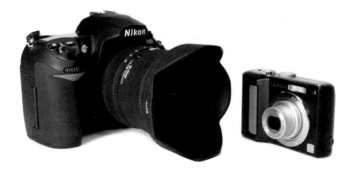

Figure 2-7: A budget lens and a better lens.

Some pros of shooting with a budget compact camera lens are that because the lenses are built right into the camera body, you don't have to worry about changing them, carrying them, dropping them, or otherwise messing with them at all. You aren't spending money after you buy the camera because the lenses are fixed. And oddly enough, having a fixed (noninterchangable) lens can give you plenty of composition options, provided that the lens has decent wide-angle and zoom capabilities. Within compact digital subclasses and price ranges, lens specifications tend to be fairly similar. Expect focal lengths to begin in the range of 28 to 35mm (35mm equivalent). How much they zoom tends to vary with price. If you want to maximize your wide-angle capability (and you probably should for HDR), look for a camera with a 35mm equivalent focal length starting below 35mm.

Some of the cons of shooting with a budget compact camera lens are that budget lenses are small, probably not of the best quality, and might not even be made of glass. However, unless you're planning to print billboard-sized prints, you can overcome this if you take good photos and are good with software processing. You don't have any flexibility because you're stuck with the lenses you've got. If you aren't happy with the field of view, you have to buy another camera.

Premium and super-zoom lenses

At this level, you've invested in a higher-quality camera and will reap the rewards of having better — and, in some cases, more specialized — lenses.

Some pros of using premium and super-zoom lenses for HDR are that like with budget compact digital cameras, the lens is conveniently, and permanently, attached to your camera. You can't forget it or lose it! As a group, premium and super-zoom lenses tend to feature wider angles when zoomed out and much more optical zoom when zoomed in than standard compacts. This increases the flexibility of the camera and what shots you can compose. Specific models may vary, however. Look for the range of zoom you like, but

realize you'll probably use the wide-angle (under 35mm) capabilities of a super-zoom lens for HDR more than telephoto (over 85mm). As such, be careful that the premium or super-zoom has the wide-angle view you need. And finally, manufacturers put better lenses in their premium products.

Some cons of using premium and super-zoom lenses for HDR are that because premium and super-zoom lenses can't be changed, your flexibility is restricted compared with the variety of lenses available for a dSLR. Also, even though these lenses are higher quality, they can't compare with the precision lenses of the upper-end dSLR market.

Wide angle lenses

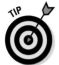

Wide and ultra-wide angle lenses are the best lenses for HDR, hands down, especially if you want to shoot landscapes, cityscapes, small interiors, large interiors, and interesting close-ups (which is pretty much everything).

Figure 2-8 shows a shot in HDR of a local building, complete with dramatic sky, green trees, interesting signs, and the tall building. A wide angle lens made it possible to be fairly close to the building (just across the street) and get the entire height and then some. This shot would be impossible without it.

Here are some pros of using wide angle lenses for HDR:

Figure 2-8: Wide angle lenses are perfect for shooting tall buildings.

- ✓ **Sweeping coverage:** A wide or ultra-wide angle lens is the indisputable king of coverage. There is no substitute when you're shooting an expansive landscape or a tall building. Many HDR photographers keep their wide angle lenses on their cameras most of the time.

- ✓ **Interior spaces:** To photograph small interiors, you need a wide angle lens. In Figure 2-9, you can see the difference between shooting an interior with a normal lens and a wide angle lens. In the photo on the left, taken with a Canon PowerShot A75 compact digital camera, you can only see a corner of the kitchen. Everything is cut off. In the photo on the

right, taken from the same location with a Sony Alpha 300 dSLR with a Sigma 10-20mm F4.5-5.6 ultra-wide angle lens, shows much more of the room. It's the difference between absurd and practical.

Normal (35mm) Wide angle (10mm)

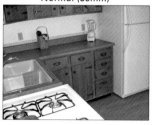 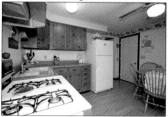

Figure 2-9: Interior shot, normal versus wide angle.

Larger interior spaces behave almost like landscapes or cityscapes. Wide angle lenses capture their magnificence, as shown in Figure 2-10.

✔ **Close-ups:** Wide angle lenses are surprisingly versatile. They enable you to get close to a subject and still see surrounding details. That makes for great HDR images.

Here are some cons of using wide angle lenses for HDR:

✔ **Distortion:** Wide angle lenses are prone to distortion levels above more traditional focal length lenses, especially as you get lower than 20mm. See what I mean in Figure 2-11.

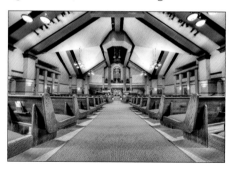

Figure 2-10: Wide angle lenses show off large interior spaces well.

✔ **Composition challenges:** Wide angle lenses offer compositional challenges above and beyond normal lenses. First, there's more to see. That makes creating an uncluttered photo a real challenge. There's so much junk everywhere! In addition, when you tilt the camera forward or back, vertical lines lean toward or away from you, respectively. This can make buildings look like they are falling toward or away from you. Check it out in Figure 2-12.

35mm equivalence

Lenses are defined by their focal lengths, which is the distance between the optical center of the lens and its focal point (where it focuses the light passing through it), which should be on the same plane as the camera sensor (or film). For compact digitals and super-zooms, you are given the actual focal length of the lens and its 35mm equivalent. The former is the actual measurement. The latter is a helpful way to compare the angle of view you see in the photo between lenses and cameras with different size sensors. It establishes a common frame of reference that you can understand. For example, the Canon G11 has a lens with a true focal length of 6.1-30.5mm. Compared to a full-frame 35mm camera, the 35mm equivalent focal length is 28-140mm. It's like adjusting for inflation.

General purpose and kit lenses

General purpose and kit lenses are those lenses that typically come with a dSLR. You can also find plenty of upgrade options in this category, ranging from 16mm to 200mm, with 17–70mm or so being a sweet spot. This is good enough to give you a wide-angle look and still be able to zoom in.

Figure 2-13 illustrates a shot in HDR from a Sony kit lens at 17mm. The final image is cropped slightly (another good reason to have a little extra field of view). This is definitely wide-angle territory, but the same lens can zoom in and focus more closely on the turtle's face with no trouble.

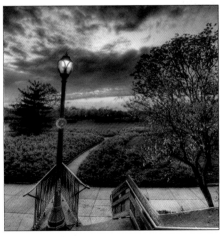

Figure 2-11: This lens produces uncomfortable "What the?" distortion.

Some pros of using general purpose and kit lenses for HDR are that general purpose lenses are so popular because they offer you the flexibility of having a range of focal lengths to choose from at a moment's notice. When shooting HDR, you can get a wide-angle shot and then zoom in closer without having to change lenses or your vantage point. (Two other advantages

of using a general purpose zoom lens over separate lenses are that you get the equivalent coverage without the weight and bulk.) For example, one 16-85mm lens weighs less and is less bulky than the four lenses it takes to shoot the same basic focal lengths with these primes: 28mm, 35mm, 50mm, and 85mm. That, and there're there. You don't need to make a decision on what lens to get, nor make an additional purchase. Someone's already taken care of it for you!

Some cons of using general purpose and kit lenses for HDR are that sometimes, the wide end of a general purpose lens cannot compete with a good, dedicated wide angle lens. Ultra-wide angle lenses can have focal lengths as wide as 10mm to 12mm, topping out between 20mm or 28mm. Many general purpose lenses start at around 17mm or 18mm. A few millimeters here and there might not seem like a big deal, but the practical effect on your photos is tremendous, as you can see in Figure 2-14.

Another con to general purpose and kit lenses is that you'll likely read or hear some debate over quality. In a nutshell, cheaper, entry-level versions perform more poorly than more expensive lenses, but consider the range of quality when shopping. In general, a high-quality prime lens will often perform better than a kit or general purpose lens at the same focal length.

Figure 2-12: The camera's alignment causes this distortion.

Figure 2-13: Bracketed HDR shot with an 17–70mm kit lens.

Other lens types

In addition to the lens types discussed in the previous sections, a few other types can be used in HDR photography:

20mm 35mm 50mm 70mm

Figure 2-14: Ranging from wide angle through normal to macro.

✔ **Primes:** Because they are fixed length lenses (no zoom capability), prime lenses do one thing, but they (should) do it very well. The most common types of primes are 35mm and 50mm.

Despite what you might hear or think, you can use primes for HDR. Wide-angle primes are great for wide-angle shots. Lenses like the 35mm or 50mm get you in closer to the action. When I was shooting an exhibit commemorating the Battle of the Bulge, the large diorama was encased in Plexiglas, and the lighting was dismal. A wide angle lens wouldn't have worked because the figures would look like tiny little ants, and the chances of getting extraneous things in the photo was larger. I was able to zoom in with my 50mm as if I were in the exhibit.

There's nothing stopping you from using a prime lens in any situation where that is the appropriate focal length. The upside is quality. The downside to using primes is the cost of investing in so many lenses, carrying them around, and needing to change them when you want to alter your field of view.

✔ **Macro:** Macro lenses are for super–close-ups. If you're shooting bees, flies, or other creepy-crawlers, you will have a hard time shooting brackets for HDR. However, you will find other subjects like flowers and small-scale still life perfectly suited for HDR.

✔ **Telephoto:** Telephoto lenses are for long shots. These lenses reach out and capture a subject from far away. As a result, they compress the sense of depth and can make some very attractive scenic shots.

Choosing a Pod, Tri or Otherwise

A tripod is almost a necessity for shooting HDR. If you find yourself in the rare situation where you have a camera with a fast frame rate, a good AEB mode, lighting conditions that allow for a fast shutter speed, and steady hands, you can fire off blur-free bracketed shots without a tripod. The HDR software should be able to align them properly.

Having said that, it's incredibly nice and often necessary to have a good tripod to keep the camera steady for your shots. Using a tripod increases the quality of your photos by a good measure.

Odd pods

You can support your camera in many different ways. You can buy large tripods, small ones, tripods with three legs and monopods with one leg. Needless to say, you can support your camera on other objects, wherever you are. These are basic photography techniques — leaning into a wall or door frame for support, resting the camera on a fence or other convenient object.

A lot of people use small, tabletop-size tripods for HDR. Shoot still life indoors or take it outside and shoot great low-angle shots with your camera near the ground. The Gorillapod, by Joby (www.joby.com), is a flexible tripod that can go anywhere and attach to virtually anything.

Compared to shooting with no support, monopods give you added stability. This can sometimes make the difference between a blurry shot and a clean one when shutter speeds need to be slow because of the available light. It's like shooting hand-held HDR with a little help.

The downside to all of these techniques is that the camera is not supported as well as it would be with a good, stable tripod.

Inexpensive tripods

Any tripod basically does what you need it to do — hold the camera steady to prevent blur. You don't have to spend a fortune, either. Having said that, you typically get what you pay for. Adorama Camera (www.adorama.com) and Amazon.com have an extensive selection of inexpensive tripods. Kodak (www.kodak.com) has several models under $30, and Joby (www.joby.com) features the Gorillapod, an innovative and inexpensive range of flexible tripods (ranging from $20 to $100).

Some benefits to using inexpensive tripods are that they're cheap. Inexpensive tripods tend to be light and easy to carry. Finally, they're good for kids to use. (My kids use my el cheap-o tripods. If the tripod gets dinged up or breaks, it's not a big deal.)

Some cons to using inexpensive tripods are that there are times, such as being outside on a windy day, when it's hard to keep a cheaper tripod solidly planted and steady. (Many times, even inexpensive tripods are fairly stable.)

Sling a weight underneath the center if you can. This will help stability. I use a gallon water jug filled with either water or sand with one end of a cord tied through the handle and the other to a hook on the tripod. You can empty the water when you're not using it.

Fun with inexpensive tripods

My kids and I sometimes have "Camera Wars." In one variation, we mount our cameras on tripods and run around the house trying to take pictures of each other, as shown in the following figure. We don't do this with my professional tripod, though. That gets put away in a cushioned bag in the closet.

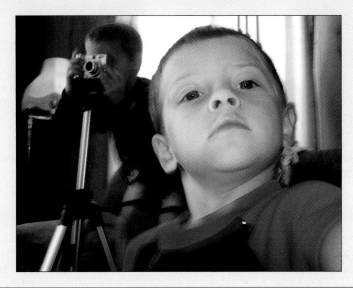

Other cons to using inexpensive tripods are that they have a nasty habit of coming unscrewed, bending, or breaking. Plastic leg release latches can be especially prone to breaking. Inexpensive tripods can't get close to the ground, and the center column rarely comes out and away from the central axis of the tripod. This isn't a disaster, but does limit the situations you can use it in. The head and legs of inexpensive tripods don't come apart. This limits your growth and flexibility.

Expensive tripods

It really does come down to this: If you want a great tripod, you're going to have to spend the money to get it. That isn't to say all expensive tripods are great, but great tripods tend to be costly. Manfrotto's 055XPROB tripod legs (the tripod I use, which is professional quality but certainly not top of the line) lists for about $180 at Adorama Camera (www.adorama.com).

Shopping tips:

- **Components:** Better tripods come in two parts: the legs and the head. Separating the components allows you to choose different pieces that suit you best.

- **Leg material:** Wood is classic, but heavy. Aluminum is today's standard but isn't indestructible and can get cold during the winter. Carbon fiber and other composites are strong and lightweight, although costly.

- **Size:** Tripod legs come in many dimensions. Make sure you get the size you need. Smaller sizes are ideal for backpacking and shooting on the run. For HDR, where size is often less of an issue, you will probably want a heavier tripod for stability.

- **Pan heads:** A traditional pan and tilt head, as shown in Figure 2-15, is a great platform. It has large controls that lock or loosen to allow movement around three axes. These heads are nice to have if you plan on shooting panoramas.

Figure 2-15: Pan and tilt heads are great for panning and tilting.

- **Ball heads:** A ball head allows a great deal of freedom when you are composing the shot, especially if you have something like the Manfrotto horizontal grip (as shown in Figure 2-16), which sports a ball head with something that looks like a joystick attached to it. You can squeeze the grip to loosen the head and compose the shot with one hand. Sweet. I picked up this one from Amazon for about $130.

Figure 2-16: Ball heads with specialized grips make composition convenient.

Additional items for your tripod

Say what? There are accessories for a tripod? Yup, and they can come in pretty darned handy, especially when shooting HDR. Check it out.

- **Quick release plates:** These plates, which attach to the bottom of your camera, allow you to quickly attach the camera to the tripod. They can help prevent slippage and vibration, too. I recommend attaching a quick release plate for each camera to improve trading cameras easily and quickly.

- **Bag:** Use a tripod storage bag (most are available from your tripod man-ufacturer, but Tamrac, Case Logic, and other companies have their own lines) for easy carrying as well as protecting your tripod while on the go and when stored.

- **Heads:** Better tripods offer more than one head. For example, use a tradi-tional ball head for quick composition, but use a pan head for panoramas.

Adding Optional Accessories to Your HDR Kit

The great thing about HDR is that you can go heavy or light, depending on your mood and the situation at hand. Use the following as a guide to get you started thinking about how you can expand your kit:

- **Bags:** Although you might need only a small pouch to protect a compact digital camera, you'll want a decent bag for a dSLR and its lenses. You not only want your equipment with you (you never know when you need that one "thing"), but you want to protect your investment from dust, dings, and life.

 Always keep your bag(s) with you! If you set down your bag, walk across a field, and then decide to switch lenses, you have to trudge back to get the bag. And, of course, you don't want someone walking away with your equipment. I prefer using sling bags (see one in Figure 2-17), loaded with a moderate amount of gear that's not too weighty.

- **A light meter:** Although using an external light meter isn't a prerequisite for shooting HDR (after all, your camera has a light meter built in), using an external meter can help you achieve the best possible exposure. (Plus, you look startlingly cool carrying one around.) In spot mode, you can point it at various parts of the scene to determine the actual dynamic range of the scene, which can help you decide on a bracketing strategy (more or less shots, as well as the exposure difference between them).

✔ **Kneepads:** HDR photography isn't something you want to go out shooting in a ruffled pink dress and high heels. As attractive as you might look, consider dressing with a mind toward practicality.

When you're looking for those interesting angles, having kneepads can save your clothing and knees. I can't count the number of times I've had to kneel down in gravel.

✔ **A shutter release cable:** Remote shutter releases are a wonderful accessory to have when shooting HDR. They keep your camera steady when shooting because you remove the possibility of jarring the camera by pressing the shutter button.

When it comes to remote shutter releases, one size does not fit all! Make sure to get one that's compatible with your camera. Most are the traditional cord variety, but some are wireless. Needless to say, wireless remotes are very cool. You won't trip over a long cord and you aren't restricted by a short

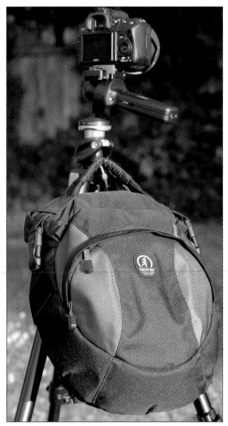

Figure 2-17: Sling bags are easy to keep with you.

cord. The top camera manufacturers sell branded wireless releases for their systems ranging from about $80 to freakishly expensive. B&H Photo (www.bhphotovideo.com) has a good selection, followed by Adorama (www.adorama.com) and Amazon (www.amazon.com).

✔ **Levels:** When you shoot landscapes, cityscapes, or large interiors with a wide angle lens, problems with camera leveling and alignment can be accentuated. To protect yourself from your lying eyes (your eyes are often fooled by details of the scene, the ground you stand on, and any tilt to your head), use a small level that you can fit in your hot (accessory) shoe, as shown in Figure 2-18.

Time to 'fess up. The level shown in Figure 2-18 is sitting on top of this Sony hot shoe (rather than in it) because it isn't compatible with this mount — something to look into if you get one. It fits fine on my Nikon, which I was using to take this photo.

If your camera doesn't have an accessory shoe, get a tripod that has a level built into the legs or head. Lacking that, you can buy a small level from the hardware store and duct tape that to your camera. (I'm only *halfway* joking with that one.)

✏ **White balance aids:** Whether you shoot HDR inside or out, using a gray card (as part of a white balance system) helps you correct color casts from different lighting and reflections. I use WhiBal from `http://rawworkflow.com`. Find it online at `www.whibal.com` for about $20 and up.

Figure 2-18: Use a level when shooting wide angle.

Other lenses: Contacts and glasses

You have to see clearly to take good photos. If you wear glasses or contacts, keep your prescription up to date. Glasses can get in the way when you try to look through the optical viewfinder of your camera, but they are reliable and dependable. Wearing bifocals or progressives can help you alternatively focus through the viewfinder and see the controls and settings on the camera. If your camera has a built-in diopter adjustment control (this includes most dSLRs), use it to adjust the focus of the viewfinder so you don't need to rely on glasses or contacts. If you need more corrective power, see if your dSLR has stronger add-on diopter adjustment viewfinder lenses.

3

Looking Hard at HDR Software

In This Chapter

▷ Putting the software puzzle together

▷ Starting with Raw editors

▷ Reviewing HDR applications

▷ Considering other applications

You can't pursue HDR photography without the right software. The key is to define what that software is, what it does, and understand how it fits in with everything else. All you really need is an HDR application to generate and tone map an HDR image. However, you might also want to use an application that either helps you create the best image possible or manage the process.

To help you sort out all the software, this chapter describes the different roles that Raw converters, HDR applications, image editors, and image management applications play in the process. I also describe some of the major players for each type of software, what they offer, and some good and bad points about each title.

In this chapter, you discover what applications you need for HDR photography and get a head start on tailoring your software kit to match you and your desires.

Software: Don't Pass HDR without It

Table 3-1 shows a general roadmap of the types of software that either assist or create HDR as well as how they fit together. The phases correspond to the main HDR workflow (see Chapter 10 for more details). Within each phase, I show you more than one type of application that can perform similar tasks.

Table 3-1		HDR Phases and Software	
Phase	*Tasks*	*Software Types*	*Examples*
1. Pre-HDR	Raw conversion	Raw editor or image management	Nikon Capture NX 2 Apple Aperture 2
2. HDR	Generate HDR	HDR application or some image editors	Photomatix Pro Photoshop
3. Tone mapping	Tone map HDR image	HDR application or some image editors	Photomatix Pro Photoshop
4. Post-HDR	Edit and finalize	Image editor or some HDR applications	Photoshop Elements Artizen HDR

H-D-R (uh-huh, uh-huh), we like it . . .

The most important software element of HDR photography is, not surprisingly, the HDR application. This is what you use to turn your bracketed photos (and single Raw exposures for pseudo-HDR) into high dynamic range images, and tone map to create super-saturated, attention-grabbing images, as shown in Figure 3-1.

 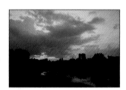 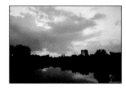

Figure 3-1: From beginning to end — brackets (left) and final image (far right).

Spend some time trying out several of the applications listed in the later section, "Surveying the HDR Software Landscape," to decide which one you like best. Choose the one that best fits your artistic sensibility, workflow, and budget. Look for the following list of features and options to help guide you in your trial and purchase:

- **Input file types:** Make sure that the HDR application accepts the file types you want to work with — Raw, JPEG, or 8- or 16-bit TIFF.

- **Output file types:** The HDR application should save a final tone mapped file in the format of your choice. Common types are JPEG and 8-bit and 16-bit TIFFs.

- **Processes Raw photos:** Some HDR applications have limited Raw support for newer or less popular cameras.

✔ **Settings management:** Being able to save and load tone mapping settings makes duplicating your work far easier. You can create baseline settings for artistic styles, subjects and genres, or conditions, and work from your saved settings rather than having to re-create the same steps each time.

✔ **Edits HDR images:** Some applications perform rudimentary HDR image editing, such as cropping, rotating, and reducing noise. Applications with more options give you greater flexibility over where in the process you decide to perform these tasks.

✔ **Generates HDR images and tone maps HDR images:** Generating an HDR image and tone mapping are defining characteristics of an HDR application. (See Figure 3-2.) Some HDR applications also have tone mapping plug-ins that work in Photoshop.

✔ **Other functionality:** Some HDR software doubles as an image editor (most notably, Photoshop).

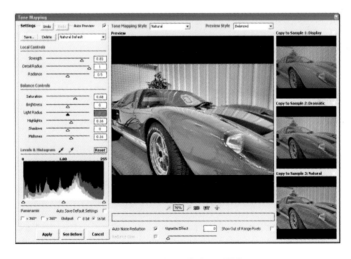

Figure 3-2: Tone mapping controls in Artizen HDR.

Rah rah for raw raw

(Also known as: *If I hear one more Raw joke, I'm going to rawr.*) Raw conversion is only an issue if you shoot Raw photos. Although you can generally plop the Raw photo directly into an HDR application, image quality is better if you convert Raw images first with a dedicated Raw editor or converter.

For more information on converting Raw photos to TIFFs for HDR, see Chapter 7.

MBA in image management

HDR photography benefits greatly from image management applications such as Adobe Lightroom and Apple Aperture. You'll take tons of photos when you're bracketing. These applications help you keep track of the photos, metadata (for exposure), date, time, and subject.

Editing for zing

One of the biggest misperceptions about HDR is that the image comes straight out of the HDR application looking perfect. Most of the time, you'll also want to use an image editing program to edit the tone mapped image before posting it online or printing. Post-HDR processing includes using an image editor to covert images to black and white, create panoramas (whose individual frames are shown in Figure 3-3), retouch (sharpen, reduce noise, fix lens distortion, correct color problems, and so on), enhance (improve contrast, saturation, and so on), crop, and/or resize for online viewing.

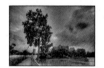 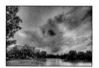 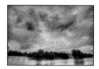 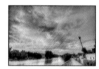 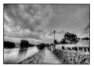

Figure 3-3: Tone mapped panorama frames ready to be stitched together.

Your Guide to Raw

If you shoot in Raw, you should convert your Raw images to TIFF before generating and tone mapping HDR. Although this is an optional step, it gives you a boost in image quality. You can read more about this process in Chapters 7 and 8, but you can start thinking about your software options now.

Using your camera's software

Camera manufacturers receive mixed reviews on their Raw conversion and image editing software. Some people love what they see, and some people hate it.

Table 3-2 lists several camera Raw software packages by manufacturer, all of which have Windows and Macintosh versions. They are all free except for Nikon's Digital Capture NX 2 (shown in Figure 3-4), which has a free trial available for download.

Figure 3-4: Nikon Capture NX 2 is a great Raw converter.

Table 3-2	Camera Raw Software by Manufacturer	
Camera Manufacturer	**Software Name**	**Cost**
Canon	Digital Photo Professional	Nada
Fuji	Hyper-Utility	Free
Kodak	EasyShare (version 7 or later)	Zip
Konica Minolta	DiMAGE Viewer	Zilch*
Nikon	Nikon Capture NX 2	$179.95 (free trial available)
Olympus	OLYMPUS Master 2	Nothing
Panasonic	SILKYPIX Developer Studio SE	N/A**
Pentax	PENTAX PHOTO Laboratory 3	Free
Sony	Sony Image Data Converter SR	Gratis

*Konica Minolta has discontinued all digital camera operations and transferred customer service to Sony.
**The SE version is limited compared with the full release, which is not free.

Stylin' with presets

Style presets are another reason to look carefully at the software that comes with your camera. Presets allow you to shoot Raw and use predefined settings researched and chosen by the manufacturer as a starting (or ending) point for conversion from Raw to JPEG or TIFF. Many times, the software presets are the exact same options that you can set in-camera.

You might want to set the camera to save Raw only, and then load the presets in software as you convert only those photos you want to keep. This frees up processor workload in the camera and storage space on your memory card, not to mention hard drive space. The other advantage to using style presets, of course, is being able to try them out before you commit them to JPEG.

Creating HDR images is a different beast than traditional photo editing. Don't write off a potentially great Raw application just because it's not as popular as the rest. Consider this information when looking at Raw applications:

- **Insider information:** It might surprise you to know that Raw photos are proprietary. Canon puts special Canon stuff in its files. Nikon, Sony, and the rest do the same. Adobe is resisting this and advocating an open Digital Negative standard. Until such time as they all agree, no one is going to know a Raw file format better than the manufacturer.

- **Decent controls:** At a minimum, you should look for the ability to control exposure (for creating brackets from a single Raw photo). That's about it, really. If you want to do some editing, restrain yourself. Remember, you aren't trying to get the perfect exposure. The brackets and HDR processing will take care of that.

- **Adequate Save As options:** If you need to convert Raw files to something that will load into an HDR application, you must have the ability to save the resulting image as an 8- or 16-bit TIFF or JPEG. For higher quality, choose 16-bit TIFF.

- **Bearable interface:** The software that comes free with your camera might have a clunky or ugly interface. What counts is that you can navigate your way around without too much confusion or fuss.

Third-party Raw software

You can buy or download a plethora of third-party Raw editors and converters. If you're unhappy with your current software and want to try something new, get your hands on one or more of the applications listed in Table 3-3.

Table 3-3	Third-Party Raw Editors		
Name	*URL*	*Platform(s)*	*Freeware?*
ACDSee Pro	`www.acdsee.com`	Win	No; free trial
Bibble	`http://bibblelabs.com`	Mac/Win/ Linux	No; free trial
BreezeBrowser Pro	`www.breezesys.com/ BreezeBrowser`	Win	No; free trial
Capture One	`www.phaseone.com`	Mac/Win	No; free trial
dcraw	`www.cybercom. net/~dcoffin/dcraw`	Mac/Win/ Linux (available at `www. insflug. org/raw`)	Yes
DxO Optics Pro	`www.dxo.com`	Mac/Win	No; free trial
LightZone	`www.lightcrafts. com/lightzone`	Mac/Win	No; free trial
RawShooter	`www.adobe.com`	Win	N/A
RawTherapee	`www.rawtherapee. com`	Win/Linux	Yes
SILKYPIX Developer Studio	`www.isl.co.jp/ SILKYPIX`	Mac/Win	No; free trial

Adobe Camera Raw

Adobe Camera Raw (ACR) is a plug-in that works within Adobe Photoshop and Photoshop Elements. It is Adobe's near-universal Raw editor and converter. ACR is very popular and has a clean and professional interface, as shown in Figure 3-5. The icons at the top are tools and the three tabs below the histogram are the main editing categories. There's not much to complain about with ACR.

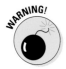

ACR works differently within Adobe Photoshop Elements than in Photoshop. The Elements version has fewer options, bells, whistles, and doodads. That won't affect you as much when it comes to preparing Raw images for HDR because, for the most part, you're after a fairly direct conversion to TIFF.

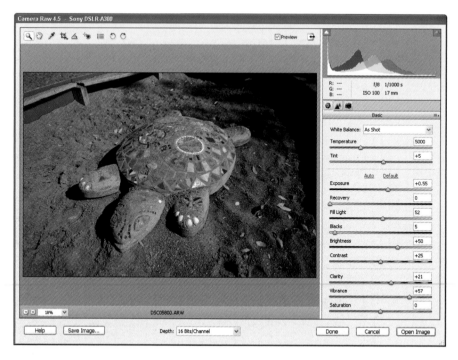

Figure 3-5: Adobe Camera Raw called from within Photoshop Elements.

Surveying the HDR Software Landscape

The following applications (presented alphabetically) specialize in HDR. In the following sections, I provide a Web address for each application (so you can investigate and download the software or trial version), a description of the software and its strengths and weaknesses, and a screen shot of some of them in action.

Artizen HDR

Artizen HDR (www.supportingcomputers.net) is one of the stronger HDR applications available. It has a nice interface that's reminiscent of a full-featured graphics editor. With Artizen HDR, after you generate and tone map the HDR image, you can edit and finalize your image.

The nifty features of Artizen HDR are its full-featured tone mapping, batch processing, and image editing capabilities. The iffy features are that it has an annoying nag screen in the trial version, and it's a Windows-only product.

Dynamic Photo HDR

Generating HDR in Dynamic Photo HDR (www.mediachance.com) is pretty fun. It has some powerful options that are very nice. Aside from all the obvious stuff, you can paint a ghosting mask (a fancy term for painting over objects that are moving, and thereby creating ghosting problems — more information on ghosting can be found in Chapter 7) onto the HDR preview to immobilize moving objects, as shown in Figure 3-6.

Figure 3-6: Resolving ghosting by painting a mask in Dynamic Photo HDR.

Dynamic Photo HDR is a good dog in that it has advanced options for HDR generation, a great ghosting routine, powerful manual alignment tools, helpful tone mapping presets, batch processing, and is available for both Mac and Windows.

easyHDR

There are two versions of easyHDR (www.easyhdr.com): Basic and Pro. The basic version is very, well, basic. You load your images and start tone mapping. You can't save HDR files, but you can open existing .hdr files and tone map them. Upgrading to easyHDR Pro gives you a lot more power. You can

generate HDR images, align them automatically or manually, and choose from many other options. You can manually alter EV information for each image, perform image size reduction as you create the HDR, choose from different HDR radiance maps (True HDR, Smart Merge, Image Stacking), change response curve, and choose from different anti-blooming and -noise settings.

The yummy things about easyHDR are that the program has a standard set of HDR features and you can create projects. The yucky things are that it gives questionable tone mapping results at times, the basic (free) version is very limited, and it's a Windows-only product.

FDRTools

FDRTools (www.fdrtools.com) comes in two flavors — Basic and Advanced — in addition to a tone mapping–only Photoshop plug-in. The thing that strikes me when firing up FDRTools is that it's a complex piece of software written for serious users — not that it doesn't look friendly, but the casual user might be intimidated at first. Figure 3-7 illustrates the FDRTools interface in HDRI Creation mode. Individual brackets are on the left, and there are windows open that serve various purposes.

FDRTools works with a project paradigm. When you create and add images to a project, you can choose to save the HDR file or not. If you save it, you have to open it as a separate image or new project. A side effect of this is that each time you open a project with multiple photos, FDRTools must re-create the HDR file, slowing things down dramatically. The advantage is having all the images and settings stored in a convenient project file that is the only thing you have to work with.

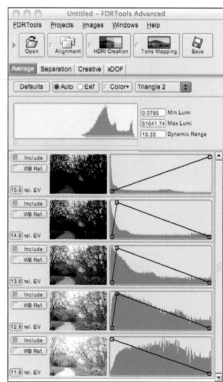

Figure 3-7: Creating an HDR image in FDRTools Advanced.

The best things about FDRTools are that it has advanced HDR tools, it creates a single program file, and it's available for both Mac and Windows. The worst thing is that it has lots of technical options, which means a steeper learning curve to effectively use all the features.

Hydra HDR plug-in for Aperture 2.1

The Hydra HDR plug-in for Aperture 2.1 (www.creaceed.com) is exactly what it says — an HDR plug-in that works from within Apple Aperture to create and tone map HDR images. Figure 3-8 illustrates the Hydra plug-in interface with brackets on the left and the main preview in the center.

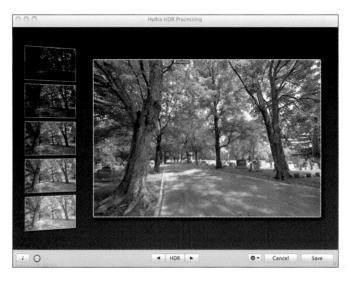

Figure 3-8: Tone mapping in Hydra.

The great things about this plug-in are that it has a really nice interface, is easy to use, it integrates seamlessly with an Aperture workflow, and Raw processing options are integrated into the plug-in. The not-so-great things about it are that you have limited tone mapping options compared to other applications, and it's available for the Mac only.

Photomatix Pro

 Photomatix Pro, from HDRsoft (www.hdrsoft.com), is a leading application in the HDR market. It has everything you need to create outstanding HDR and a few things you don't need but might find useful.

There are two tone mapping modes. The Details Enhancer is the traditional tool used by a number of HDR photographers. It has a plethora of settings and controls in one floating window and a tone mapping preview in the main window. Photomatix Pro also has a Tone Compressor (another tone mapping paradigm) and Exposure Fusion (formerly known as Exposure Blending).

Staying current with HDR applications

I can't list every HDR application that's out there, of course. Some are pretty expensive, or have yet to gain any traction, so I chose not to cover them in this book.

HDR software is an evolving field, so keep checking into software and plug-ins. Developers all over the world are working feverishly to attend to your HDR needs and bring you the right mix of features at the right cost.

The pros of Photomatix Pro are that it produces great images and has full-featured HDR and tone mapping options, single- and multiple-batch processing options, and several methods with a profusion of controls. To boot, Photomatix is friendly, not too complicated, and available for Mac and Windows (and also with plug-ins for Adobe Lightroom and Adobe Aperture). The cons are that the interface is sometimes clunky, there is no manual alignment option, and it has limited HDR and post-HDR editing although it will let you rotate and crop your images.

Qtpfsgui

Creating HDR images in Qtpfsgui (http://qtpfsgui.sourceforge.net) is pretty straightforward and similar to many other applications. It boils down to creating a new HDR image by selecting bracketed source photos and aligning them. The odd name (quitpeefizgooey is probably a close pronunciation), comes from the program and libraries used to build it (you can see exactly which ones on its Web site).

The green light for Qtpfsgui is that it has lots of options, and you can use manual alignment. The red light for it is that sometimes there are too many options that aren't well explained, and it feels like a scientific application due to the terminology and opaque option names. In addition, if your system needs QT4 installed to run Qtpfsgui, it's 131MB!

Integrating More Cool Software into Your HDR Workflow

Who doesn't want to use all the software they possibly can? The applications described in the following sections assist HDR on the front or back end. Some, like Photoshop, can handle every task. Others, like Photoshop Elements, are only useful in the editing and finishing phase.

Corel Paint Shop Pro Photo

Paint Shop Pro (www.corel.com) is a full-featured raster and vector graphics editor, complete with a bevy of photo editing tools and features, including a limited HDR capability. For the price, you can hardly go wrong with this package. You might prefer to create and tone map your HDR images in an HDR-specific application and then finish it in Paint Shop Pro.

Paint Shop Pro is like Batman in that you get a lot of bang for the buck with it because it can generate and tone map HDR as well as edit images. It's like the Joker in that it has limited HDR and tone mapping features, has some memory issues, and can be buggy at times.

Adobe Photoshop

Photoshop (www.adobe.com) is the leader in the graphics and intensive photo editing market, and for good reason. There's not much it can't do, and what it does do it does very well. Although other packages handle the routine elements of photo editing just as well (brightness, contrast, and so on), Photoshop has many other powerful features that complement your work and workflow.

Photoshop is worth buying because it's very powerful, it's the industry-standard image editing application, it integrates well with other Adobe products, it can generate and tone map HDR on its own, and it's compatible with both Mac and Windows. The downside with Photoshop is that it's expensive and it can be unwieldy and takes time to master.

Adobe Photoshop Elements

Photoshop Elements (www.adobe.com) is Adobe's slimmed-down version of Photoshop. It is aimed squarely at the consumer image and photo editing market. It's light, fun, easy, and pretty cool. Most of the basics are here, but there are some omissions when it comes to serious work.

The affirmative parts about Photoshop Elements are that it's easy to use, inexpensive, has handy image management features, and still can do most of what you want it to. The negative parts of Photoshop Elements are that it doesn't have a Curves tool, masks (which affect blending), no Duotone mode (which affects your ability to tone images), and no Lab Color mode.

Adobe Lightroom

Lightroom (www.adobe.com), as shown in Figure 3-9, is an image management and editing application that is available for Macintosh and Windows platforms. Notice the Develop tab at the top-right of the interface. This is where you will work to change settings to convert Raw photos. Lightroom is to photographers what Photoshop is to graphic artists.

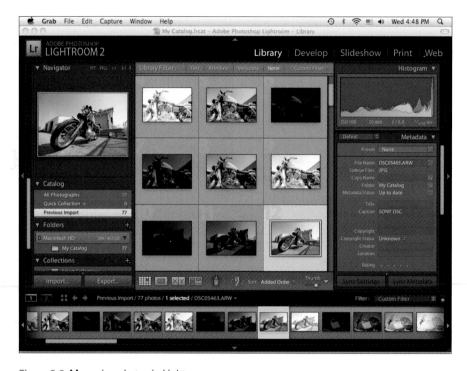

Figure 3-9: Managing photos in Lightroom.

Lightroom is a great application that helps you manage your photo collection and perform routine (and not so routine) photo editing without having to leave the program. You should get consistently good results from Lightroom, no matter what camera you have or your other workflow needs. It also has integrated Raw image processing capabilities, great image management software (which allows you to manage, rate, develop, and publish images), and works on Macs and Windows. The downside is that you might not care for the Raw editor, and you might not want to bother with its image management.

HDRsoft (the makers of Photomatix Pro) has an export plug-in that works within Lightroom. Select the images you want to process and then export them to Photomatix Pro. You can even reimport them at no extra cost.

Apple Aperture

Aperture (www.apple.com) is Apple's answer to Adobe's (Lightroom) application. As shown in Figure 3-10, Aperture is an image management and editing application that offers essentially the same functionality as Adobe Lightroom, especially when it comes to HDR photography and Raw photo processing.

Figure 3-10: Apple Aperture is a strong contender.

The "comfort food" aspects of Apple Aperture are that it's fun to use, has great compatibility with Mac OS, has nice Raw editing capability complete with access to EXIF data, and can export images to HDR applications. The "fast food" aspects are that it's Mac only, and you might not care for its Raw image editor.

There is a handy Photomatix Pro export plug-in for Aperture that helps you get your game on faster. You can export photos and tone map them in Photomatix Pro without ever leaving Aperture. Select the image or brackets you want to process, choose Images⇨Edit With⇨Photomatix HDR Tone Mapping, and you're in business.

Part II
Putting the Photography in HDR Photography

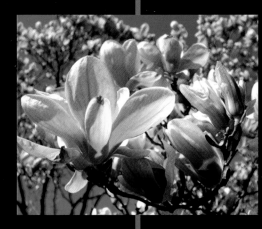

In this part . . .

This part is about choosing the best scenes for HDR and then taking the pictures. HDR photography uses a special technique — bracketing — to take more than one photo of a scene. You have to set your camera up and operate it a bit differently than normal.

In Chapter 4, you find out how to surgically attach your camera and become a cyborg photographer. Really. Chapter 5 is one of the most important chapters in the book. You discover different techniques to shoot HDR brackets using different cameras. Finally, because it's not always possible to set up a tripod to shoot brackets, Chapter 6 gives you the lowdown on when to break the rules and shoot the best single raw photos for HDR.

Becoming One with Your Camera

In This Chapter

▶ Understanding exposure and HDR

▶ Configuring your camera for HDR

▶ Using exposure compensation

▶ Preparing to shoot manual brackets

▶ Auto exposure bracketing

*H*DR photography is more than just "point and shoot." It involves understanding exposure and using your camera to set up and capture a wide dynamic range of light through brackets. If you are familiar with these concepts, HDR isn't overwhelmingly different. If you are new to photography, HDR will help you learn a great deal.

Different cameras have different features, strengths, and limitations. HDR is flexible enough to roll with the punches. It is possible to shoot HDR with cameras ranging from cheap budget compact digital cameras all the way up to the most expensive dSLRs. You can shoot single Raw exposures more casually and still have fun with pseudo-HDR, but the big payoff of pursuing HDR comes when you start to tackle the brackets.

How you do all this depends on your camera. In this chapter, I show you how to get your camera set up and ready to shoot HDR based on whether it has exposure compensation, a manual shooting mode, or full-up auto bracketing.

If you have trouble understanding some of what's going on here, remember to consult your camera's manual. There are also some pretty good *For Dummies* books out there that cover digital photography in general, dSLRs in general, and some camera models in particular.

The Secrets (Shh . . .) of Exposure

Because HDR involves getting around the limitations of dynamic range in modern digital photography, it stands to reason that exposure is a critical concept to understand. When you're setting up your camera to shoot bracketed photos, you need to be comfortable thinking and acting quickly.

Exposure is how much light enters the camera for the length of time the shutter is open. An *exposure* is shorthand for a photograph, or *frame* (which is a throwback to a frame of film).

You control exposure by changing how the camera operates. There are three primary ways to do this, as shown in Table 4-1. Each variable has the same effect — raising or lowering the exposure. They all do it differently, as well as having a different major side effect.

Table 4-1	Controlling Exposure	
Variable	*How It Works*	*Side Effect?!*
Aperture	Changes the size of the opening in the lens that lets light in the camera	Shortens or deepens the depth of field
Shutter Speed	Changes the length of time the shutter (the thing that keeps light out) is open	Stops or blurs motion
ISO	Changes the digital camera sensor's sensitivity to light	Raises or lowers noise

Here are some of the more important concepts related to exposure and how to control it for HDR:

✔ **Aperture:** Aperture is the size of the opening in the lens, measured in f-numbers. The f-number (also called an f-stop) is inversely proportional to the size of the opening (the aperture).

In other words, a larger aperture has a smaller f-number and a smaller aperture has a larger f-number. The size of the lens and the actual size of the opening are irrelevant in comparing exposure. You can see this relationship play out in Figure 4-1, where each succeeding f-stop is half as large as the previous (but the numbers get larger).

A larger aperture creates a shallow depth of field, which is the area you perceive to be in *acceptable focus*. A smaller aperture increases the depth of field. This is illustrated in Figure 4-2, where the wide aperture of f/1.4 has a much smaller depth of field than the second shot, taken at f/16.

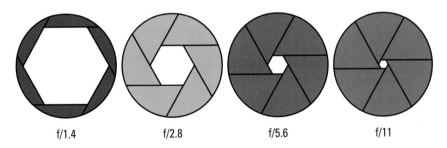

| f/1.4 | f/2.8 | f/5.6 | f/11 |

Figure 4-1: The lens aperture lets light into the camera.

For HDR, it is best to keep aperture constant between brackets so the depth of field does not change.

Aperture f/1.4

✓ **Shutter speed:** Shutter speed is the length of time the shutter stays open and allows light to enter the camera and strike the sensor. You control this value to let less or more light in, which in turn darkens or brightens the photo.

Aperture f/16

For HDR, fast shutter speeds are less important than traditional hand-held photography because you will often be taking photos of inanimate objects with the camera mounted on a tripod. For hand-held auto bracketed HDR, a faster shutter speed is more important.

✓ **ISO:** For digital cameras, ISO equates to sensor gain (the sensitivity to light). The higher the ISO, the greater the camera's ability to capture scenes with less light. The counterweight to this is always noise, as shown in Figure 4-3. Notice in particular the noise is much more apparent in areas of even tone — the green concourse floor and white cinderblock wall.

Figure 4-2: Comparing depths of field from two different apertures.

For HDR photography, the lowest possible ISO is the best setting. Raise it only if you cannot get the shot any other way.

ISO 100

ISO 1600

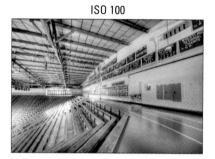
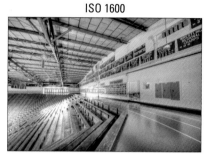

Figure 4-3: High ISO settings dramatically increase noise.

Photographic stops/EV

Akin to how f-stops work (as I mention in the preceding bullet list), a photographic stop is a principle that allows you to compare changes in exposure. One stop doubles or halves the amount of light for a given photo, depending on whether you increase or reduce exposure.

This behavior applies to all the methods of controlling exposure, which means you can describe aperture, shutter speed, and ISOs in terms of stops.

- Stopping down means you are reducing exposure.
- Stopping up means you are increasing it.

Camera controls can change stops incrementally, which means you can change the shutter speed by a third of a stop.

Here's where Exposure Value (EV) comes into play: One EV is the equivalent of a stop of exposure. EV often refers to the location of the current exposure on the camera's exposure index or exposure display. It can also refer to the relative distance from one exposure to this mark or another exposure, expressed in EV.

Figure 4-4: The exposure index in action.

Figure 4-4 shows the LCD monitor of my Sony dSLR, which has an exposure index handily visible at all times. It is marked off from -2 to +2 EV, with ticks every third of an EV (which is normally one shutter speed or aperture increment one way or another).

This is your guide to measure the effects of altering your camera's settings on exposure in manual mode. In this case, the combination of 1/5 second shutter speed, f/8 aperture, and ISO 100 result in an anticipated overexposure of +2.0 EV.

EV 0.0 is assumed to be the ideal exposure given the lighting conditions at hand. Only you can tell whether it is aesthetically the correct exposure or not.

If a camera in manual mode meters a scene and tells you the current exposure is +1.0 EV, you know the photo will be overexposed by a stop. You should either increase (make faster) the shutter speed or make the aperture smaller to bring the exposure down to 0.0 EV. Similarly, a bracketed photo taken at EV -2.0 is intentionally underexposed by two stops.

When setting auto exposure bracketing distance, you set the relative EV that each exposure differs from the ones around it. Common settings are +/-0.3, +/-0.7, +/-1.0, and +/-2.0. While the lower settings are not as effective for HDR, +/-1.0 and +/-2.0 are right in the ballpark.

- **Underexposed:** A photo is underexposed if it is too dark. In HDR, you shoot underexposed photos on purpose to tone down highlights in a scene, which will retain their details.

- **Overexposed:** An overexposed photo is too bright. In HDR, you shoot overexposed photos on purpose to reveal details in shadows.

Bracketing

Bracketing is taking two or more photos with different exposures of the same scene at the same time. Back in the day when film was king, bracketing was a way to cover more exposure possibilities (like placing more bets on different numbers at a roulette wheel — you stand a greater chance of winning). Without digital exposures and auto review, you could only be sure you got the best exposure when the film was developed. With HDR, bracketing is not about being uncertain of the correct exposure, but rather, increasing the amount of exposure data you've gathered.

Bracketing most often assumes that the central exposure is at 0.0 EV but this does not have to be the case.

The word *bracket* can be used as a verb, as in, "I told my assistant to bracket the scene." It can also refer to a single photo in the bracketed set.

A bracketed set is a group of bracketed photos that all go together, as seen in Figure 4-5. This is a 5-shot bracketed set, taken at +/- 1.0 EV. You'll often see people indicate the exposure settings of a bracketed set as -2/-1/0/+1/+2 EV.

See how it all fits together?

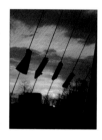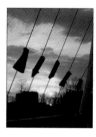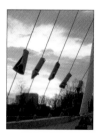

Figure 4-5: A 5-exposure bracketed set at -2/-1/0/+1/+2 EV.

Metering

Your camera has the ability to mea-
sure the amount of light in a scene
and calculate the proper exposure.
Most of the time, the camera meters
the scene when you press the shut-
ter release button halfway down. In
this way, you can take a reading and
then alter the controls to change the
exposure.

There are several different metering
modes. Your camera might have
one of several types such as multi-
metering, center-weighted, spot,
partial, or average. Figure 4-6 shows
two shots of a garage. The lighting
is somewhat complicated. Spot
mode — centered on the dark
garage — raises the exposure so
the interior can be seen but at the
expense of everything else. Matrix
mode leaves the garage too dark
while everything else looks pretty
good.

Figure 4-6: Different metering methods often
produce different photos.

 HDR is generally compatible with
multi-metering, which evaluates all the light sources in a scene. You may
need to switch modes, however, to take into account very bright or dark
areas.

Configuring Your Camera for HDR

One of the most important elements of shooting HDR photography is configuring your camera. You change the settings to optimize the outcome for HDR rather than a traditional digital photograph.

Different types of cameras have different capabilities. Each of the following sections generalizes your situation by what your camera can do. Find the method you can use (experimentation notwithstanding) based on the following criteria:

✓ **Exposure Compensation Bracketing:** Only cameras *without* a manual mode or auto exposure bracketing (AEB) need to use exposure compensation. This includes most compact digital cameras. Newer models don't often allow you to directly alter the exposure. This makes traditional bracketing impossible.

This is a sneaky workaround for that limitation. You can use exposure compensation to indirectly change shutter speed and therefore manually bracket a scene.

Figure 4-7 shows exposure compensation in action on a budget compact camera. The camera is in Programmed Auto mode — there is no manual mode and the camera does not have AEB — and the exposure is adjusted to -2.0 EV (that's why it is so dark) in preparation to shoot the lower bracket.

Figure 4-7: Using exposure compensation to shoot HDR.

✓ **Manual Bracketing:** Any camera with a manual mode can manually bracket a scene. Exposure compensation bracketing is very similar but uses the exposure compensation control instead of directly changing shutter speed.

If your camera limits the exposure difference between auto brackets to less than +/- 1.0 EV, you will find manual bracketing, although a pain, to be more practical.

✓ **Auto Exposure Bracketing (AEB):** AEB is found on many dSLRs and the occasional compact camera or super-zoom. You don't need a manual mode for AEB to work on most cameras.

✓ **Single-Shot HDR:** Any camera that shoots Raw photos can perform single-shot HDR.

The following sections take you up to the point just before you make the initial exposure adjustments and start taking the photos. Bracketing and shooting single exposures are covered in Chapters 5 and 6.

Setting Up Exposure Compensation

Exposure compensation bracketing is a fantastic workaround. It enables you to take a camera without manual controls or auto bracketing and manually bracket a scene. Bypass limitations and proceed directly to HDR!

This section shows you how to get started and is optimized for cameras that don't have manual shooting mode or AEB. I am using a Canon PowerShot A480 to illustrate. Follow these steps to get your camera set up to shoot brackets using exposure compensation:

1. **Turn on the camera.**

 Make sure you are in shooting and not playback mode.

 Always check to make sure that you have enough battery power to last for your shooting session. You can change batteries between bracketed sets, but it will ruin your composition. Also confirm that you have enough memory card space to store the photos. If not, delete photos, swap cards, or download existing photos and then reformat the card.

2. **Mount your camera on a tripod.**

 For compact digital cameras, this is a necessity. The things you have going against you are a slow frame rate and manual bracketing. Neither of these allow for hand-held bracketing.

 Depending on your personal preference, you can get all the settings dialed into the camera while you hold it, and then mount it on the tripod.

3. **Based on the specific capabilities of your camera, select an appropriate shooting mode.**

 Some cameras disable exposure compensation depending on the mode you are in. Consult your documentation to confirm which modes make exposure compensation available.

 Choose a mode that suits the scene you are shooting:

 - **Auto:** Good all-around mode.
 - **Programmed Auto:** If your camera disables exposure compensation in auto mode (Canons do this), try programmed auto, often abbreviated as P, and seen in Figure 4-8. Notice that for this camera, all shooting modes are accessed through the back screen by pressing the Mode button.

• **Scene:** Different cameras have different scenes to choose from, such as Baby, Party, Sports, Landscape, Portrait, and so forth. The various modes seem to be multiplying, although they are fairly consistent within brands. Each mode will change the camera's settings and optimize them for the given conditions.

Figure 4-8: The P and Program are pretty big giveaways that you are in Program mode.

Pay particular attention to your camera's manual and identify the right scene that you are shooting. Focus, in particular, can be thrown off if the scene is set to something close (like Food) and you are outside and need focus set to infinity.

4. **Choose picture quality, size, and other photo settings.**

 Choose the largest, best photo quality you can. This will result in the best HDR image down the road. In addition, you often have creative control over how the camera processes data from the sensor and converts it into a JPEG file format. You may have color or style options that produce a more vivid photo.

5. **If possible, turn off the flash.**

 You don't want the flash to fire, thinking it is making up for a bad exposure. You *want* the dark exposure to be dark.

6. **If possible, set ISO to the lowest possible value, as in Figure 4-9.**

 This helps fight the noise battle. If raising ISO increases the noise on a $2,500 camera, you can imagine what it's going to do on a $150 budget compact.

7. **Turn off dynamic range optimization.**

 The point of HDR is to use bracketed photos to capture increased dynamic range. You want each photograph to be a

Figure 4-9: How low can you go? How low can you go?

true representation of the scene whether it is really bright or dark. DR optimizers, which often affect JPEGs and leave Raw photos alone, defeat this purpose.

Having said that, the difference isn't that great. You won't be stopped by the police if you've left your DR optimizer on (as I have many times).

8. If necessary (and possible), set focus to infinity and turn face detection off.

Some compact digital cameras have two or three auto focus modes, such as normal, macro, and infinity. At the very least, make sure you are not in macro mode unless you are shooting something very close. Infinity works very well, assuming you are a reasonable distance away from the subject. Check to make sure what your minimum focus distance is or you won't be able to focus on a close subject.

9. If desired, turn on LCD guide lines.

These little lines form a grid on the LCD and help you align and compose the shot. I use them all the time. (See Figure 4-10.)

10. If desired, turn photo review off.

When you manually bracket by altering the exposure control, you will be working hard to get the pictures fired off quickly for most scenes. You lose time when the camera decides to review each shot for 2 seconds.

Figure 4-10: Grid lines help you align your subjects.

If you need to, shoot a test shot and review it for the proper focus. Then get back in and shoot the entire thing without review.

At this point, your camera is set up and ready to shoot brackets. The rest of the story is explained in Chapter 5.

Preparing to Manually Bracket a Scene

Some cameras do not have AEB. Others have it but it's stinky. For example, the Sony Alpha 300 is a great entry-level dSLR that has auto bracketing. The problem is, the exposure difference between brackets is limited to +/- 0.3 or +/- 0.7 EV. That's too little for HDR given the fact that this camera limits you

to 3 shots. You want a wider range of light than this camera offers. Despite this, the Sony excels at manual bracketing.

Follow these steps (I'm using the Sony Alpha 300 to illustrate) to set up your camera to manually bracket a scene:

1. **Turn on your camera.**

 Make sure you are in shooting and not playback mode.

 Always check to make sure that you have enough battery power to last. You can change batteries in between bracketed sets, but it will ruin your composition to have to do this between brackets. Also confirm that you have enough memory card space to store the photos. If not, delete photos, swap cards, or download existing photos and then reformat the card.

2. **Mount your camera on a tripod.**

 Manual bracketing requires you to use a tripod even if you are shooting Raw exposures because it takes time to change the settings between brackets. Hand-held bracketing requires a fast frame rate (fps) and AEB pdq for the fyi of the omg of the HDR.

3. **Attach any additional gear.**

 If you use a remote shutter release or level, attach them to the camera now. Try not to trip over the remote shutter release cable or bonk your head on the level.

4. **Enter manual shooting mode, as in Figure 4-11.**

 Manual mode is a must for manual bracketing unless you are using exposure compensation. If that's the case, you're in the wrong section.

 Notice that this camera (a Sony Alpha 300) has a nice big burly mode knob on top — not all do. Even though this is a dSLR, it still has an auto mode as well as scenes. These are irrelevant for manual bracketing, however.

 Figure 4-11: Set phasers on stun and mode to manual.

5. **Choose a file format, picture quality, and other photo settings.**

 This determines what file format you'll be using in software, whether JPEG or Raw. Raw photos, of course, can be edited when converting. Pay special attention to JPEG options, as they are much less forgiving. Once you take a JPEG, that's pretty much it.

6. **Turn off the flash.**

7. Set ISO to minimum.

Strive to shoot at ISO 100. This results in the lowest noise per photo, which can add up over three or more brackets. If you have to raise it, do so no more than necessary.

8. Set the drive/release mode for a single shot.

Since you're shooting manual brackets, you don't want to accidentally fire off five shots. There's no real harm in that, but it will make sorting through the photos on your computer harder.

9. Turn noise reduction off.

You don't want noise reduction slowing you down. Do what you can (low ISO) to reduce noise beforehand. Remove the rest in software.

10. Turn off anti-shake or vibration reduction features, as in Figure 4-12.

These features can cause alignment problems and aren't necessary when you mount your camera on a tripod.

Figure 4-12: Super steady anti-shakey is now off. Feel free to move around the cabin.

11. Confirm metering mode.

Although matrix-type metering (the default on most cameras) should be sufficient in most cases, you may need to experiment with other modes if you aren't getting the brackets you want.

If in doubt, look to see if the center bracket (0.0 EV) is a good photo. If it is, the metering is probably fine, even if it is not scientifically calibrated and fully verified by the Department of Weights, Measures, and Meters. If the central subject is too bright or in too much shadow, consider changing to spot or center-weighted mode.

Bracketing will more than likely take care of this, but you should be looking to get the best possible center exposure. It will pay dividends that will become more obvious later in the book.

12. Choose a focus mode.

Most of the time, auto focusing is preferred. If the camera has trouble getting a focus lock, however, you may have to tell Scotty down in Engineering to back off while you kick in the manual override.

From here, you're ready to compose the shot and start taking pictures.

Dialing in Auto Bracketing

Auto exposure bracketing (AEB) is a fantastic time-saver. You don't have to fiddle with exposure controls in the middle of the shot. All you have to do is make sure your camera is configured correctly, set up the initial shot, and then press the button.

Most dSLRs have auto bracketing, although you will find that each manufacturer implements it somewhat differently. Currently, Canon limits you to three shots but allows you to alter the AEB amount up to +/- 2.0 EV in 1/3 EV increments. Nikon, on the other hand, limits you to a maximum exposure increment of +/- 1.0 EV but allows you to take up to 9 shots in many cameras.

I use a Nikon D200 to illustrate the steps to set up auto exposure bracketing:

0. For some cameras, pre-configure underlying AEB settings.

That's right — this step takes place before the first step. It's like going to 11, only in reverse.

Depending on your camera, pre-configure AEB before you leave home. You don't want to be looking at a sunset that is quickly fading while you are hunting through your camera's menu system double-checking a bunch of complicated AEB settings.

For Nikons, this can take a few minutes but once it's done you can leave it alone. Regardless of the brand, check your documentation and read through the AEB section until you fully understand what's going on. Look for settings such as these in your menus (using the Nikon D200 as an example, default settings indicated by (d)):

- **Auto Bracketing Set:** This setting (see Figure 4-13, which shows the D200 bracketing menu) controls what the camera changes to create the brackets. It can be exposure, flash level (this type of bracketing changes flash intensity to alter exposure), white balance, or a combination. Options are AE & Flash (d), AE Only, Flash Only, and WB Bracketing.

- **Auto Bracketing in M Exposure Mode:** This setting defines how bracketing is accomplished when AE & Flash or AE Only modes are selected and

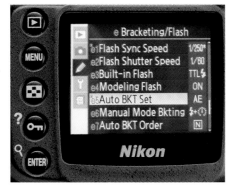

Figure 4-13: Navigating through AEB options.

the camera is in manual mode. Options are Flash/Speed (d), Flash/Speed/Aperture, Flash/Aperture, and Flash Only.

- **Auto Bracketing Order:** This one is fairly simple. The option sets the order the brackets are taken, in relation to what it metered (MTR). Options are MTR>Under>Over (d) and Under>MTR>Over.

- **Auto Bracketing Selection Method:** Defines how to turn bracketing on or off. Options are Manual Value Select (d) and Preset Value Select.

Not all cameras require this much setup. With many Canon and Sony cameras, for example, you just turn it on! The point here is to show you that it can be complicated and scare you into reading your manual. Without further reader intimidation, let's continue.

1. **Turn on your camera.**

Make sure you are in shooting and not playback mode. Always check to make sure that you have enough battery power to last. You can change batteries in between bracketed sets, but it will ruin your composition. Also confirm that you have enough memory card space to store the photos. If not, delete photos, swap cards, or download existing photos and then reformat the card.

2. **If desired, mount your camera on a tripod.**

If you have a fast enough frame rate and AEB, you can get by with shooting hand-held brackets. The caveat is your shutter speed has to be fast enough to avoid blurring.

For example, taking exterior shots in good light allows a fast shutter speed, even at an aperture like f/8. Inside is another story. It's not unheard of for the bright end of a bracketed set to take a few seconds inside. If you can't get shutter speed fast enough to avoid blurring, grab the tripod.

3. **If you're using a tripod, attach any additional gear.**

If you are shooting hand-held AEB, you won't need a remote shutter release or level. Otherwise, attach them to the camera now.

4. **Choose a shooting mode.**

Depending on you and your camera, you may want to be in fully manual mode, but you can also decide on something a little more automatic.

Double-check with your camera's manual to make sure your shooting mode and AEB are simpatico.

Here are some advantages of using specific modes with AEB:

- **Programmed Auto (aka Program AE, Programmed AE, and so on):** Programmed modes are fully automatic. Enter the mode and that's that. The camera will set the optimum exposure and use AEB (if available in this mode) to capture the brackets. The downside

to this is that you don't directly control shutter speed or aperture, which takes the creative control out of your hands.

You may have the option of using a Flexible Program, also called Program Shift. In this case, select aperture and shutter speed from a preset list of combinations.

- **Manual:** You have the most control in manual mode, which is often good. It minimizes the chance some sort of auto ISO gizmo will kick in or your flash will decide to flash when you least expect it. Manual means you're in charge.

- **Aperture Priority:** This is a very popular mode for HDR because it lets you set the depth of field for creative and focus purposes and lets the camera figure out the right shutter speed to make it happen.

- **Shutter Priority:** This mode is less beneficial in bracketing because anything moving fast enough to demand a high shutter speed is moving too fast to bracket. On the other hand, if you are going *sans tripod,* dial in a fast shutter speed to minimize or eliminate blurring caused by your own movement.

- **Scene:** Great for beginners. Select a scene like Landscape and you're off to the HDRaces.

Remember, all of these modes except manual only work for HDR when you use auto bracketing. Otherwise, the exposure is set and you will not be able to change it except by using the Exposure Control.

5. **Confirm file format, picture quality, and other photo settings.**

6. **Enable auto exposure bracketing.**

 You have to turn AEB on. For some cameras (such as Sony cameras), it may be accessed through the Drive button. Some cameras may have a button (Bracket or Fn), while others require you to access and enable bracketing from the menu system.

7. **If possible, select the number of brackets, as in Figure 4-14.**

 Many cameras default to 3 exposures and 3 exposures only (read that with a Sean Connery accent *à la The Hunt for Red October*). If you can choose more, your bracketed set will have a greater overall dynamic range.

 From a practical perspective, 3 is fine, although you may miss some range if the scene you shoot has a tremendous contrast between lights and darks. Increase the number of brackets to 5 if your maximum bracketing range is only +/-1.0 EV. You can go to 7 or 9 exposures (Nikon users, mainly) if you are concerned that you won't capture enough range.

8. **Choose a bracketing range/increment.**

 A good choice for 3 brackets is +/- 2.0 EV. This gives you a total range from the underexposed to the overexposed photo of 4.0 EV. You may be limited to +/- 0.3 or 0.7 EV. If this is the case, consider going to manual

bracketing or take more than one AEB set starting at different points.

Use +/- 1.0 EV if you have no choice. You'll get good overall dynamic range if you shoot 5 or more brackets.

9. **Set Release (Drive) mode.**

For AEB, set the release mode to high speed, continuous, or high speed continuous to take the bracketed shots with one press of the shutter release button and in the shortest amount of time.

10. **Turn off the flash if not needed.**

11. **Set ISO to minimum to control noise.**

12. **Turn noise reduction off to ensure a good frame rate.**

13. **Turn off anti-shake or vibration reduction.**

This is if you want to be really nerdy about things. I've made just about every mistake possible while shooting HDR, including forgetting to turn off anti-shake or vibration reduction. It's not going to matter that much. But, if you want to go all-out, camera manuals tell you to turn vibration reduction/anti-shake features off if you use a tripod.

14. **Choose a metering mode for the best center exposure (the one at 0.0 EV).**

15. **Choose a focus mode that works best for the given situation.**

That's it. You're ready to compose the shot and start shooting.

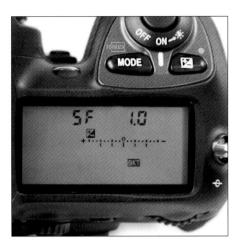

Figure 4-14: Five brackets selected with a range of +/-1.0 EV between each shot.

Getting Ready for Single-Shot HDR

The great thing about shooting single-shot HDR is you don't have to do anything special.

The biggest problem you will face is forgetting to change the settings around if you decide to switch back and forth between different types of photography with the same camera.

Here is a handy checklist of things to look for when switching from HDR back to normal photography:

- **Turn off AEB:** You may have to set the number of brackets to 0. I've taken many a bracketed set when I thought I was just shooting normal photos.

- **Zero previously set exposure compensation:** I hate it when I forget to do this and afterward take a terribly blown out picture because the compensation was set to +2.0 EV. In fact, it's even worse when I forget to reset the camera and give it to one of my kids to take photos with. Figure 4-15 shows the result. My son Ben took this well-composed photo of his brother Sam mowing the yard at +2.0 EV.

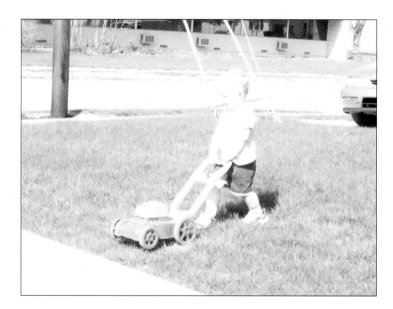

Figure 4-15: That's one sunny day — +2.0 EV sunnier, in fact.

- **Turn on anti-shake/vibration reduction measures:** You will probably be shooting hand held, which means these features are very helpful.

- **Turn on noise reduction features:** This is not as critical because these kick in only for high ISO or long exposures. Still, it's nice to have. If you prefer to handle noise in software, always leave this off.

- **Turn on auto-ISO features:** This moves the camera back toward auto.

 The theme here, and with many of these settings, is to help you get the right exposure. You won't be shooting brackets, so it's even more important to nail the exposure.

✔ **Set proper shooting mode:** You may have a favorite mode you like to keep the camera in while not shooting brackets.

✔ **Set desired metering mode:** Another safeguard to get the right exposure for the conditions you are in and the subject you are shooting.

✔ **Return to desired focus mode:** This is a personal preference.

✔ **Enable auto flash, if necessary:** It can be a surprise when you try to take that perfect photo, need the flash, and have it off.

✔ **Return to preferred release/drive mode:** Mainly for consistency. You don't want surprises.

Other helpful hints

Here are some more hints that don't neatly fit elsewhere. It's nothing huge, but they are helpful, hints, and most definitely other.

✔ **Reset the camera:** One problem with shooting HDR is that it generally requires the camera to be in a completely different mode, than, say, shooting portraits. You have the ISO set to its minimum, may have bracketing enabled, and have possibly turned off auto focus. When you pick up the camera to take photos of your kids and change everything, make sure to reset it. Some cameras (the Nikon D200 to name one), have shooting banks that allow you to save different camera configurations for different purposes. You might set up an HDR, Interior Portraits, Outside Portraits, and Macro bank.

✔ **Cleaning:** Before going out on an important shoot, clean your camera and lenses.

Clean the camera sensor (dSLRs only) only if you must. There's no sense trying to clean it when there is no visible dust. You risk adding more dust with no discernable upside.

✔ **Starting with a clean card:** Assuming you have downloaded the photos, wipe your memory card every time you start a new shoot. Reformat it from the camera menu system so your image numbering system stays intact.

Warning: Make sure you've downloaded the photos first!

✔ **Batteries:** It isn't fun to run out of batteries while on scene shooting HDR, especially if you are out in the hinterlands, shooting impressive landscapes. Buy more. Recharge them and keep them in your bag. Look at your battery meter (if you have one) before getting started.

Bracketing Exposures for HDR

In This Chapter

▶ Deciding how many brackets to shoot
▶ Comparing differences
▶ Bracketing with exposure compensation
▶ Manual bracketing
▶ Shooting automatic brackets
▶ Using an external light meter

*B*racketing, the technical heart of HDR, is the photographic process you use to shoot differently exposed photos of the same scene. Each photo contains a segment or slice of the total dynamic range that was present. Together, they capture something close to what you see with your eyes.

It sounds simple enough. Shoot a few photos of a scene and then have the software put it all together as an HDR image that you tone map. When you get ready to take the photos, however, several questions come to mind.

✔ How many brackets do you need? Two, three, four, or more?

✔ What exposure value (EV) distance should you use: +/–1.0 EV or +/–2.0 EV? More? Less?

✔ How do you shoot brackets on different cameras with different capabilities?

✔ How do you shoot multiple sets of auto exposure bracketing (AEB) of a single scene?

✔ Can you use an external light meter?

The answers to these questions — the subjects of this chapter — provide a firm foundation for you to shoot digital HDR photography with many different types of cameras in all sorts of situations.

Big Answers for Big Bracketing Questions

The two fundamental questions that dominate most discussions of HDR are

- ✔ How many brackets do you need to shoot?
- ✔ What is the best format: JPEG or Raw?

The answers to these questions are both aesthetic and technical in nature:

- ✔ **Aesthetic:** The differences are largely perceptual. It depends on what you like and the level of quality you can live with.

- ✔ **Technical:** A scene's dynamic range affects how many brackets should be used to fully capture it, and the capabilities of your camera play an important role. Because of these issues, the number of brackets you want to shoot can change from one set to the next.

If your camera shoots JPEG and not Raw photos, you obviously have no choice but to shoot your brackets with JPEG.

Deciding how many brackets to shoot

Knowing how many brackets to shoot is clearly an important factor in HDR. It provides the much-needed information of where to start manual bracketing and how to configure (if possible) AEB on your camera.

Finding the right answer to this question depends on several things. The dynamic range of the scene, the capabilities and limitations of your gear and your personal style all play a role.

- ✔ **The dynamic range of the scene:** Three exposures shot at –2/0/+2 EV can handle most scenes. Scenes with the sun, white clouds, bright reflections off water, metal, or buildings, might require more underexposed brackets, and scenes with very dark areas (either in shadow or because of the light) need more overexposed brackets.

 A very high dynamic range is shown in Figure 5-1. In this case, the sun presents a very strong light source, and the dark shadows along the tree line are at the opposite end of the spectrum. Such a scenario calls for more brackets if you can shoot them. If you can't (or don't want to) shoot more, you'll *clip* (exposure data goes off the scale in either direction, getting cut off and lost) lows or highs.

-4.0 EV

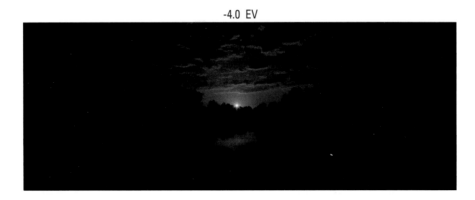

0.0 EV

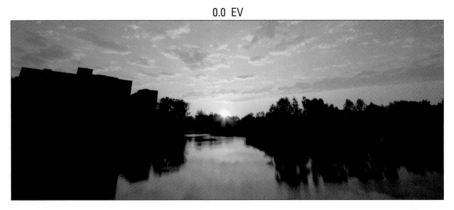

+4.0 EV

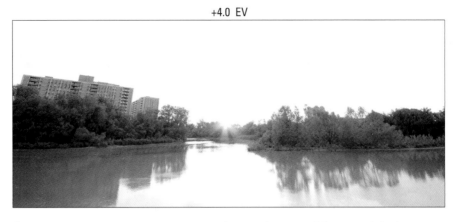

Figure 5-1: This scene has a very large dynamic range because of the sun and shadows.

✔ **Your gear:** Your gear limits the number of brackets you can take in many ways:

- *If using exposure compensation,* you're limited to an EV range of +/–2.0 EV. This effectively limits the number of brackets you can reasonably take.

- *If using AEB,* you're stuck with how many brackets you can program the camera to take. Often, this is only three. Some cameras can shoot more. Alternatively, you can take multiple bracketed sets (centered on different center exposures) or revert to manual brackets.

- *If using manual mode,* you're limited by shutter speed and aperture. If the scene is very bright, you might not be able to shoot fast enough (say, 1/4000 second or faster) at f/8. You might have to *stop-down* (decrease the aperture by increasing the f-number).

For example, the dark exposure in Figure 5-1 (taken with a Nikon D200) was shot with a shutter speed of 1/2500 second, well beyond what most compact digital cameras can take at f/8. Comparatively, the Panasonic Lumix LZ8 maxes out at f/8 and 1/2000 second in manual mode. Because its aperture can't get any smaller and the shutter speed can't get any faster, that photo is beyond the capabilities of the LZ8.

✔ **Your style:** Some photographers don't deviate from three brackets at –2/0/+2 EV. It's their style. Some like five brackets at +/–1.0 EV or some other combination. That's the great thing about artistic freedom: It's free.

Table 5-1 summarizes the rationale for choosing a specific number of brackets.

Table 5-1	Bracketology Summary	
Brackets	**Rationale**	**Notes**
2	Being different; fewer shots to process.	Most AEB modes will not shoot 2 brackets.
3	Standard AEB brackets; good range if separated by +/–2.0 EV.	Works well manually and with exposure compensation; less effective at +/–1.0 EV and under.

Brackets	Rationale	Notes
4	It is sometimes necessary to depart from symmetric brackets to account for a particularly dark or bright area.	You end up with exposures looking something like −4/−2/0/+2 EV.
5	Less noise; more details.	Similar to 3 exposures at +/−2.0 EV, only 5 exposures are normally shot at +/−1.0 EV with AEB. Manually, you would get a large dynamic range shooting +/−2.0 EV.
7–9	Incredible dynamic range (to the point of overkill for many scenes) if shooting at +/−2.0 EV. Most shoot 7 and 9 bracketed sets using +/−1.0 EV.	Best with a pro-caliber dSLR. Much more difficult if you are shooting manually (forget about moving objects like clouds). Impossible with exposure compensation.
9+	You're shooting the surface of the sun from the dark side of the moon or you're trying to impress your date.	Send me a postcard. I've always been interested in the dark side of the moon, especially as it relates to Pink Floyd.

As you get more experience, your own bracketing pattern and preferences emerge. You might settle on using three exposures, for example, separated by +/−2.0 EV. That serves as your baseline, which you can modify or extend based on the conditions at the scene.

Seeing the difference

Reading about why you can or should shoot more or fewer brackets is one thing. Seeing the difference among different numbers of brackets of the same scene — and comparing them in Raw versus JPEG format — is even more illuminating.

Upcoming figures present a close crop of the same scene, processed using different numbers of brackets in different formats. A differently cropped version of the brackets of the full image is shown earlier in Figure 5-1, and

the final, processed shot (nine exposures from TIFFs) is shown here. For the upcoming examples, I zoomed in on the sun and tree line to show both extremes of the spectrum of light and dark in this scene.

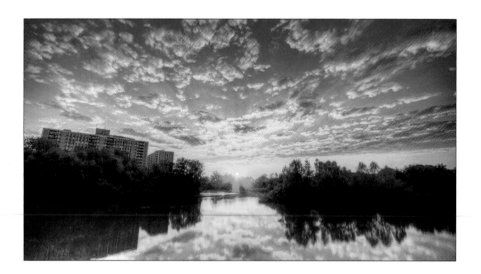

The same settings were used to generate and tone map the HDR images. The tone mapping settings in Photomatix Pro 3.2 are fairly plain. Strength is 100, Color Saturation is 80, Smoothing is in Slider mode at 0.0, Microcontrast is +5, White Point is 2.231%, and the Black Point is 0.559%. All other values are at their defaults. The final results have not been spruced up in any way. This is how it looks straight out of Photomatix Pro. For information on what these settings mean and how to use them in Photomatix Pro, jump over to Chapter 8.

Figure 5-2 illustrates an HDR image tone mapped from JPEG brackets. Pay special attention to the sun, the rays of light, clouds, the tops of the trees, and the shadows in the trees.

Table 5-2 summarizes what can be gleaned from looking at the different swatches in Figure 5-2. Just so you know, *posterizing* (not to be confused with pasteurizing) looks like a badly compressed JPEG or an old-fashioned GIF stuck with 256 of the wrong colors. You expect to see a smooth color gradient but instead get distinct bands or areas of blech.

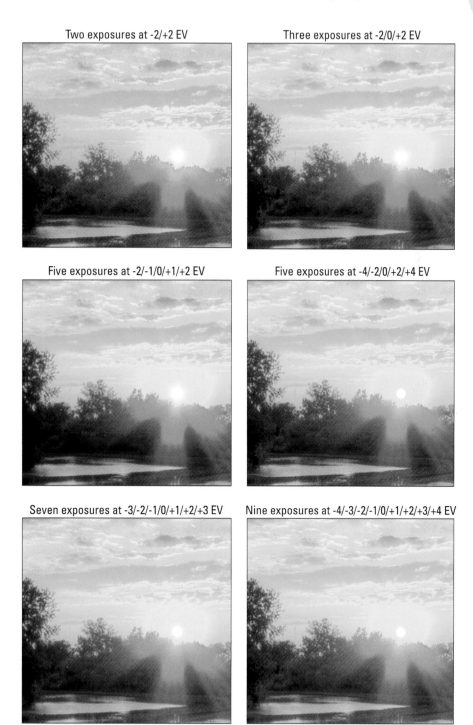

Figure 5-2: HDR images processed from JPEG brackets.

Table 5-2		Comparing JPEG Brackets	
Brackets	**EV Difference**	**Total EV Range**	**Notes**
2	4.0	4	Surprisingly good from a distance; posterized close in; noisy
3	2.0	4	Much better; smoother gradations of color; less noise
5	1.0	4	Very good; even smoother and less noise
5	2.0	8	Better dynamic range (look at the shadows); posterization (you have to be zoomed in quite a ways to see it) and noise problems
7	1.0	6	Very good dynamic range, less noise
9	1.0	8	Best image quality; greatest dynamic range with fewest problems

Overall, JPEGs perform well. If you look at the overall image versus this magnified area, they all look pretty good. If that's your intent, you don't need to overdo it. Shooting more brackets at a smaller EV distance lowers noise and gives you a smoother gradation between colors.

Figure 5-3 illustrates the same scene created from Raw exposures. Compare each set of images in terms of the number of brackets and their EV difference. Make sure to compare similar images between JPEG and TIFF.

Table 5-3 summarizes the differences among the number of brackets when created from Raw exposures converted to 16-bit TIFFs.

Table 5-3		Comparing TIFF (from Raw) Brackets	
Brackets	**EV Difference**	**Total EV Range**	**Notes**
2	4.0	4	Better range than comparable JPEG; smoother; some noise problems
3	2.0	4	A definite improvement over 2 exposures; a bit noisy
5	1.0	4	Very good; less noise
5	2.0	8	Large dynamic range; less noise
7	1.0	6	Smooth; good looking
9	1.0	8	Excellent dynamic range; very low noise

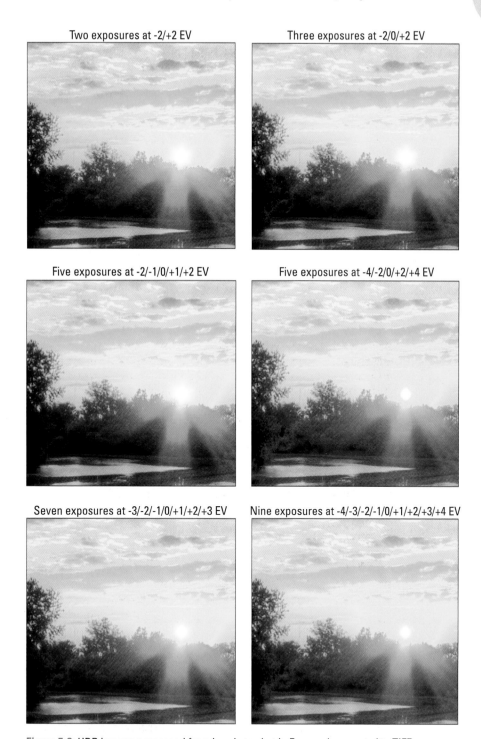

Figure 5-3: HDR images processed from brackets shot in Raw and converted to TIFF.

Even at the lowest level, 16-bit TIFFs (from Raw) perform better than JPEGs because there is more dynamic range inherent in a 16-bit TIFF than in an 8-bit JPEG. Is the difference earth-shattering? Not really, but if you're going for the highest-quality image that can be printed out at a larger size to sell (*giclée prints,* which are fine art prints of the highest quality), TIFFs do make a definite difference. (See Chapter 11 for more about creating TIFFs for print and archiving.)

The quality improvement in TIFFs mirrors that seen in JPEGs. The more brackets you shoot, the greater the dynamic range you capture. Shooting with a smaller EV difference (+/–1.0 EV) results in less noise, and a combination of more brackets with small EV differences results in smoother color. The difference between five exposures shot at +/–1.0 EV rather than +/–2.0 EV shows this trade-off very well.

The bottom line is to shoot as many brackets in Raw as practical with a small EV difference if you want the highest quality. Three brackets at +/–2.0 and five brackets at +/–1.0 EV are good for most situations. Use JPEGs if you want a good image but aren't concerned about getting the most quality possible.

Shooting Bracketed Photos

Shooting brackets is where it's at. This is where you feel the most like an HDR photographer because it's different than shooting single exposures. Make sure your camera is set up according to the type of brackets you can (or want to) shoot (see Chapter 4) and follow the steps in the appropriate section.

Read through all the sections, regardless of which method you gravitate to so that you can gain important perspectives on how to shoot HDR. This comes in handy, no matter what the situation.

The steps outlined in the upcoming sections on exposure compensation and manual bracketing are predicated on a few things:

✔ **Three — the number of the brackets, that is:** The steps are based on taking three brackets, as shown in Figure 5-4. This illustration shows three brackets set up in relation to the EV index: one at –2.0 EV, another at 0.0 EV, and the third at +2.0 EV.

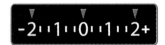

Figure 5-4: Three brackets separated by +/–2.0 EV.

If you wish to shoot more or fewer brackets, change your approach accordingly. For example, five brackets at +/–1.0 EV require that you set exposure compensation to –2.0, –1.0, 0.0, +1.0, and +2.0 for the respective brackets.

✔ **The order of the brackets shall be under, even, over:** You can, of course, shoot them in any order you like, but for the sake of clarity, the examples follow this format.

✔ **Exposure jumping:** Sometimes the exposure jumps around between brackets. After you start shooting, ignore any changes and be consistent with the bracket distance. If necessary (you think the exposure is really hopping), start over when the conditions are more stable.

One more thing: All examples were shot at ISO 100 and an aperture of f/8 unless otherwise noted. You can vary these settings at your own discretion, of course.

Using exposure compensation

Exposure compensation is a fallback method to shoot brackets. If you don't have a camera that has a manual shooting mode or AEB (which includes almost anyone without a dSLR or advanced compact/super-zoom), there is no other option. The main advantage is you can use a camera otherwise unsuited to HDR without immediately having to go buy something expensive.

Another major benefit is that it steps you away from the inner workings of your camera and exposure control. You don't have to mess with shutter speed or most other settings. Just call up exposure compensation and set it to shoot the appropriate brackets — the camera handles the rest (it changes shutter speeds for you). Follow these steps to shoot brackets using the exposure compensation method:

1. **Set up your camera.**

 See Chapter 4 for the lowdown on this important step.

2. **Compose the scene.**

3. **Double-check camera settings.**

 Make sure that you're in the right shooting mode and that the flash is off.

 Check your camera's manual to see what modes exposure compensation is compatible with. Depending on the camera, you can control exposure compensation and disable flash while in many scene modes, programmed auto, and possibly auto mode. For example, the Canon PowerShot A480 allows you to force the flash off in auto mode, but it doesn't let you access exposure compensation. You must be in program or scene mode for that.

 If you're shooting a scene with clouds, you should turn off review (when the camera shows you the photo you just took for a few seconds) so you can get right back to shooting. Look under your system configuration or playback menu and turn off review or auto review.

4. **Meter the scene.**

 Press the shutter release button halfway down. You might see exposure or focus information appear, telling you the camera has "got it."

 If flashing red lights appear and the camera can't focus, you might not be able to continue given the current conditions. This can happen in low-light conditions when focusing on a neutral gray object, such as clouds at dusk. You might need to switch to manual focusing if you have it.

5. **Set exposure compensation to –2.0 EV.**

 This normally requires you to press a button (the universal symbol for exposure compensation is shown in the margin) to bring up the exposure compensation index on the back of your camera, and then press another button to lower the number to –2.0 EV.

6. **Shoot the underexposed bracket.**

 This one is dark, as shown in Figure 5-5. Notice that the tree to the left and the foreground are completely dark. The sunset looks nice. One down, two to go.

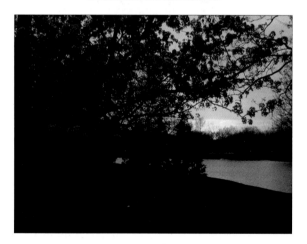

Figure 5-5: The underexposed photo appears dark; this is good.

If you turned off review, you can continue right into the next step. Otherwise, you might have to wait until the camera comes back into shooting mode to continue. You can speed it up sometimes by nudging the shutter release button (but not enough to take another photo).

7. Set exposure compensation to 0.0 EV.

This brings the exposure back to normal, as seen in Figure 5-6. You always want one good photo at 0.0 EV.

8. Take the center bracket.

Figure 5-6 shows the exposure at 0.0 EV. This is basically a standard snapshot. Notice, however, that the dynamic range of this scene is too large to capture. The foreground is a bit too dark.

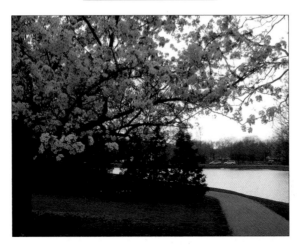

Figure 5-6: The center bracket is a good average exposure.

9. Set exposure compensation to +2.0 EV.

This raises the exposure (as shown on the meter in Figure 5-7) to create an overexposed photo.

10. Take the overexposed bracket.

The final bracket is shown in Figure 5-7. The highlights are blown out, but what was previously in shadow is now well lit. That's it!

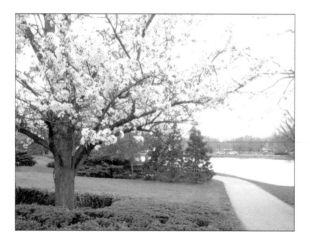

Figure 5-7: The final bracket captures the details in shadows.

The mechanics of shooting brackets using exposure compensation are pretty simple. You're not working directly with shutter speeds or anything more complicated than moving the EV index from –2.0 to 0.0 to +2.0.

Manual bracketing

Manual bracketing is very similar to shooting using exposure compensation, only you're directly manipulating shutter speed and watching its effect on EV. And, like exposure compensation, one of the main reasons to use manual bracketing is if your camera doesn't have AEB, or if it's not suitable for HDR.

For example, I shot HDR manually for quite some time with a Sony Alpha 300 dSLR. It has AEB, but the maximum exposure difference between brackets is only +/– 0.7 EV. This results in a total range between the lower and upper brackets of 1.4 EV — far less that I wanted for most situations.

Bracketing in the beginning

It might interest you to know that bracketing sprang into being well before HDR and digital photography. Bracketing was originally used to give photographers different exposures to choose from — hoping one would nail it. Of course, this was in the days of film, when you couldn't call up a preview of the photo you just took on the camera's LCD screen to know whether it was off and you needed to reshoot. Believe it or not, bracketing was such a viable technique that even some film cameras have auto bracketing features.

Whether you have a camera that shoots AEB or not, learning to shoot manual brackets is very helpful. After a bit of practice, HDR photography (brackets, exposure, and the other aspects or terminology) becomes imprinted on your brain. You'll also get better working with your camera this way.

Follow these steps to shoot manual brackets:

1. **Set up your camera.**

 You can read how in Chapter 4.

2. **Compose the scene.**

3. **Double-check camera settings.**

 You want to be in manual or aperture priority mode with the right f-number dialed in, the ISO as low as you can go, flash off (mostly), focus mode set to your preference, anti-shake turned off, noise reduction off, review off, drive mode set to your preference, and metering mode set.

4. **Meter the shot.**

 Press the shutter release button halfway down to get a meter reading. The camera shows you where your current settings put the exposure.

 Make sure you get a good focus as well, if using auto focus. This is triggered by metering. If you're manually focusing, now is a good time to double-check it.

5. **Set the shutter speed so that the EV meter reads –2.0 EV.**

 For the first exposure, you're moving from wherever the camera happened to be set up to where you need it to go. That can sometimes be a long way.

 When you shoot in manual mode, you're paying attention to two things at once: the shutter speed and EV index.

For most cameras, three "clicks" of shutter speed equal 1.0 EV. Therefore, if the camera says that you're at +1.0 EV, shorten the shutter speed (remember that faster shutter speeds result in less exposure) by nine increments.

Putting that in terms of shutter speeds, Figure 5-8 illustrates what you need to do. If you shoot at 1/30 (1.0 EV), you'll go past 1/40, 1/50, 1/60 (0.0 EV), 1/80, 1/100, 1/125 (–1.0 EV), 1/160, 1/200, and come to rest on 1/250 (–2.0 EV), which is –3.0 EV from where you were (which is relevant only to show you how far you had to go to get here), but –2.0 EV is on the exposure index (which is where you want to be). The final EV index is also illustrated.

Initial meter and movement | Set, with shutter speed

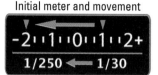 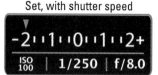

Figure 5-8: Move the exposure from the first reading to -2.0 EV to set your first bracket.

For the underexposed photo, double-check the shutter speed to make sure it's fast enough for the scene at hand. If you're shooting fast-moving clouds, for example, a slow shutter speed can smear them. If needed, increase your aperture or ISO.

6. Shoot the underexposed bracket.

If you're trying to move swiftly, here is where you reap the dividends of turning off review. Otherwise, you have to wait or speed up the camera to get back to shooting because the camera wants to show you the photo you just took.

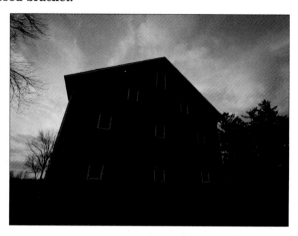

Figure 5-9 shows an underexposed photo of a barn near sunset. The sky and clouds show up

Figure 5-9: Pay attention to clouds and highlights in this bracket.

very nicely at –2.0 EV and f/8, and none of the highlights are blown.

7. **Set shutter speed so the EV meter reads 0.0 EV.**

You're reducing the shutter speed, as shown by the meter in Figure 5-10. This raises the exposure because the camera lets more light in to strike the sensor.

8. **Take the center bracket.**

It's especially helpful to have the center bracket perfectly exposed, as shown in Figure 5-10. This way, you have a good photo regardless of whether the HDR processing looks good or not. In addition, you can use this center bracket as a blending layer in software to heighten the sense of realism. In this case, the tree branches to the left are moving, which causes a problem in the final HDR image. That is overcome by using the branches from this photo.

9. **Set the shutter speed so the EV meter reads +2.0 EV.**

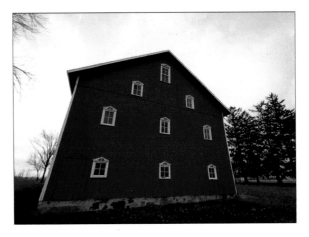

Figure 5-10: Shadows are brightening, but highlights are, too.

Figure 5-11: Highlights are blown out; this is okay for this bracket.

Getting faster again, as shown in Figure 5-11.

10. Take the overexposed bracket.

The final sequence of this bracketed set is shown in Figure 5-11. Notice that the sky is almost completely washed out, but details in the grass, barn, and trees to the right are brought out. This is what bracketing does.

With time, you should be able to knock out a three-to-five exposure bracket fairly quickly, assuming the shutter speeds are reasonably fast. This means you can overcome some cloud movement, but not all.

Auto bracketing

Auto bracketing is the bee's knees. It takes a tremendous amount of workload off you and transfers it to your camera. (Make sure to tip your camera afterward by giving it a healthy battery recharge.) Not only that (yes, there are advantages beyond catering to your life of leisure), you shoot faster. A camera with a normal frame rate can shoot faster brackets than even the most dexterous photographer in manual mode. The faster your camera, the more scenes you can shoot that are hard or impossible manually — moving clouds, some foliage, people (in some circumstances). AEB also opens up the world of hand-held, bracketed HDR photography.

Follow these steps to shoot auto exposure brackets. This example consists of five brackets at +/−1.0 EV, as shown on the meter in Figure 5-12.

Figure 5-12: Five brackets are set up at +/−1.0 EV.

1. Set up your camera.

See Chapter 4 for all things camera. This example consists of five brackets at +/−1.0 EV, as shown on the meter in Figure 5-12.

2. Compose the scene.

3. Double-check the camera settings.

Nothing worse than thinking you're going to take five nice brackets of a scene only to find out (after the fact) you're in the wrong shooting mode, forget to manually focus, and accidentally are at ISO 1600.

4. Meter the shot.

For most cameras, press the shutter release (or remote) button halfway down to meter the scene.

If you have a blazingly fast dSLR and are in continuous high-speed shooting mode, it's easy to accidentally fire off ten shots while you're trying to meter. Some cameras, like the Nikon D200, have alternate metering buttons. I use the AF-ON button (learn what every button does on your camera) to safely meter and auto focus without accidentally taking pictures.

5. **If you're in a shooting mode that requires you to set the exposure, do so by adjusting the shutter speed so that the EV index reads 0.0.**

Consider the following, though:

- You might need to offset the exposure or change the metering mode in conditions with extreme highs or lows. The problem is that there is often no way of knowing this until after you take a round of brackets.

The upcoming example shots bear this out. The low bracket, shot at –2.0 EV, still blew out the clouds at the top right. Thankfully, you can manipulate Raw exposures easily in an editor. The exposure for this bracket was lowered to reveal details, and then saved as a new low bracket, adding to the total number. The final sequence was six exposures at –3/–2/–1/0/+1/+2 EV rather than the five original shots.

- If you have a live histogram on your camera, you can use it to estimate whether you can capture the entire dynamic range in your sequence of brackets.

- If you're in a semi-automatic or programmed mode, the camera might set the exposure automatically.

With those caveats and alternate realities out the way, it's time to continue.

6. **Press and hold the shutter release button (or remote) to take the photos.**

Bada bing, bada boom. One set of brackets (as shown in Figure 5-13), coming up! Notice that the difference between each exposure is not tremendous. This is because they are separated by +/– 1.0 EV. These brackets cover the same range as three exposures at +/–2.0 EV.

Shooting multiple auto brackets

If you have AEB but don't have the greatest EV range (at and under +/–1.0, like the Sony Alpha 300), you shoot multiple AEB sets one right after another to extend your dynamic range. Here's how:

1. **Set up to perform a standard AEB set.**

You'll want to be in manual shooting mode or aperture priority for this.

2. **Meter the shot.**

3. **Set the underexposed AEB exposure region.**

This works just like shooting manual brackets, only you're shooting bracketed sets.

Figure 5-13: Five exposures shot using AEB separated by +/–1.0 EV.

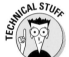

For example, if you're using a compact digital camera that has AEB but limits the range to +/–1.0, a normal bracketed set would include exposures at –1.0, 0.0, and +1.0 EV. Lower the initial exposure (through exposure compensation on a compact digital camera without manual mode, or directly with shutter speed on a camera with more control) to –2.0 EV. This set captures –3.0, –2.0 and –1.0 EV.

In this example, I'm using an EV difference between brackets of +/–0.7 (two-thirds) of an EV. The EV range has been lowered, as shown in Figure 5-14, to center on –1.3 EV. The lower bracket extends to –2.0, and the upper bracket is at –0.7 EV.

Figure 5-14: The first AEB set is well underexposed.

4. Shoot the first set.

Shoot each set as standard AEB. Press the shutter release button (or your remote) and hold it down to finish the set. Figure 5-15 shows the first three brackets, separated by +/–0.7 EV.

-2.0 EV -1.3 EV -0.7 EV

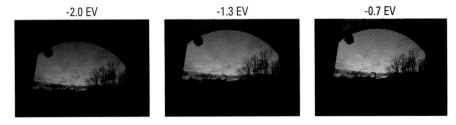

Figure 5-15: You see a smaller difference between exposures at +/–0.7 EV.

5. Set the middle AEB exposure region.

Raise the EV to 0.0. This is your center bracket with exposures at –0.7, 0.0, and +0.7 EV. The meter is shown in Figure 5-16. Notice that the lower bracket is a duplicate of the upper bracket of the first set.

Figure 5-16: This set acts like a center exposure.

6. Shoot the middle set.

The middle set of brackets, as shown in Figure 5-17, acts like a center exposure of a normal bracketed set. If the clouds or other objects are moving too fast and you get smearing in the final image, you can fall back to this set and process it separately.

-0.7 EV 0.0 EV +0.7 EV

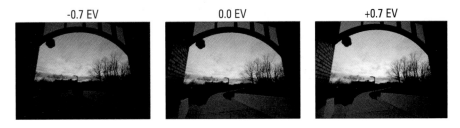

Figure 5-17: The middle set has two duplicate exposures.

7. Set the upper AEB region.

Raise the EV to +1.3. This captures brackets at +0.7, +1.3, and +2.0 EV, as seen on the meter in Figure 5-18. Notice that the lower bracket is another duplicate.

Figure 5-18: The upper and final AEB set.

8. Shoot the upper set.

The last set is shown in Figure 5-19.

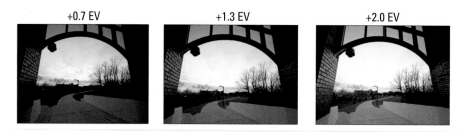

Figure 5-19: The upper set is collectively overexposed.

In the end, as seen in Figure 5-20, you'll have nine bracketed photos. If you have shot with the exposure ranges in this example, you have exposures at –2.0, –1.3, –0.7, 0.0, +0.7, +1.3, and +2.0. Two of these are duplicates. You can toss those out during software processing. The final bracketed set comprises seven exposures +/–0.7 EV with a total range of 4 EV. Not ideal, but compared to having too little dynamic range for some scenes, it's the way to go.

Figure 5-20: Throw away any duplicate exposures and keep the rest.

Using Alternate Metering Strategies

Using a preconceived bracketing strategy works well, but the downside is not knowing whether you're really capturing the full dynamic range of the scene with the brackets (if you pay attention to a live histogram, you're closer to knowing). A more studious approach relies on metering highs and lows in the scene with a light meter or your camera to come up with a more reliable estimate of how many brackets you should shoot.

These strategies are not as accessible if you use exposure compensation. Most cameras limit the total EV compensation exposure range from –2.0 to +2.0 EV. Therefore, it's important to have a camera with a manual shooting mode for these methods.

Working with a light meter

Using an external light meter takes a bit more time and preparation than setting up your camera and shooting normal brackets, not to mention the fact that you have to purchase a light meter with a spot mode. After the metering and figuring are done, however, you'll shoot the photos much like manual bracketing.

Follow these steps to use the alternate metering strategy with a light meter:

1. **Set up your light meter.**

 Keep the aperture constant by using aperture priority mode on your light meter. Set ISO and aperture to the same as your camera.

 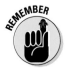

 These examples use ISO 100 and the aperture of f/8. Changing these settings won't materially affect how you shoot anything — as long as you're consistent within a bracketed set.

 Figure 5-21 shows my light meter (and my wife's hand). The white thing at the top — a Lumisphere — is used to measure incident (as opposed to reflected) light. Incident mode is used to get an average exposure and set the shutter speed for 0.0 EV.

 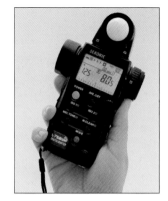

 Use spot mode to meter the lows and highs. For this meter, you must look through the eyepiece on the right and out the spot lens to the left, which you aim at the location you want to measure.

 Please refer to your light meter manual for the specifics on how to configure and use your light meter.

 Figure 5-21: An external light meter.

2. **Set up your camera for manual bracketing, as detailed in Chapter 4.**

3. **Compose the scene.**

4. **Meter a highlight with your external light meter.**

 Figure 5-22 illustrates putting the spot circle of the light meter on a bright spot in the scene while taking a measurement. In this case, the bright front end on the car works well. You can take a few different measurements of various areas of the scene (the sky, chrome, and so on) and choose the brightest one.

 Make a note of the shutter speed. This is where the high bracket is shot. In this case, it's 1/1000 second.

5. **Meter a shadow with the light meter.**

 Figure 5-23 shows the meter looking at a dark area of the scene. Make a note of the reading. In this case, the shutter speed is 1/4 second.

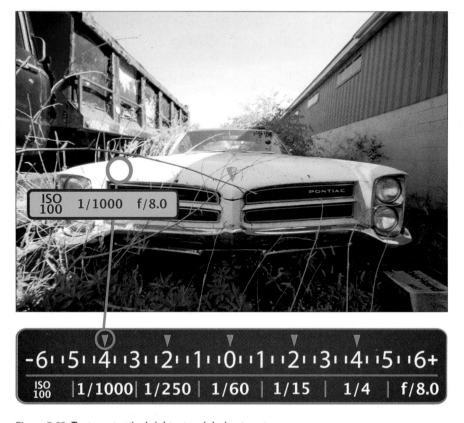

Figure 5-22: Try to meter the brightest and darkest spots.

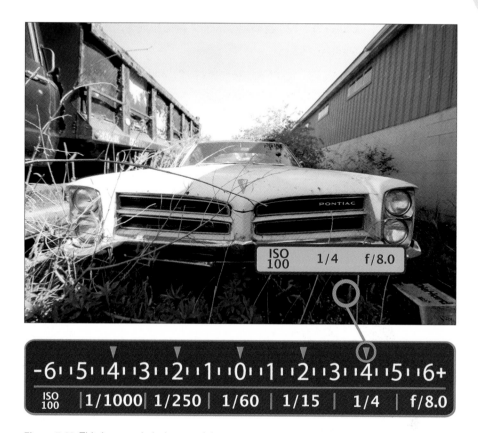

Figure 5-23: This is a good, dark area of the scene.

6. Take an average light reading.

Switch to Incident mode on your light meter and take an average reading of the scene. You can also use your camera for this, even when mounted on a tripod.

This measures the overall exposure and gives you the shutter speed necessary to set exposure to 0.0 EV value. Make a note of the shutter speed. In this case, the reading is 1/60 second for 0.0 EV.

7. Calculate the points at which you want to bracket.

You have now measured three data points and have three shutter speeds to show for it. You have the low and high points of the scene from Spot mode and the 0.0 EV point by using the Luminance mode (or your camera).

Using this information, decide on a bracketing strategy (refer to Figures 5-22 and 5-23). Notice that the low bracket is at –4.0 EV and the correct shutter speed is 1/1000 second. This is where you set the

camera for the first shot. Afterward, each bracket is incremented by +2.0 EV (shutter speeds are also shown) until the high point is also photographed.

In this case, it's nice — although not always the case — that the low and high points are at +/–4.0 EV, respectively, and that there is an even +/–2.0 EV difference that connects them.

In situations where the figures aren't as evenly spread, start at 0.0 EV and measure outward in both directions the number of EV you need to shoot to include the high and low values. It's okay to go past them — but you don't want to come up short.

What you do next depends on whether you're using AEB or manual mode.

AEB

If you're using AEB, set the center exposure (0.0 EV) on your camera and configure AEB settings (if possible) to include the number of shots and EV difference.

Make sure to account for the entire dynamic range of the scene. In other words, if you need a spread of 6.0 EV evenly centered on 0.0 EV (+/–3.0 EV), you can shoot six brackets at +/–1.0 EV to cover the scene. If the spread is 7.0 EV (+/–3.5 EV from 0), you can shoot nine brackets at +/–1.0 EV or five brackets at +/–2.0 EV. These examples cover the entire range. If your camera is limited by the number of brackets or the exposure distance between them, you can settle for the best it can do, or revert to manual mode.

If your AEB has the capability and you have set the number of brackets and EV range, complete bracketing as you would normally using AEB. You can stop here.

Manual mode

If you're using manual mode, complete the following steps:

1. **Set the shutter speed to the value indicated by your calculation for the low end of the dynamic range you wish to capture.**

 Although you can shoot them in any order you wish, I find it convenient to start at the underexposed end of the dynamic range and progress upward.

 Figure 5-24 illustrates the complete sequence, starting from low to high, including the shutter speeds.

Figure 5-24: Moving from low meter reading to high via brackets.

2. Shoot the bracketed photo.

3. Increment the shutter speed to space the bracket by the EV distance you desire: for example, 1.0 or 2.0 EV.

Generally, three ticks of shutter speed equals +/−1.0 EV. Change by six ticks if you want to bracket by +/−2.0 EV.

4. Shoot another bracketed photo.

5. Plug and chug.

Continue incrementing shutter speed and taking bracketed photos until you progress from the low end through the center exposure (0.0 EV) and complete at the top end.

You finish with a complete, bracketed set of photos, as shown in Figure 5-25. This result is a five-bracket set at +/−2.0 EV for a total range of 8 EV. Using this method, you know that you accounted for the entire dynamic range of the scene.

-4.0 EV -2.0 EV

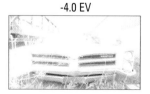

0.0 EV +2.0 EV -4.0 EV

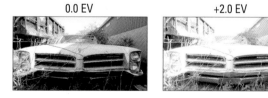

Figure 5-25: This set consists of five exposures at +/−2.0 EV.

Alternate metering with your camera

You can use your camera in place of an external light meter to perform the previous procedure, but it is decidedly more cumbersome.

The catch is to meter before mounting your camera on the tripod and composing the scene. After you do this, moving the camera at all (which is necessary to perform the spot metering) destroys the composition. If you're shooting hand-held brackets, you can meter and bracket more fluidly.

To use your camera to meter highs and lows in the scene, try these general steps and then bracket the scene as described earlier:

1. **Set up your camera for manual bracketing.**

2. **Perform a quick composition before you mount your camera on the tripod.**

3. **Switch your camera to spot metering mode.**

4. **Meter lows and highs.**

5. **Switch your camera to matrix or evaluative metering mode.**

6. **Take an average reading to set 0.0 EV.**

7. **Mount your camera on the tripod.**

8. **Dial in the final composition.**

9. **Determine EV range and shoot brackets.**

6

Shooting Single-Exposure HDR

*U*nfortunately, digital cameras aren't magic wands. Strike that. It's probably better that they aren't. Otherwise, you might be tempted to turn people into flower pots and yell things like, "*Expecto Patronum!*" or "*Expelliarmus!*" when you take your pictures.

Back to *our* story.

The technology simply doesn't exist to enable you to go out and shoot bracketed HDR in every possible circumstance. When the conditions conspire against you, single-exposure HDR is a viable way to wring as much dynamic range from a single Raw photo as possible, and then tone map it like traditional, bracketed HDR. But, you have to be ready and willing (and have a camera that supports the Raw photo format). If you're interested in HDR but don't want to go to the trouble of setting up a tripod and shooting brackets, single-exposure HDR is a great way to get into HDR, experiment with it, and learn how to use the software.

This chapter shows you what single-exposure HDR (also known as single-shot HDR, pseudo-HDR, or a tone mapped Raw exposure) is all about, how to do it, and why.

Knowing When to Break the Rules

Unless you plan on abandoning any pretense of shooting brackets, you need to know when and why to shoot single exposures for HDR. This assures that you choose the right tool for the job, given the gear you have and the circumstance you're in.

When to shoot single exposures for HDR basically boils down to movement:

- ✔ **You're moving.** If you're moving around, you can't always take bracketed photos. If you have a fast-enough camera and AEB, you *might* be able to get off three shots without blurring or alignment problems. For the most part, though, you won't be able to.

 This isn't the same as standing still and taking hand-held, bracketed HDR. You *can* get off good brackets in that case — if you have a high frame rate (3 frames per second [fps] is adequate but 5 fps is very nice to have) and use AEB.

 You might think the solution to this is to always use a tripod or monopod (easier to manage but not as stable). That might be true. Sometimes, however, that's impossible. This situation is illustrated in Figure 6-1, where I am taking a photo from inside a train ride at our local zoo. Although I'm reasonably stable (there's a joke in there somewhere) and I'm holding the camera steady, there is enough motion in this scene to make bracketing pointless. No camera can take bracketed photos of the scenery rushing past.

Figure 6-1: Riding the train to single-exposure HDR.

↙ **The subject is moving (or can't be still).** The other circumstance that will push you out of your bracket-shooting comfort zone is when your subject is moving: say, when you're photographing people or animals. You might be standing still and have your camera mounted on a sturdy tripod, but if the subject is moving, you won't be able to get off brackets without enormous alignment problems.

Figure 6-2: Galloping toward single-exposure HDR.

Figure 6-2 shows this situation in action. I'm standing just outside a paddock at a friend's farm when this beautiful horse galloped past, too fast to make brackets possible.

Terminology alert!

HDR has a lot of terminology competing to use the same four words (exposure, bracket, Raw, and Rumpelstiltskin). It can be very confusing. For the purpose of this chapter, I distinguish between two types of single-exposure HDR, both created from one original Raw exposure (the photo). I use the terms *single-exposure (Raw)* and *single-exposure (brackets)*.

When you see *single-exposure (Raw)*, that indicates that the Raw photo from the camera is opened directly in the HDR application (such as Photomatix Pro) and tone mapped. No intervening steps are necessary. You don't convert the Raw photo to TIFFs (bracketed or single), nor do you technically generate an HDR file. Photomatix Pro automatically generates a pseudo-HDR file for you to tone map when you

drop the Raw exposure into the interface or open it from the menu. As such, there are no options when you generate the pseudo-HDR file like when you use normal brackets.

Single-exposure (brackets) refers to the process where you take the original Raw photo from the camera and use your Raw editor to create brackets. I sometimes call them *software brackets* or *pseudo-brackets* to differentiate them from bracketed exposures captured at the scene. After you convert the Raw file into software-bracketed TIFFs or JPEGs, the process continues as if they were standard brackets. The HDR application won't know the difference, but you might need to clarify the EV range between each image.

You might *want* to shoot single exposures for HDR, though, in these circumstances:

- ✔ **Casual shooting:** Maybe you're out for a walk with your camera, exploring your neighborhood. You didn't take your tripod with you, and you don't have a camera with AEB and a fast frame rate (which makes hand-held HDR effectively impossible). Solution? Take photos in Raw and process them as single-exposure HDR.

Figure 6-3: Shooting for HDR on the fly.

I took the photo in Figure 6-3 as I walked around our local Johnny Appleseed Festival. I saw the photogenic gentleman in question and asked to take his picture. This is a perfect situation for casual photography and single-exposure HDR.

- ✔ **Bracketing problems:** Say you did set your camera to photograph brackets and successfully completed the shoot, only to find out in software that you have problems, such as ghosting or something movement related, as shown in Figure 6-4. This close crop of a car moving away from the camera while I shot the brackets created ghosting, so the car appears in each bracket in a different position.

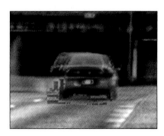

Figure 6-4: Use single-exposure HDR techniques to correct ghosting problems.

You can ignore these problems if you want (although not always recommended — see Chapter 15) and press ahead, or use single-exposure HDR to process one bracket to use as an overlay and freeze the situation. I cover this more fully in Chapter 10.

Satisfying the Minimum Requirements

The requirements for single-exposure HDR are somewhat different than bracketed HDR. The least you need to have, in addition to other helpful suggestions, comprises

- ✔ **File format:** You must shoot in Raw. It's that simple. JPEGs need not apply.

- ✔ **Gear:**

 - • *Camera:* The camera must support Raw, of course. Any camera will do, but you'll be most satisfied with a dSLR. Premium compacts and super-zooms that support the Raw file format will work but have much more noise, especially at higher ISOs. Not many (if any) budget compact cameras support Raw.

 - • *Tripod:* You don't need a tripod for single-exposure HDR unless you're a real stickler for stability and the conditions allow it. (You can try a monopod if you want to steady your camera without the hassle of a tripod. You'll look like a sideline photographer at the Super Bowl.)

- ✔ **Software:** Single-exposure HDR uses the same complement of software that bracketed HDR uses. Depending on the workflow you choose (Raw or brackets), you might need a Raw editor.

Work-flow, Flow, Flow Your Boat

By and large, single-exposure HDR follows the same workflow as bracketed HDR:

1. Configure your camera as described in Chapter 4, paying special attention to the material that prepares you to shoot single-shot HDR.

 The thing you're after is the single best shot you can get. Pay attention to the lighting conditions, subject, movement, and any artistic effect (depth of field, motion blur, and so on) you're after.

 If you're shooting in manual exposure mode, review the information on exposure in Chapter 4, paying special attention to exposure control side effects. If you use auto, a priority mode, or programmed auto mode, you have fewer decisions to make.

2. Compose the scene.

 For single-exposure HDR, this step can take anywhere from 1/4000 second to several minutes, depending on the scene and situation. With most casual shots, you simply point and shoot — you have very little time to compose the shot. For arranged shots, you can often position your subject or take your time and analyze different angles. This is where your composition skills shine.

3. Take the photos.

Even if you can't bracket, you can still set your camera to shoot individual exposures at high speeds (continuous high-speed shooting). In fact, I recommend taking several bursts of shots, if possible, so you'll have a range of single exposures to choose from.

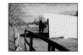 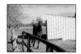 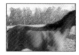

4. Choose your single-exposure method in software.

Choose from two approaches when using single Raw exposures for HDR:

- *Single-exposure (Raw):* Throw the Raw photo into your HDR application and create pseudo-HDR from a single source image. As bizarre as it sounds, using a single image can work — and it produces excellent results much of the time. It's not truly HDR, but it has something to do with HDR.

Figure 6-5 shows a flowering tree in HDR. The Raw exposure was dropped into Photomatix and processed directly as pseudo-HDR. The colors are simply maahvelous.

Raw

HDR

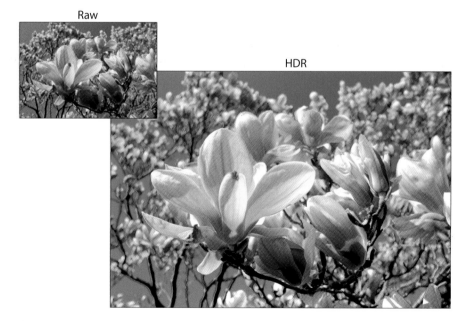

Figure 6-5: HDR processed directly from the Raw file.

- *Single-exposure (brackets):* Process the single Raw exposure into brackets by opening it up in a Raw editor and saving versions of the file with different exposures. Three brackets at –2/0/+2 EV is generally accepted as the best method. You might wish to experiment with five brackets at –2/– 1/0/+1/2 EV or other combinations.

You're still working with a single Raw image, no matter how many brackets you create. You can't increase the dynamic range of squat with single-exposure HDR. What you're doing is trying to squeeze all the dynamic range you can from the single image. For more information on this process, please hop over to Chapter 7 and then come back.

When finished, you'll have two or more bracketed images that you can treat the same as any other bracketed set. Load them into your HDR application to generate the HDR image. Figure 6-6 shows the collection of images surrounding this method. Start with an original Raw photo, which you then transform into brackets (three, in this case). The brackets form the source for the HDR image, which is tone mapped and finalized.

5. Generate HDR.

 If you're using a single Raw exposure, you can drop it on Photomatix Pro, which will automatically generate the pseudo-HDR image and start the tone mapping process. (Photomatix Pro is the only HDR application at this time that features pseudo-HDR from a single Raw exposure.)

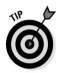

 If you're working with manually generated brackets, generate the HDR image as you would normally. You don't need to align the images or worry about ghosting, so you can turn off those options (if available). You might need to identify the relative EV difference between the images. Please see Chapter 7 for a detailed walkthrough.

6. Tone map the single Raw exposure or brackets.

 For detailed information on tone mapping, see Chapters 8 and 9. Single-exposure HDR tone mapping advice is given in the following sections.

 As with HDR in general, it's hard to predict whether an image will look good, or how much you can push the settings to accentuate details and drama.

Figure 6-6: Raw photo into three brackets into a tone mapped HDR image.

Figure 6-7 shows a photo of my son Jacob being tone mapped in Photomatix Pro. The settings produce a fairly realistic look.

7. Edit and publish the tone mapped image.

As with multi-exposure HDR, finish your project by editing it in your favorite image editor. Single-exposure HDR tends to be noisier, but on the other hand, you don't have to worry about ghosting or movement. You might need to perform tasks such as noise reduction, sharpening, adjusting brightness and contrast, color, cropping, and publishing. For more information on this step, see Chapters 10 and 11.

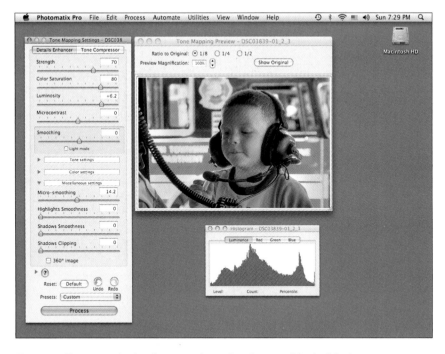

Figure 6-7: Tone mapping is where you determine the overall look of the image.

Tone Mapping Single Exposures

More complete coverage on tone mapping is presented later in the book (Chapters 8 and 9). However, to make this a more practical chapter, I decided to jump the gun a bit and show a few examples of tone mapping single exposures.

Technically, tone mapping single exposures (whether Raw or a Raw converted to brackets) is identical to tone mapping bracketed exposures. The difference is that you probably shot different subjects and scenes. For example, bracketed HDR excels at shooting landscapes, cityscapes, objects, and interiors. These are the more traditional HDR scenes. Single-exposure HDR tends to involve shots of people, animals, action and other dynamic scenes, and casual shots.

Shooting single-exposure HDR on the go

This example is another reason single-exposure HDR is so much fun and accessible. My wife took this shot (Figure 6-8) of our oldest son, Ben. I'm the family HDR expert who carries around bags of gear and a tripod. She likes

taking our smaller, lighter dSLR (a Sony Alpha 300) with the kit lens, and shooting on the go. I have her use RAW+JPEG so that I have access to the Raw exposures for HDR. It's perfect.

In this case, the single Raw exposure was converted to three 16-bit TIFFs to start. In Photomatix Pro, the default tone mapping settings (using the Details Enhancer tab) were too "vanilla." However, the settings I use as a starting point for multi-exposure HDR (my baseline) were too harsh.

At times (especially when tone mapping people), expect to reduce the Strength setting and increase the Micro-Smoothing setting. This keeps faces from being too detailed and riddled with dark lines. (Although there are cases where this is what you want, that's not what I wanted my 7-year-old to look like!) The result is a nice balance between color, clarity, and detail in his face.

Before	After
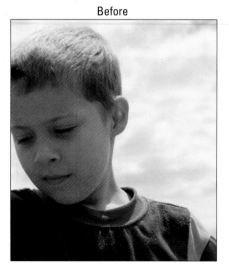	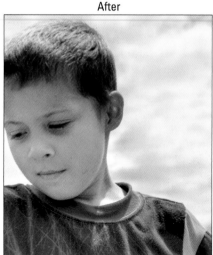

Figure 6-8: A portrait, realistically tone mapped.

The clouds, however, were another story. They were too dark and ruined the effect. This is where you have to let yourself go a little bit and realize your boss isn't standing over your shoulder checking your work. I love HDR, but when I run into its limits, I don't lose any sleep over using what looks best (and accomplishing that in an image editor after tone mapping is completed). Unless you're entering a contest with strict rules or are otherwise in a situation where your methods are restricted, give yourself that freedom, too.

I took the tone mapped image of Ben and used the un-HDR-ified Raw image for the clouds. Then I blended them in Photoshop Elements to capture the best of both worlds. For more information on this kind of blending, see Chapter 10.

Increasing contrast and details

Figure 6-9 illustrates an action shot that is impossible to bracket. This Monster Truck Rally is one of those "not quite ready for prime time" photos that somehow is still compelling. Nothing is really sharp, but the movement and colors faithfully impart the impact of the scene. The rider just coming around the near pylon is the least blurred, which draws your attention to him.

Those factors make realism less important in this scene as it otherwise might be. My main goal was to bring out the small details in the scene — contrast in the grass, the riders, and the quads. I took the single Raw exposure and converted it into three software brackets. Then in Photomatix Pro, I set the Strength to 100 and reduced the Smoothing setting to High. This accentuates contrast and local details. I increased the Luminosity setting to +5.0 to bring even more details out of the shadows. The final look was attained by a moderate amount of noise reduction and saturation in Photoshop afterward.

Reducing noise

Figure 6-10 shows the controls of a fire engine. (I'm still using the pictures I took on that casual trip out with the family!)

The reason I go on about what I was doing when I captured photos is to give you ideas of where you can go to get interesting shots. You'll exhaust the flowers in your backyard in about 15 minutes. After that, you need to venture out farther to find interesting subjects.

Before

After

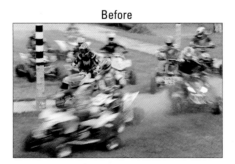 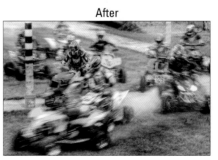

Figure 6-9: Single-shot action tone mapped and edited dramatically.

The tone mapping settings for Figure 6-10 aren't all that remarkable. Strength is 100, and Color Saturation is at 80. Luminosity is 4.0, and Micro-smoothing is at 6.2. No extreme smoothing or other tricks were used. The point of this example is to show you a representative sample of the noise levels you can see coming from a single Raw exposure tone mapped in Photomatix. As you can see, noise is definitely visible in this image. It appears more strongly in darker areas, but is especially visible in even-toned areas of any brightness — clouds, blue sky, glass, and other smooth materials. You catch a break if your subject has a lot of texture. This hides noise. (Other than a slight levels adjustment to warm up this image and cropping, this photo is unretouched, so you can see the noise for what it is.)

Using a single Raw photo without converting to brackets

Figure 6-11 shows a close shot of a hawk at the zoo. It is a beautiful bird, and I was standing no more than 5 feet from it when I took the photo. This example illustrates using a single Raw photo without converting it to brackets in a Raw editor. The Raw photo was simply dropped in Photomatix Pro and tone mapped. I compared the differences, and the bird looked better using the Raw photo. That is always the criteria I use — what looks better.

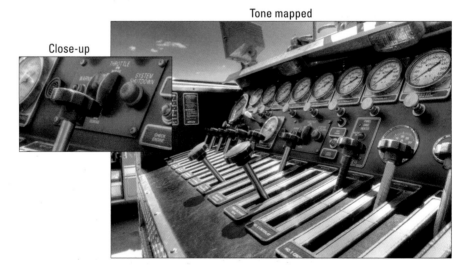

Tone mapped

Close-up

Figure 6-10: Single-exposure HDR can be noisier than bracketed HDR.

In this case, a realistic shot seemed the most appropriate. To achieve this effect, Strength was kept very low (40 out of 100) and Micro-smoothing was increased to 19.3. This kept the image looking realistic. Luminosity and Microcontrast were both maximized (+10.0), which lightened the shadows and increased local area contrast respectively. This basically balanced the light in the photo. Normally, when you increase Luminosity and Microcontrast, you get a more dramatic look. Lowering Strength was the key to keeping that from happening.

Before

After

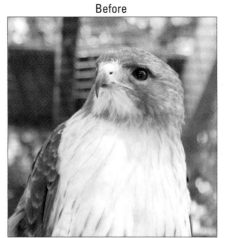 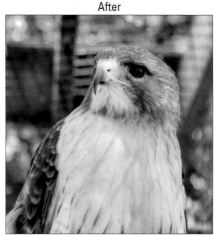

Figure 6-11: Animals make great single-exposure HDR subjects.

Comparing Results

Quite frankly, the dodgiest aspect of HDR photography is the lack of consistency regarding what method (of the many) to use to achieve the best appearance in the final image. I can tell you what methods are *technically* the best — those which preserve the greatest dynamic range in a scene and make the least number of compromises along the way. However, following the best technical methodology does not always translate into the best looking image, which is what HDR and photography are about.

This section features a Mini Cooper. Three processing options are shown: a developed Raw photo, tone mapping as a single-exposure (Raw), and tone mapping as a single-exposure (brackets). The latter two use the same settings in Photomatix Pro. None of the images have been spruced up in Photoshop.

Let the faceoff begin:

✔ **A developed Raw photo:** Figure 6-12 is the control image, processed as a single Raw photo and exported as a TIFF. This is basically what you get out of the camera in the form of a JPEG. The shot is rather bland, and the lightness of the sky predominates. On the positive side, the details look pretty good and there is not much noise. All in all, not a very good look here. The photo needs work.

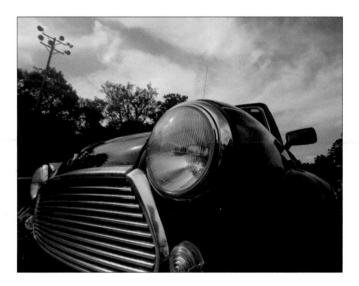

Figure 6-12: A standard Raw photo.

✔ **Single-exposure (Raw):** Figure 6-13 shows the results of the Raw exposure bring dropped directly into Photomatix Pro and tone mapped. I purposefully went for some drama because I thought the clouds and car looked much better this way. Compared with the Raw photo, this has better light balance between the subject (the Mini) and the background (the sky). In fact, they reversed: The car is now lighter, and the sky as a whole is darker. The metallic paint of the car stands out much better, too.

Despite what some might say about single-exposure (Raw) photos, this is an acceptable image. In fact, more than that — it looks really good, as long as you don't mind it not being a photocopy of the original.

✔ **Single-exposure (brackets):** Figure 6-14 shows the result of tone mapping a Raw exposure converted to three brackets (–2/0/+2 EV). (For more information on converting a Raw exposure into brackets, see Chapter 7.) Like the single-exposure (Raw) image, it was tone mapped in Photomatix Pro with identical settings. This version might have a little less contrast, but the car is improved. It looks green now, which is its true color.

Overall, this looks to be the best version of this image. It has better color, good dynamics, light balance, texture, and details. This doesn't always translate to every picture under the sun, but there is nothing inherently wrong with this method — it produces good results.

Figure 6-13: Tone mapped single-exposure (Raw).

Figure 6-14: Tone mapped single-exposure (brackets).

You can see that the difference between single-exposure (Raw) and single-exposure (brackets) are often a matter of taste. I happen to like the latter method on this image, but there are times when I prefer the former. The purpose of this comparison is to disprove the point that either of these methods is pointless. They're not. They clearly add value to the original image.

The moral of this story is this: Do not discount single-exposure HDR from the outset as being technologically inferior. It can and does produce images close in quality to those created from multiple bracketed sets. It may not do so in every instance, but that's when you get to use your skills and judgment as a photographer and artist to decide. Use all the tools at your disposal to create the images that match your style the best.

Part III
The Soft(er)ware Side of HDR

In this part . . .

*H*DR is as much about software as it is about taking photos, so this part immerses you in the software process of generating and tone mapping an HDR image, and then editing and publishing your final image.

Chapter 7 starts the ball rolling by showing you how to turn your bracketed (or single exposure) photos into HDR images. This interim step is necessary and important, so don't skip this chapter. Chapter 8 provides a ton of tone mapping reference material so you understand what you're doing when you tone map in Chapter 9, which is the other "most important chapter" in the book. I walk you through how to tone map your HDR images in Photomatix Pro. Aside from taking the photos, this is the heart of HDR.

Chapter 10 is another process and workflow chapter. You discover how layers can help you edit your images and how to manage them. You also get a large dose of an editing workflow, followed by helpful blending techniques. Chapter 11 finishes this part by showing you different ways to fix problems in your images (ranging from too much noise, distractions, and distortion) and enhance the good parts (such as contrast, color, and highlights). I finish with a section on publishing your final images.

Generating HDR

In This Chapter

▶ Understanding HDR images and files

▶ Converting Raw photo brackets for HDR

▶ Converting single Raw photos to brackets

▶ Generating HDR from your source images

*Y*ou might think the whole point of HDR photography is to produce an HDR image or file, right? Wrong. The point of HDR photography, outside of the laboratory and other technical venues, is to create a *usable* (for the rest of us) low dynamic range image that you can view and print with technology that is generally available today. To get that image, most likely a JPEG or TIFF, you need HDR images and sometimes files. (I explain the difference between images and files in this chapter.) Time for a little "howdy-do."

An HDR image's claim to fame is that it's nothing like a normal photo or image file. Rather, it's a specialized, high dynamic range image created by analyzing and merging pixel data from a bunch of differently exposed photographs. It works a little like Goldilocks and the Three Bears. This one's too hot. This one's too cold. This one's juuust right.

Unless you're applying for a job at Industrial Light and Magic, you don't need to know all the intricacies and inner workings of HDR images and file types, the complex algorithms that decide which pixel is better than another, or what data types programmers use to create HDR images and files. What you need to master — which just happens to be the subject of this chapter — are the tools and techniques to create HDR images and files for further use.

The Unbearable Lightness of HDR

Sometimes HDR terminology can be confusing. Everything is HDR *this* and HDR *that*. Create, generate, save, shoot, publish, manipulate HDR.

Does this refer to photos, an open file, a saved file, the final product, or something else?

Thankfully, it's much simpler than that. Two components of HDR photography are at the heart of the matter: HDR images and HDR files. These are the things in HDR photography that put the H and the D in the R. Other activities help create, manage, or transform them.

HDelightfullyR images and files

HDR images and files have the following general properties:

- ✏ **HDR image:** An HDR *image* is a high-bit–depth image (normally 32 bits per channel) that contains color and brightness information across a very wide dynamic range. When you generate HDR or load a saved HDR file in an application, something like Figure 7-1 shows up onscreen. This is an HDR image comprising bracketed photos. It doesn't look very good in this format, though, because the clouds are blown out and parts of the greenery are too dark. The data is in the file, but the image has more dynamic range than the system on which it's being displayed can handle.

 An HDR image is an ephemeral thing: It exists to be transformed. You can edit HDR images in most HDR software before you get to *tone mapping* (mapping data with a large dynamic range into a smaller dynamic range). Tone mapping is discussed in depth in Chapters 8 and 9. You may be able to reduce the level of noise in the HDR image, rotate it, examine properties (such as bit depth), look at the histogram, or crop it.

Figure 7-1: An HDR image onscreen before tone mapping.

✔ **HDR file:** An HDR *file* is an HDR image encoded and saved by HDR soft-ware to retain the high dynamic range nature of the originally generated data. HDR files use an internal scheme defined by the unique HDR file format you choose, which is the subject of the next section.

Oddly enough, there is very little you can do with HDR images and files besides view them with specialized software or turn them into something else. The "something else," for HDR photographers, is a low dynamic range TIFF or JPEG that displays properly on monitors, plays well with Web brows-ers and iPhones, and can be printed.

An HDR file is simply a stepping stone. It rests between the photographs you take with your camera and the final file you proudly show everyone. You won't print it out, post it online, or even look at it very much on your monitor.

Choosing an HDR file format

When you create an HDR image, you'll often be given the chance to save it as an HDR file for later use. Whether you save it as an HDR file depends partly on preference and partly on what you plan on doing. Normally, you'll jump right into tone mapping, save the final low dynamic range result, and never miss not having an HDR file stored on your hard drive. In cases where you might be testing a number of different settings on a single HDR image, how-ever, saving an HDR file the first time through will save you time in the long run because you won't have to continually re-create it. You can load the HDR file and work with new settings in a snap. Another scenario where using an HDR file saves you time and trouble is if you want to share it with someone and don't want the hassle of tracking multiple photo files. Generate the HDR, and then make that available for others to tone map.

If you decide to save an HDR file, you must choose a format from several competing HDR file formats. Three, however, are very widespread and deserve special attention — these are summarized in Table 7-1.

Table 7-1		Popular HDR File Formats	
Format	*Extension*	*Bits per Pixel*	*Why to Use*
Radiance RGBE	.hdr	32	Superlative dynamic range; sacrifices some color precision but results in smaller file size
OpenEXR	.exr	48	High color precision at the expense of some dynamic range; can be compressed
Floating point TIFF/PSD	.tiff .psd	96	Very accurate with large dynamic range but results in huge file sizes and wasted internal data space

In case you're wondering, I generally use the Radiance format when I need to save an HDR file because it preserves the greatest dynamic range without excessive file bloating — and it's the first file type in the Save as Type drop-down list in Photmatix Pro. (For more information about Radiance RGBE and OpenEXR formats, see `www.radiance-online.org` and `www.openexr.com`, respectively.)

Thankfully, HDR photography comes down to the photos. This isn't a contest to see who can create the HDR file with the greatest dynamic range or a strict comparison of bits and precision. It's about taking and presenting beautiful pictures.

Converting Raw Photos

One of the great things about HDR photography is that you can tailor your workflow to the amount of effort and picture quality that are important to you. You don't have to shoot Raw photos if you don't want to or your camera can't. If you shoot in Raw, you don't have to convert those photos to another format (TIFF or JPEG) before you generate the HDR image. If you wish to, however, you can convert your Raw photos and save them in one of a few different formats.

Different approaches yield different results, of course. Consider these issues when deciding whether to convert Raw photos:

✔ **Quality:** In general, you achieve the best quality by shooting Raw photos and converting them to 16-bit TIFFs for use in HDR. Trailing this "Qualitus Maximus" option is converting the Raw photos to 8-bit TIFFs, then using camera JPEGs, followed by using the unconverted Raw files themselves (the HDR software converts them automatically, leaving you no control). Choose the quality you need and can afford, bearing in mind that different software choices can produce different results.

Figure 7-2 illustrates two small sections of a tone mapped HDR image created from different source image types. The original five bracketed Raw photos are Nikon NEF files and have been processed through Nikon Capture NX 2 to create the 8- and 16-bit TIFFs. The JPEGs were generated in-camera. Photomatix Pro was used to generate the HDR and tone map the result.

JPEG — and sometimes Raw appearance — can be dramatically affected by the processing options you choose in the camera.

Comparing two areas reveals different effects of the format in use:

• *Clouds and sky:* The TIFFs are relatively equal in quality, with details and textures well preserved. You can see the nuances of the cloud and sky in both TIFFs. The JPEG and Raw have lost detail and take on a color cast by comparison.

- *Words and sign:* All four source image types show fairly good quality for this man-made object. The JPEG is surprisingly good although the colors are close to being oversaturated. Notice that the image generated from the Raw photos is the softest.

✔ **Workflow:** If you're shooting a tremendous number of photos for HDR, or perhaps you're shooting a large number of photos in general and need to fit HDR into an existing workflow, using different processes for different images can be an issue. For example, if you use Apple Aperture and that's where you spend all your conversion and editing time, using something else can throw a wrench into things. Choose the workflow that makes you want to create HDR, not throw it out the window.

✔ **Cost:** Cameras, gear, and most software cost money (see Chapters 2 and 3). If your supply of cash is limited, start where you can (the inexpensive and free stuff) and move up to more expensive options when you can. Don't sweat it.

✔ **Single Raw exposures:** The same principles apply to converting single Raw exposures.

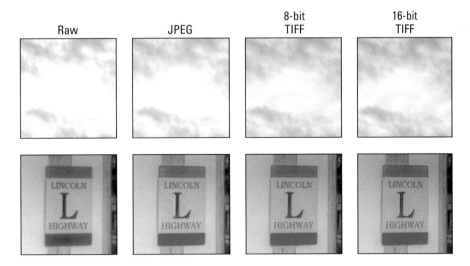

Figure 7-2: Comparing different conversions.

Principle principles

Converting Raw photos for HDR requires a different mindset than traditional digital photo processing, which aims to create the best looking photo possible. Here are a few differences:

- ✔ **Don't mess with exposure.** The point of bracketed photos is to have different exposures, so it's best to leave this alone unless you're converting a single Raw photo to exposure brackets.

- ✔ **Don't rescue detail from highlights or shadows.** HDR takes care of this in tone mapping.

- ✔ **Avoid dynamic range adjustments.** Some Raw editors have dynamic range adjustments that play with shadow and highlight detail, bringing them together. This defeats the purpose of HDR.

- ✔ **Be careful about making color and tone changes.** If you must make color and tone changes (for practical or artistic reasons), be consistent unless you're experimenting with color variations between brackets.

- ✔ **Fix white balance if necessary.** You can delay fixing the white balance, but if you prefer, fix it now. White balance corrections compensate for different lighting that can impart a colored tint to your photos or turn what should be white to a shade of gray.

- ✔ **Don't over-sharpen.** Sharpening bracketed photos is often an important part of getting a good, sharp result in HDR. Don't overdo it, though, or artifacts will be magnified in HDR.

Be careful of making changes that make tone mapping harder and increase the level of noise or artifacts in your images. Trust the HDR part of the process to do what it's supposed to do (enhance details, contrast, and control exposure) while using the Raw editor's strengths to convert Raw photos.

Converting bracketed photos

If you decide to convert bracketed Raw photos to TIFFs or JPEGs before generating the HDR image, follow these steps:

1. **Open the bracketed source images in your Raw editor.**

2. **Make the necessary changes to the conversion settings.**

 Keep a light hand on the controls, as shown in Figure 7-3, which shows several brackets of an old, abandoned dump truck. You're not after the *Mona Lisa* in this step. Remember the principle principles (see the preceding section).

 Develop presets based on your favorite conversion settings to speed things up. You might have a preset that performs a straight conversion, another with more noise reduction, and another that sharpens the image a bit. Choose the appropriate preset and apply.

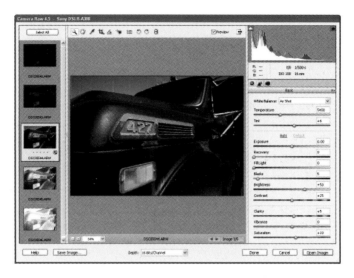

Figure 7-3: Converting several Raw brackets with Adobe Camera Raw.

3. Save the result.

Saving converted Raw files as 16-bit TIFFs results in the highest quality but the largest file size. 8-bit TIFFs are the next best choice, with JPEG bringing up the rear.

4. Repeat Steps 2 and 3 on the rest of the bracketed photos.

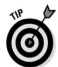

Many Raw converters allow batch processing. Figure 7-4 shows the Batch Process dialog box from Nikon Capture NX 2. Set up a conversion preset, name it something logical, and then run the batch routine on the bracketed Raw photos. Make sure to save the results as 8- or 16-bit TIFFs or JPEGs. This is a great time-saver when you dump 300 pictures from a photo shoot onto your computer!

Figure 7-4: Cooking a batch of Raw cookies in Capture NX 2.

Creating brackets from one Raw exposure

You can create brackets from a single Raw exposure by altering the exposure value (EV) in your Raw editor and saving the results. Here's how to perform the procedure in Adobe Camera Raw:

1. **Open the single Raw source image in Photoshop Elements or Photoshop to launch Adobe Camera Raw.**

 Adobe Camera Raw can't be launched as a separate process. It automatically opens when you open or drop a Raw photo in Photoshop.

2. **Make any necessary changes to the image.**

 You might want to carefully sharpen and tweak color temperature or white balance. The restrictions here are less stringent than editing separate brackets because this image serves as the master bracket.

3. **Lower the exposure by –2.0 EV by adjusting the Exposure slider or entering –2.0 in the Exposure text box.**

 The Exposure slider is on the Basic tab, as shown in Figure 7-5, whose icon is a small, six-blade diaphragm (creating a lens aperture). Select the tab if you can't see the Exposure slider.

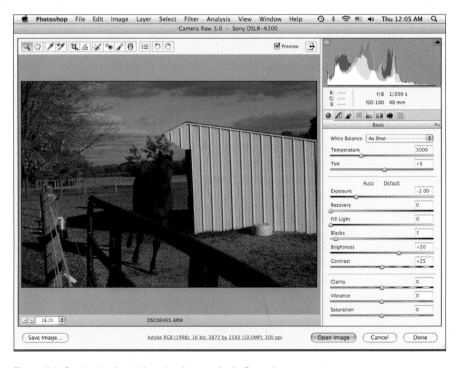

Figure 7-5: Saving the lower bracket from a single Raw photo.

This gives you the underexposed image, as seen in the top image in Figure 7-6. Notice the effect lowering the exposure has on the highlights. In this case, the sky and white shed have gone from close to being washed out to nicely exposed. You can experiment with lowering the EV by smaller increments and creating more files if you like, but you should have a total range of at least +/–4.0 EV across your brackets.

4. **Save the lower bracket as a new file.**

It helps to use a file naming convention. For example, I prefer to keep the original filename and append information at the end, such as the bracket number (DSC_1303-01.tif, DSC_1303-02.tif, DSC_1303-03.tif), add the Raw application I used (DSC_1303-acr-01.tif), or specify a preset (DSC_1303-noisereduction-01.tif).

For the highest quality, choose 16-bit TIFF. If space is a concern, choose 8-bit TIFF. You can choose JPEG if you like, but your HDR image may suffer from noise problems as a result.

5. **Raise the exposure back to 0.0 EV by adjusting the Exposure slider or entering** 0.0 **in the Exposure text box.**

This is your center, perfectly exposed bracket. (See the middle image in Figure 7-6.)

6. **Save the middle bracket.**

Choose the same format as the previous bracket. Remember to name this bracket something different than the first bracket. I simply increment my own bracket number, as described in Step 4.

7. **Raise the exposure to +2.0 EV by adjusting the Exposure slider or entering** +2.0 **in the Exposure text box.**

Third time's the charm. This is the overexposed bracket. (See the bottom image in Figure 7-6.) Notice that the other

-2.0 EV

0.0 EV

+2.0 EV

Figure 7-6: One Raw photo converted to three brackets.

settings are the same. That's pretty important.

8. Save the upper bracket.

Choose the same format as the previous brackets. Name appropriately, using the convention you've decided upon (see Step 4 for helpful guidance).

Figure 7-7 illustrates the finalized HDR image that was created from the three bracketed images in Figure 7-6.

Figure 7-7: The finalized HDR photo.

Creating HDR

As I discuss earlier in this chapter, an HDR image is different than the tone mapped image. HDR images are generated first, and then tone mapped to transform them into a relatively finished product. HDR images are created from source photos, and tone mapping works on the HDR image.

The following sections explain how to create HDR images in the leading HDR applications: Photomatix Pro and Photoshop. Remember that you can use bracketed JPEGs, TIFFs, or Raw exposures as your source images for HDR. If you're using a single file, it has to be a Raw photo or 16-bit TIFF.

If you like how one application creates HDR images but can't stand how it tone maps them, create the HDR image in it, save it as an HDR file, and then open it in a different HDR application (the one you prefer to tone map in). You are free to be as creative as you want!

Photomatix Pro

Photomatix Pro has a powerful yet straightforward process for generating HDR:

1. Launch Photomatix.

You can also invoke Photomatix Pro from within Lightroom or Aperture if you have the export plug-ins installed.

2. **Select Generate HDR image from the Workflow Shortcuts dialog box.**

 Alternatively, choose Process⇨ Generate HDR. The Generate HDR — Selecting Source Images dialog box opens for you to select bracketed images with.

3. **Select the bracketed source images.**

 Click the Browse button to browse to the folder on your system that contains the bracketed sources images you want

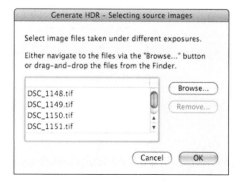

Figure 7-8: Adding bracketed images to Photomatix Pro.

to use for HDR. Select them one at a time or together, and click Open to add them to the Generate HDR dialog box (as shown in Figure 7-8).

4. **Click OK to continue.**

 If Photomatix can decode the exposure information without your help, it displays the Generate HDR – Options dialog box, as described in the next step.

 If there isn't *EXIF information* (data in the photo file that contains helpful information like the time it was taken, the exposure settings, and so on) in the files, or perhaps you saved brackets from the same original Raw exposure, Photomatix might ask you to correct the EV spacing, as shown in Figure 7-9. Notice that you can select a range from the drop-down list or enter values yourself. Click OK to finish correcting exposure information.

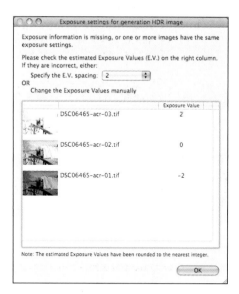

Figure 7-9: Correcting exposures.

5. Choose the HDR options you wish from the Generate HDR – Options dialog box.

The Generate HDR — Options dialog box is shown in Figure 7-10. This has a lot of options, but you'll be clicking through them in no time.

Select from the following options that appear in the dialog box:

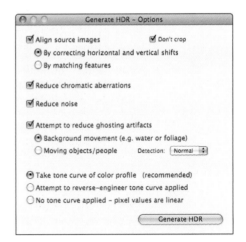

Figure 7-10: Selecting options for generating the HDR.

- *Align Source Images:* Select this check box if you're concerned with slight movement of the camera. Choose a method that fits the type of problem you may be having. The By Correcting Horizontal and Vertical Shifts option is best used for small adjustments, and the By Matching Features option works better for larger alignment problems, such as hand-held bracketing. Select the Don't Crop check box to keep the images at their original size, regardless of shifting caused by alignment. You might see rows of irregularly exposed pixels on the border of your image if you deselect Don't Crop. Cropping automatically removes them.

- *Reduce Chromatic Aberrations:* Select this check box to reduce red/cyan/blue/yellow fringing. This can be a problem when edge contrast and saturation is high, especially when shooting toward brighter lighting, like the sun.

- *Reduce Noise:* Select this check box to reduce noise in the combined HDR image. Reducing noise at this stage can give you more headroom when you tone map. Alternatively, if you have a good noise-reduction routine in your graphics application, you might wish to tackle it later.

You can leave the Reduce Chromatic Aberrations and Reduce Noise check boxes deselected and apply them after the HDR image is generated. This helps reduce needless processing until you determine whether the options are needed after reviewing the HDR image.

- *Attempt to Reduce Ghosting Artifacts:* Select this check box, and then select either the Background Movement or Moving Objects/

People radio button. You may also choose a level for the detection algorithm from the Detection drop-down list to make sure you're getting all movement erased.

- *Take Tone Curve of Color Profile:* This radio button is available only if you're using images that have a tone curve, such as JPEGs or TIFFs. It isn't active when you use Raw images (which are linear and have no tone curve). If this option is available, select it to use the tone curve of the color profile attached to the source images. Alternatively, select the Attempt to Reverse-Engineer Tone Curve Applied radio button.

The following options are only visible if you are using Raw photos to generate the HDR image (see Figure 7-11 to see how the dialog box changes):

- *Select an option from the White Balance drop-down list if needed.* As Shot is the default and should be adequate. The list reveals common camera options such as Daylight, Cloudy, and Tungsten. If there were white balance problems in the original photos, you can attempt to correct that here or wait and correct it during tone mapping or even later. You may also choose to return in the process and convert the Raw files to 16-bit TIFFs and attempt to correct the problem in your Raw editor.

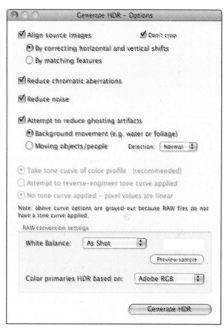

Figure 7-11: The Raw options in the Generate HDR – Options dialog box.

- *Select a color profile from the Color Primaries HDR Based On drop-down list.* You can choose sRGB, Adobe RGB, or ProPhoto RGB. sRGB is much more widely used, although it is the smallest color space and therefore not as true a representation of the actual colors than the other spaces. Adobe RGB has a wider range of colors than sRGB and is a popular color profile among photographers. ProPhoto RGB has the widest array of colors and will clip the least but is less prevalent and not as compatible across applications like Web browsers.

REMEMBER

You can choose a high-quality color profile (Adobe RGB or ProPhoto RGB) now without much concern for portability since you will probably continue to edit the image, even after tone mapping. If you won't be doing any more editing before posting on the Web (that is, saving directly from Photomatix Pro as a JPEG), you should choose sRGB because it's a more universal profile.

6. When you're happy with your selections, click OK (Windows) or the Generate HDR button (Mac).

Photomatix Pro churns and chugs as it generates your HDR file. Dialog boxes show you where it is in the process, depending on the options you chose. When it's finished, it displays the HDR file for you to save (if you like), edit, and tone map.

7. (Optional) Save the HDR file for future use (choose File➪Save).

8. Select Radiance RGB from the File Format drop-down list, name your file, and click Save.

Photoshop

Photoshop creates HDR files, as you would expect, smoothly and professionally. To generate HDR in Photoshop, follow these handy-dandy steps:

1. Launch Photoshop, and (optional) open the bracketed photos.

You have the option of opening your bracketed images now — the ones that will be the source photos for creating HDR. You also have the option later to automatically select all open images to merge into HDR instead of navigating and selecting them yourself.

If you have more images open than you want to merge, select photos that aren't part of the same bracketed set, or some other irregular combination, you're presented with an error message and asked to reconsider. Then Donald Trump will come in and fire you.

2. Choose File➪Automate➪ Merge to HDR.

The Merge to HDR dialog box opens, as shown in Figure 7-12, pretty as you please. Add your source images using this dialog box.

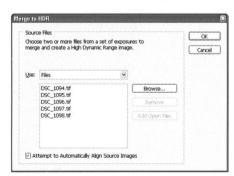

Figure 7-12: Merging HDR traffic in Photoshop.

3. **Choose source images as follows:**

 - *If the images are open:* Click the Add Open Files button.

 - *If the image aren't open:* Choose Files from the Use drop-down list, and then click the Browse button. Navigate to the folder that contains the bracketed photos and select them.

 If you add a photo you don't want, select it after it appears in the Merge to HDR dialog box and then click the Remove button.

 - *To add all images from a folder:* Choose Folder from the Use drop-down list, and then click the Browse button. Navigate to the folder you want and select it.

If you select Raw images in the Merge to HDR dialog box, Photoshop will apply the ACR default settings to process them. If you select files converted previously by ACR and saved as TIFFs or JPEGs, you might see a warning about dynamic range. Click the Continue button.

4. **(Optional) Select the Attempt to Automatically Align Source Images check box.**

 This option helps align details in images and is especially helpful for hand-held brackets. If you shot your images using a tripod, you might not need to align source images. If you're using brackets created from a single Raw photo, this isn't necessary because there can be no misalignment of the same photo. If in doubt, try it with the check box deselected, and look at the image at high magnification. If you see smeared details, ghosting from static objects, or what looks like a double-exposure, come back and select this check box.

5. **Click OK to continue.**

 Photoshop launches into a flurry of activity as it merges the files into an HDR image. If there is a question about the exposure values of the images, Photoshop displays the Manually Set EV dialog box, as shown in Figure 7-13. Enter the correct camera parameters in the Exposure Time, f-Stop, and ISO text boxes, or select EV and enter the value in the EV text box (useful for brackets from a single Raw exposure, but rather than relative EV differences, you take the provided absolute value and then add and subtract from that). Then click OK.

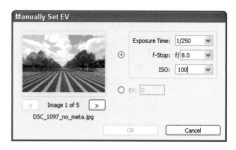

Figure 7-13: Correcting exposure in Photoshop the manly way.

When finished, the Merge to HDR dialog box reappears in a new form, as shown in Figure 7-14. A large preview window and the bracketed images appear on the left.

Figure 7-14: Previewing HDR in Photoshop.

6. **Select the images you want to remove from the preview from the left side of the dialog box. Select them again to add them back.**

 This allows you to change the balance of the HDR file toward under- or overexposure. You should be well served by trusting in your brackets, but experiment if the fancy strikes you.

7. **Click the +/– buttons at the bottom of the dialog box to zoom in and out of the Merged Result image while you experiment with the source images and white point.**

8. **To retain the most flexibility, choose 32 Bit/Channel from the Bit Depth drop-down list.**

 This allows you to save the resulting HDR file should you desire. If you set it to less (16 Bit/Channel or 8 Bit/Channel) and click OK, Photoshop automatically starts the HDR conversion process (Photoshop's terminology for tone mapping) and reduces the bit depth of the image. If you know what you want and don't need to save the HDR file, selecting the bit depth saves time.

9. **Drag the Set White Point Preview slider left or right to alter the image's exposure.**

 This is not a permanent change. You have the chance to review and finalize the image's exposure during HDR conversion. This change shows up in the Exposure slider of the Exposure and Gamma method of the HDR Conversion dialog box.

10. **(Optional) If desired, load a camera response curve from disk by selecting the Load From File radio button and clicking the button.**

 You can also save the current camera response curve for use in later HDR projects by clicking the Save Response Curve As button. If you want to keep things absolutely consistent across a photo shoot, save the a camera response curve for the first set of images, and then load it for subsequent sets from the same shoot.

 Camera response curves map the relationship between the amount of light that hits the camera sensor and the digital value it stores in a given pixel. Photoshop apparently takes images that you feed into the "HDR machine" and constructs a response curve for each camera it identifies. How often it does so and whether it updates every time is anyone's guess. If you attempt to load a response curve saved from one camera to images generated from another, you receive a warning telling you exactly what cameras you have been using and the fact that using one for another might not be such a good idea.

11. **Click OK to create the HDR file.**

 You're done. The HDR image opens in Photoshop. There is no obvious indication from the image itself that this is an HDR image and not an ordinary photo. However, if you look at the image title bar, Photoshop includes HDR in the name.

12. **(Optional) Save the HDR image (choose File⇨Save As).**

 Photoshop supports many different HDR file types, including the standard Radiance RGBE and OpenEXR formats. You may also choose from any other 32-bits-per-channel format within Photoshop, such as TIFF or PSD. If you choose PDS, though, you might not be able to open these images in other HDR applications.

Photoshop Elements 8

With the release of Photoshop Elements 8, Elements has joined the ranks of HDR-aware applications. That's the good news. The iffy news is that the HDR feature is not that powerful — it's basically exposure blending with a little tone mapping thrown in. Nevertheless, you can do more in Elements 8 than in 7, and anything that accepts bracketed exposures isn't all that bad in my book.

Regardless of what mode you want to use, you start out the same way:

1. **Open the bracketed images.**

 First you have to place the bracketed images in the Project Bin at the bottom of the screen. Do this by opening them (I'm not using the Elements Organizer). They can be Raw (in which case you'll be presented with the Adobe Camera Raw interface), TIFF, or JPEG.

2. **Select the images.**

 Select from 2–10 images in the Project Bin. Ctrl+click (Windows) or ⌘+click (Mac) to select non-adjacent images. Select the first, and then Shift+click the last if they are adjacent in the bin, as shown in Figure 7-15.

3. **Choose File⇨New⇨Photomerge Exposure.**

 This launches the HDR module and Photoshop Elements churns a bit while it prepares things.

At this point, you're ready to choose between pursuing Automatic and Manual modes. You can switch back and forth between the two modes easily by selecting the tab with the appropriate name. In addition, you can click the Reset button to start over, the Done button to finish and apply the settings, or the Cancel button to abort the process.

Figure 7-15: Selecting exposures from the Project Bin.

8

Preparing to Tone Map

In This Chapter

▷ Understanding tone mapping

▷ Discovering Photomatix Pro

▷ Exploring Details Enhancer in detail

▷ Reviewing Tone Compressor

▷ Understanding how tone mapping works in Photoshop

*E*verything else in HDR either leads up to or follows tone mapping (a truism of the finest caliber). Or, to put it another way, tone mapping is where HDR turns from promise to practice. All the photographs, brackets, metering, converting, and trudging around with your camera and tripod have brought you to the point where you're ready to turn your HDR image right back into a low dynamic range image. With HDR photography, however, you're in charge. It's a circle-of-life kind of thing.

And to be successful at tone mapping, you need to speak the language. This chapter, therefore, continues that process. You'll read about tone mapping in general but also delve into specific tone mapping features found in two of the leading applications in the HDR community: Photomatix Pro and Photoshop. With this information at hand, you'll be ready to tackle tone mapping in earnest with a greater possibility of creating fantastic images.

Tone Mapping 101

Tone mapping occurs when you convert a higher dynamic range image to one with a lower dynamic range, most often a JPEG or TIFF. The HDR image is, of course, created from bracketed photos with a wide range of exposures.

One aspect of the tone mapping process is illustrated by Figure 8-1: namely, squeezing dynamic range. This is important because monitors, printers, and standard graphics files are incompatible with HDR images. The large dynamic range of the HDR image (taken just outside a large building with a very large portico) is mapped into the lower dynamic range during tone mapping (which you perform after you create the HDR image in your HDR application). Notice that the EV range of the HDR image ranges from below –6 to above +9 EV, which is well beyond the capabilities of an 8- or 16-bit image. Tone mapping allows you to see something like the original dynamic range of the image, using a less-capable format. Aside from all the technical mumbo jumbo, without tone mapping, there is no point to HDR photography. This is where you decide, based on the information available in the high bit-depth HDR image, what the final low dynamic range image looks like. And that is the point — creating a final image you can continue to edit, post on the Web, and print to hang on your refrigerator.

When monitors, printers, and computers work with 32-bit HDR images — like JPEGs — tone mapping might shrink in importance because there will be no need to tone map an HDR image to a low dynamic range space — it'll be compatible with everything as originally shot.

And that's not all that happens when you tone map.

Given a bracketed set of images, if you examine two points and compare their brightness (luminance), they have a distinct relationship with each other, as shown in Figure 8-2. In this case, the spot on the building is darker than the clouds. No matter what image of the bracketed set you look at, the two points have the same relationship to each other in terms of luminance. Although the contrast between them diminishes as either point gets blown out or lost in shadow, the basic relationship stays the same. To reiterate, in this bracketed set, a point in the shadowed area of the building is always darker than the clouds, regardless of the bracket you look at.

Tone mapping breaks this relationship. As you tone map the HDR image, you don't have to keep the same brightness relationship between the two points. You can alter and even reverse it so that the darker point becomes the lighter point. In fact, this is exactly what happened. In the tone mapped file, the same spot in shadow on the building is slightly *lighter* than the clouds!

This is why tone mapping is different than blending exposures and other techniques that simply compress the larger dynamic range into a smaller space. Tone mapping allows you to take the high dynamic range data and change the brightness relationship between different points of the image. This is where your photographer's judgment and artistry come into play.

32-bit HDR image

HDR histogram

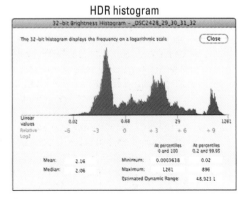

HDR EV range

JPEG EV range

Tone mapped image in progress

Tone mapped image histogram

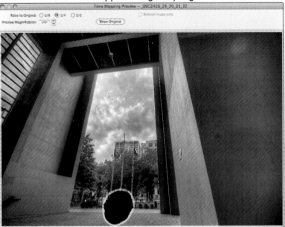

Figure 8-1: Tone mapping reduces EV range.

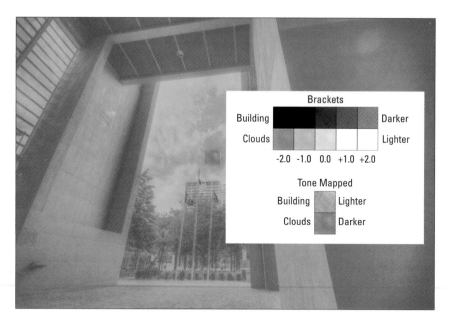

Figure 8-2: Tone mapping alters tonal relationships.

Figure 8-3 shows the final tone mapped image. Irrespective of all the technical processes going on in the HDR application, I wanted to create an aesthetically pleasing finished image, which meant fiddling with the tone mapping settings in Photomatix Pro until I was satisfied. The wealth of exposure data provided by the bracketed photos gives you the flexibility to accomplish the same thing with your HDR images.

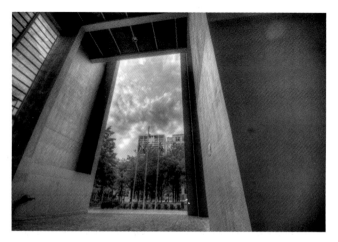

Figure 8-3: This image emphasizes the exposure data I chose through the process of tone mapping.

Getting Acquainted with Photomatix Pro

To effectively use any HDR application, you must know what the controls do. They are the interface between you, the mathematical algorithms that define tone mapping, and the image. With this knowledge, you can consciously guide the image where you want it to go. That beats randomly moving sliders any day.

Photomatix Pro is a nifty program. It's very popular because it produces great images. Beyond that, the controls make sense, are easy to use, and the program is packaged nicely with a few alternate modes (Exposure Fusion and the Tone Compressor) besides the traditional tone mapping method, the Details Enhancer. Navigate to www.hdrsoft.com to download the trial (Mac and Windows). You can purchase it for around $100, depending on the package you get. Figure 8-4 shows the shortcuts you can click to jump into Photomatix Pro. This dialog box pops up automatically when you open Photomatix, or you can bring it up by choosing View⇨Show Workflow Shortcuts.

Figure 8-4: Workflow shortcuts in Photomatix Pro.

Here's a quick overview of the shortcuts shown:

- ✓ **Generate HDR Image:** I cover this in Chapter 7.

- ✓ **Tone Mapping:** This option leads to two different tone mapping methods:

 - *Details Enhancer:* This is the classic HDR tone mapping method, which you use for a distinctive HDR look (although very realistic results are also possible).

 - *Tone Compressor:* An alternative tone mapping method, Tone Compressor produces generally more realistic results than Details Enhancer and is somewhat simpler to use.

- ✓ **Exposure Fusion:** Blends light and dark areas from different exposures; produces even more realistic results with less noise; is simpler and has fewer steps than either tone mapping method.

- ✓ **Batch Processing:** Use to automatically process a bracketed set or multiple sets with the same settings; a magnificent time-saver.

- ✓ **Batch Single Files:** Use to automatically process saved HDR files and single Raw images; another wonderful time-saver.

- ✓ **Tutorial:** The tutorial is a small Web presentation with a handful of pages with basic information. It's a handy guide to get started using Photomatix Pro.

To get to Details Enhancer or Tone Compressor, start by clicking Tone Mapping. This is the route you'll use the most in HDR.

Exploring Details Enhancer

Details Enhancer is where you'll spend most of your time in Photomatix Pro to tone map your HDR images. As you can see from Figure 8-5, there are a number of controls. Thankfully, they are well organized into functional areas. The three floating windows in Figure 8-5 show the settings, image preview, and histogram.

The following sections cover the tone mapping settings available in Details Enhancer.

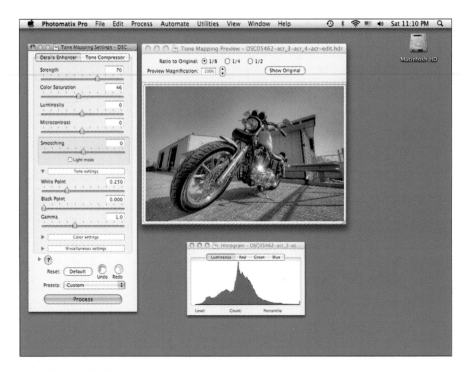

Figure 8-5: Details Enhancer.

General controls

The first section, as shown in Figure 8-6, contains the general controls, which are accessible no matter what other section of the dialog box is expanded.

Loupe-d loupe

Photomatix has a tool that isn't critical to the process of tone mapping, but is nonetheless cool. It's called the Loupe, and it enlarges a square portion of your image so you can get a really good close-up look at what you're doing.

Click where you want to magnify in the tone mapping preview window to open the Loupe and drag its marquee around in the preview window to move to different areas.

This section and the following sections have a number of what I call "mini-max" images that show the settings in the extreme. They are all the same bracketed HDR image of a Harley-Davidson motorcycle, tone mapped to show the minimum and maximum values of one setting at a time. The other settings are at their default. No attempt was made to make the images look finished. The goal is to show you what each setting does by isolating its effect.

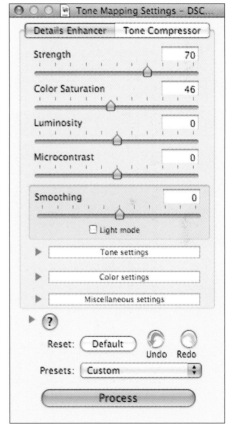

Figure 8-6: General controls with default settings.

✏ **Strength:** This setting controls contrast enhancement strength, both local and global. Although it's not technically the strength of the overall tone mapping effect, it acts like it. The default value is 70. For a more dramatic effect, raise Strength toward 100. Conversely, to create a more realistic effect, lower strength to 50 or lower.

Quite often, lowering Strength lightens an image, and raising it darkens the image. Lower values produce a more realistic effect. High values, between 80 and 100, look great and don't have to look unrealistic if other settings aren't underdone (primarily smoothing). More on smoothing in a bit.

Figure 8-7 illustrates the minimum (left) and maximum (right) settings. Notice that the minimum value results in a more realistic, less-contrasted image, and the stronger setting really pumps up the drama (in this case, at the cost of some haloing).

✔ **Color Saturation:** This setting controls color strength or intensity. The default is, oddly enough, 46. Raise for more intense color; lower for more subdued color. Reduce to 0 for a grayscale image.

Color that's too intense can look garish (which looks great with a nice meal — or is that garnish?) and raise the noise level of the image. Values between 60 and 80 result in nice, strong color. If your colors are already muted, bumping up to 100 can help make the colors appear more normal.

You might be tempted to use the Color Saturation control to create a black-and-white image, but I wouldn't recommend this approach because you have no control over the black and white tonality. Chapter 13 shows other methods that give you more control over the process. The strongly saturated image looks pretty good.

✔ **Luminosity:** Affects overall brightness by adjusting tonal compression of the image. It helps to think of Luminosity, in part, as a shadow brightness control. Raising it brightens shadows, and lowering it darkens shadows.

Contrast is also affected when you change the Luminosity setting. Higher Luminosity values lower contrast, and lower values have the effect of increasing contrast.

The default is 0. Raising Luminosity sometimes has the effect of bringing out more details from clouds that are on the verge of blowing out.

✔ **Microcontrast**: Accentuates local contrast.

Higher settings amplify local contrast and also have the effect of darkening the image. Lower values reduce local contrast and have the effect of lightening the image. The default is 0. Higher settings can increase the drama of the image.

Strength=0 Strength=100

 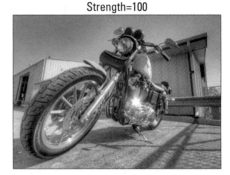

Figure 8-7: Minimum and maximum Strength.

✔ **Smoothing:** Controls the level that contrast enhancements are smoothed out. This setting plays the largest role in determining how the tone mapped image looks, and is responsible for much of the debate over style and aesthetics. Smoothing comes in two modes:

• *Slider mode:* Control smoothing with a free-ranging slider. Higher values produce more smoothing while lower values result in less. Pay attention to the light balance across the image as you consider different strengths. The default is 0.

• *Light mode:* Select the Light Mode check box to see discrete buttons that control smoothing strength, as shown in Figure 8-8. Options are Min, Low, Mid, High, and Max.

Figure 8-8: Smoothing in light mode.

As shown in Figure 8-9, lower settings produce a much less realistic image, complete with halos between areas of different contrast, because they are not smoothed, or blended, together. Min and Max produce more realistic results.

Each smoothing mode has its own unique algorithm. It helps to think of slider mode as a fine-tuning range above Max in light mode. Generally, all slider mode settings produce a smoother image than light mode.

Light Smoothing=Min

Light Smoothing=Max

Figure 8-9: The range of Light Smoothing.

Tone settings

The next section of the Details Enhancer dialog box contains the Tone settings, as shown in Figure 8-10. If it isn't visible, click the arrow beside the name and it will expand. This section has basic tone controls.

✓ **White Point:** Sets the white point, or maximum luminosity, of the tone mapped image (think high end of dynamic range). Higher settings produce more contrast and a brighter image. Lower settings do the opposite. The default is 0.25%.

Figure 8-10: Tone settings with default values loaded.

Pay attention to the image and histogram as you make White Point changes so you don't blow out highlights.

Figure 8-11 shows both ends of the spectrum. At 0%, White Point doesn't do much of anything. Notice the blown highlights at the maximum level.

✓ **Black Point:** Sets the black point, or minimum luminosity, of the tone mapped image (think low end of dynamic range). Higher settings result in a darker, more contrasted image. Lower settings do the opposite. The default is 0%.

Pay attention to the image and histogram as you make Black Point changes so you don't lose details in shadows.

Like with White Point, 0% does nothing. Raising Black Point to its maximum level deepens the darker tones in the image.

✓ **Gamma:** Sets the mid-point of the tone mapped image. Higher settings lighten the image and lower settings darken it. Each pixel isn't lightened or darkened by the same amount, however. You're moving the brightness mid-point around, which has the effect of squeezing or expanding highlights or shadows into a smaller or larger space on the histogram. In general, you shouldn't have to mess with Gamma.

White Point=0%

White Point=Max %

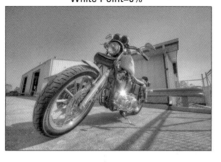
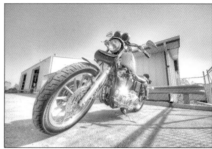

Figure 8-11: Low versus high white point.

Color settings

The next section contains Color settings, as shown in Figure 8-12. Here are the controls for the image's color temperature and saturation controls for shadows and highlights.

Figure 8-12: The Color controls with default settings.

- ✔ **Temperature:** The Temperature control lets you change the color temperature of the tone mapped image. Moving the slider right produces a reddish cast while moving the slider to the left results in a blue feeling. The default is 0. Figure 8-13 illustrates the visual result of moving the Temperature control from its minimum to maximum.

 If you work in Raw, consider correcting color temperature problems when you convert the Raw files to TIFF for HDR. If you use JPEGs, you can correct the problem here. If there are color cast problems in certain areas of the image, wait until post-HDR processing, where you can apply masks or otherwise selectively alter the image's temperature.

- ✔ **Saturation Highlights:** The color strength within the highlights of the tone mapped image. Raise to intensify the colors in brighter parts of the image. Lower to reduce them. The default is 0.

 I often use this control as a tool to investigate the tonal regions of the image. Lower to minimum; then raise to maximum to see where the highlights are. You can also create different artistic effects.

- ✔ **Saturation Shadows:** The same as Saturation Highlights, except for the darker areas of the image. The default is 0.

 Experiment with the Saturation Highlights and Saturation Shadows controls in relation to the overall Color Saturation control. For example, setting Saturation Highlights to 100 and lowering the overall Color Saturation to 0 results in colored highlights and the rest of the image in grayscale.

Temperature=-10.0 Temperature=+10.0

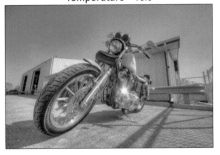

Figure 8-13: Going from brrski brr to rose-colored lenses.

What's your color temperature?

Color temperature is a strange thing. The color of the light a light source (say, a light bulb in your kitchen) emits reveals temperature (measured in degrees Kelvin). Hotter color temperatures are blue, and cooler color temperatures are red. It gets tricky because we tend to assign values to blue and red that are the opposite. We say a warmer color is red and a cooler color is blue, which completely contradicts their actual temperature.

Miscellaneous settings

Miscellaneous settings, as shown in Figure 8-14, is the final section with tone mapping settings. These are related to smoothing and clipping.

- **Micro-smoothing:** Smoothes details in the tone mapped image. The default value is 2.0.

 As shown in Figure 8-15, higher settings result in a lighter, more realistic appearance and can also reduce image noise. Lower settings perform very little or no smoothing.

- **Highlights Smoothness:** Smoothes highlights, leaving the darker parts of the image alone. The default is 0. Higher values tend to lighten the image. Use Highlights Smoothness to blend areas where highlights and shadows meet.

Figure 8-14: Miscellaneous controls with defaults loaded.

- **Shadows Smoothness:** Smoothes shadows, leaving the brighter parts of the image alone. The default is 0. Higher values also darken the image. Use Shadows Smoothness to blend the border where highlights and shadows meet.

 Neither Shadows Smoothness nor Highlights Smoothness controls are panaceas, but they have a good effect if properly used.

- **Shadows Clipping:** Sets the dark point where shadows are clipped (thrown away). The default is 0. Raising this control can help fight noise in very dark areas by clipping them, which removes them from the tone mapped image.

 Figure 8-16 shows Shadows Clipping at 0 (the default) and at 100, which shows you the effect very clearly.

✔ **360 Image:** If you're shooting a 360-degree panorama, selecting this check box ensures that the left and right borders of an image are tone mapped in relation to each other, eliminating differences between the two ends (which, in reality, are together) that result in an obvious seam.

Figure 8-15: Micro-smoothing from 0 to 100.

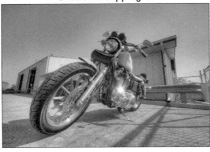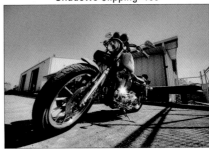

Figure 8-16: Not clipping versus clipping shadows.

Examining Tone Compressor

Tone Compressor, as shown in Figure 8-17, is another way to tone map an HDR image in Photomatix Pro. As the name suggests, dark and light tones on the extremes of the histogram are compressed toward the middle. In this case, the result is a very clean, realistic image of a lamppost over a river at sunset. The blue sky is simply gorgeous.

The controls in Tone Compressor are much simpler than Details Enhancer:

✔ **Brightness:** 'Zactly what it says. Brightness. The default is 0. Raise it or lower it to change the brightness of the image.

✔ **Tonal Range Compression:** Controls how much to squeeze the low and high ends of the histogram toward the middle. The default is 0.

✔ **Contrast Adaptation:** This control works a little bit like Vibrancy or Saturation. The default is 0. Raise it to make colors more intense; lower it to mute them. Of course, you're changing contrast at the same time. Higher values appear less contrasted, and lower values have more contrast.

✔ **And the rest (sung to the theme song of *Gilligan's Island*):** White Point, Black Point, Color Temperature, and Color Saturation are the same controls as found in the Details Enhancer method.

Figure 8-17: The Photomatix Pro Tone Compressor.

Exposure fusing in Photomatix Pro

Photomatix Pro also has a nifty tool called Exposure Fusion (formerly known as Exposure Blending). Use it by selecting Exposure Fusion from the Workflow Shortcuts dialog box (as seen on TV and in Figure 8-4). It isn't HDR, but it does use brackets to blend the photos of a bracketed set. The results are very realistic and have less noise than tone mapped images. Select brackets just like you would while tone mapping.

Here are the ways to fuse exposures in Photomatix Pro:

- **Average:** No options. See what it looks like. If you like it, great. If not, move on.

- **Highlights & Shadows — Auto:** Ditto.

- **Highlights & Shadows — Adjust:** You have more options to control the process here, ranging from Accentuation, Blending Point, and Shadows, to Midtone.

- **Highlights & Shadows – 2 images:** Pick and choose two images from the bracketed set you want to fuse together. Aside from that, there are no options.

- **Highlights & Shadows – Intensive:** This is the most intensive Exposure Fusing method. Or mode. Or whatever. There are a few controls to play around with: Strength, Color Saturation, and Radius. This is also the most demanding process for your computer.

Just for kicks, try creating a multiple exposure look using Exposure Fusion. Choose two or more different source images with the same size in pixels and load them into Exposure Fusion. Experiment with different methods until you find the least objectionable!

Using Photoshop

Tone mapping options are much more limited in Adobe Photoshop — and I'm not talking Elements, where tone mapping options are nonexistent. I find that in Photoshop CS3 and CS4, the aim is generally to present a much more realistic result.

Creating an HDR image in Photoshop is covered in Chapter 7 and tone mapping steps are covered in Chapter 9.

With a 32 bit per channel HDR image loaded in Photoshop, you can find the four tone mapping methods by choosing Image⇨Mode⇨8Bits/Channel or 16Bits/Channel. This opens the HDR Conversion dialog box (you see the different options in the following figures). The four methods are

✔ **Exposure and Gamma:** This is a fancy name for brightness (exposure) and contrast (gamma). You are in control of the sliders and can choose whatever values look good to you.

Figure 8-18 shows the Exposure and Gamma options in the HDR Conversion dialog box that you can use to work on an HDR image. You can see from the photo that this is a very realistic result. The histogram indicates there are not very many highlights, however.

Figure 8-18: The Exposure and Gamma options.

✏ **Highlight Compression:** Similar to Tone Compressor in Photomatix Pro, but Highlight Compression (so far as that's its name) squeezes highlights in a 32-bit/channel HDR image down to where they don't clip in a 16-bit or 8-bit/channel low dynamic range image. There are no controls for this method. Choose it from the Method drop-down list to use it.

Figure 8-19 illustrates the HDR Conversion dialog box with the Highlight Compression option selected, and the result on an HDR image. This image would require a lot of work to make it look presentable — the tree is far too dark.

✏ **Equalize Histogram:** This tool is also similar to the Tone Compressor in Photomatix Pro. Equalize Histogram squeezes the entire dynamic range of the HDR image into the low dynamic range image space while trying to retain an appropriate contrast level. There are no controls for this method. Choose it from the Method drop-down list (everyone say it now) to use it.

Figure 8-20 shows the Equalize Histogram option selected and the effect. Not bad, although in this case, it looks a little posterized.

Figure 8-19: Using Highlight Compression.

Figure 8-20: Equalizing the histogram.

✏ **Local Adaptation:** This is the squirrelly one, but it's also the method that can create more artistic results. The Local Adaptation is selected in Figure 8-21. The two controls are Radius and Threshold sliders (shown at their default values), and you can use the histogram to apply a toning curve.

Notice that a tone curve has been applied to the histogram (click the arrows by the Toning Curve and Histogram label if you don't see this area) to control the image's overall brightness and contrast. Bring in the end points of the histogram and alter contrast by changing the curve. Although you can see it in every method, you can edit only when you use the Local Adaptation method.

The point of Local Adaptation is to alter *local* contrast. The settings operate like this:

- *Radius:* Radius acts like a local contrast control. Turning it up emphasizes local contrast, and turning it down reduces local contrast. Use Radius to control the overall strength of the tone mapping effect.

Figure 8-22 shows the minimum and maximum values for Radius, while Threshold stays at the default. To see where the difference is largest, look at the leaves and the bright area on the wall. They are much brighter when Radius is at maximum.

- **Threshold:** Threshold acts like a smoothing control. Increasing it smoothes the effects of increased local contrast. Use Threshold to smooth differences between light and dark areas.

Figure 8-23 illustrates minimum and maximum values for Threshold. Radius is at the default value. Here, the difference is dramatic. With Threshold at minimum, the image is very smoothed — almost blurred. At maximum, there are obvious halos that detract from the image.

Reduce the Radius and/or Threshold if you're having problems with halos.

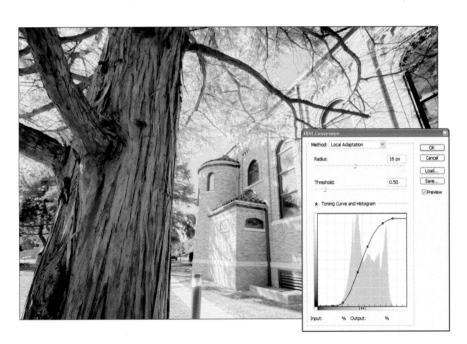

Figure 8-21: Local Adaptation is where the fun is.

Radius Min

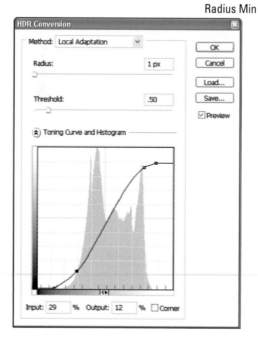

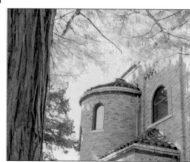

Radius Max

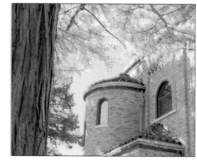

Figure 8-22: Radius at its minimum and maximum.

Threshold Min

Threshold Max

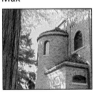

Figure 8-23: Threshold at its minimum and maximum.

9

Tone Mapping for Fun and Profit

In This Chapter

▷ Developing a tone mapping workflow

▷ Tone mapping with Photomatix

▷ Tone mapping with Photoshop

▷ Comparing different approaches

▷ Automated bracket processing

▷ Batch-processing single files

*E*arlier chapters lay a broad yet detailed foundation of knowledge about high dynamic range digital photography strong enough for you to begin tone mapping. This chapter takes you through the process of tone mapping using two of the leading HDR applications, Photomatix Pro and Photoshop, using their respective Details Enhancer and the HDR Conversion routines. I also show you how to use Photoshop Elements 8 to tone map an HDR image.

Following that, you find tips and techniques on how to get the best images out of Photomatix, and how to batch-process brackets or single files automatically.

Tone Mapping with Photomatix Pro

It's time to get down to the practical matter of tone mapping an HDR image in Photomatix Pro. If you need additional clarification on the meaning of the settings, see Chapter 7.

You don't have to perfect an image in tone mapping. You can continue to edit in your graphics application.

Getting ready to tone map

Before you can tone map, you must complete the photography and have your bracketed (or single Raw) images ready. Here's a checklist to make sure everything is in order:

- **Photos taken:** Check. Have two or more bracketed photos ready, shot as described in Chapters 4 and 5. Alternatively, you can use a single Raw photo for single-exposure HDR.

- **Raw images converted to TIFF, if desired:** Roger. As covered in Chapter 7, you might wish to convert Raw photos to TIFFs to get the best quality. Single Raw exposures can either be used directly for HDR (pseudo-HDR) or converted to brackets in a Raw editor. Chapter 7 has more detailed information on converting Raw images.

- **HDR image generated:** Affirmative. The low dynamic range source images must be combined to create a single high dynamic range (HDR) image, as shown in Chapter 7.

Looks like you're ready to get started!

Getting started to tone map

If your seat is in its upright and locked position, with tray table stored, you can get started. Launch Photomatix Pro and generate HDR on the fly or load a saved HDR image (see Chapter 7). If you need to brush up on what each setting does, please consult Chapter 8.

Using presets every time you tone map

No matter what HDR application you use, presets are worth your time and trouble to use. In general, presets allow you to manage your tone mapping process by making it possible for you to create and use your own tone mapping styles, baselines, or starting points in the form of self-created presets. Load one or more presets that may apply to the image at hand and use the best one as a starting point to start tweaking.

Save a settings file or preset every time you tone map an image and file them so that you can find them if needed. I keep mine with the unedited tone mapped file in a folder with the pre- and post-HDR working files for that bracketed set.

Saving a preset for each tone mapped image that you have finished allows you to duplicate your work if you need to. Without a preset, should you want to go back and start over, you're left guessing what settings you used to create an image. That is most definitely infuriating, especially if you want to tweak around the edges instead of starting from scratch.

With the HDR image ready and onscreen in Photomatix Pro, complete the following steps to tone map it:

1. **Invoke the tone mapping process by clicking the Tone Mapping button (see Figure 9-1) or by choosing Process⇨Tone Mapping.**

 This launches the Details Enhancer, as shown in Figure 9-2. You can switch tabs between the Details Enhancer and Tone Compressor at any time.

2. **Load baseline settings by choosing a preset option from the Presets drop-down list, or by adjusting the settings in the Details Enhancer by hand.**

 Each time you load an image to tone map, reset the controls manually (which takes time) or with the help of a preset that you created beforehand. The purpose of this step is to create a fairly neutral starting point for all your photos.

 If you choose the preset route, select Default from the Presets drop-down list (seen near the bottom of the Details Enhancer window). Or create a preset of your own to load when you need by selecting Save Settings from the Presets menu (your current settings are saved with the filename of your choice). My preferred settings deviate from the default in Strength, Color Saturation, White Point, and Black Point. In each of these instances, I prefer higher values to start with.

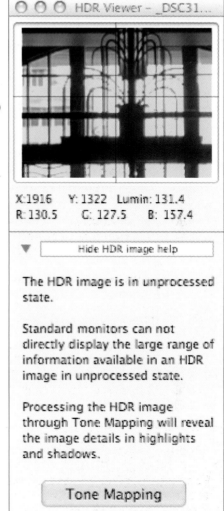

X: 1916 Y: 1322 Lumin: 131.4
R: 130.5 G: 127.5 B: 157.4

▼ Hide HDR image help

The HDR image is in unprocessed state.

Standard monitors can not directly display the large range of information available in an HDR image in unprocessed state.

Processing the HDR image through Tone Mapping will reveal the image details in highlights and shadows.

Tone Mapping

Figure 9-1: Starting to tone map.

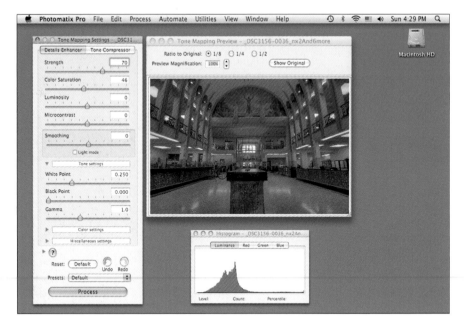

Figure 9-2: The Details Enhancer.

3. Analyze the image.

Look at the effect your baseline settings have on the HDR image, as shown in Figure 9-3. Sometimes what you see is good; sometimes bad, and sometimes in between.

Don't expect it to be perfect. The point is to use this as a starting point. If you have other baselines for different conditions or artistic effects (interiors, exteriors, strong, realistic, and so on), load them and see what they look like. Sometimes you will be surprised.

Examine your reaction and use that as an indicator as to where the image could be changed. Think in terms of these characteristics:

- **Overall brightness:** Is the image too bright, too dark, or just right? Use the histogram to see a graph of where the pixels are distributed in the image, from dark to light. Figure 9-4 illustrates an area of the image that is very bright, and even needs to be toned down some.

- **Light balance:** Sometimes certain areas of the image are too dark or too light. Compare adjacent areas that have different balances of brightness and tone. Figure 9-5 shows three such areas. Pay attention to tonal differences where they meet, such as between the floor and counter (high contrast but uniform), the ceiling and decor (close in contrast), and the upper floor structural area (smaller areas with differing contrasts).

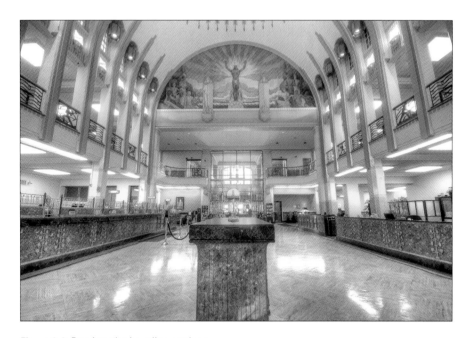

Figure 9-3: Preview the baseline settings.

Come up with solutions rather than simply observe. The counter should be more vibrant compared with the floor; the mural should have more contrast than the wall; the lights in the upper areas are too bright. These things should be corrected.

Figure 9-4: Try to keep from blowing out areas.

✏ **Image contrast:** Does the image look like a light gray overlay is on top of it, as in Figure 9-6? If so, there is not enough image contrast. In this case, the floor and stone table reveal that there isn't enough overall contrast in the image.

✏ **Details:** Are the details visible enough? Do they pop? Details can be accentuated or smoothed by adjusting local contrast settings. Part of the mural is shown in Figure 9-7. It looks bright enough, but there could be much better contrast.

Figure 9-5: Analyze different areas and decide what to do about them.

✔ **Noise:** What is the noise level? Is it acceptable, or has it been accentuated? Figure 9-8 illustrates a good place to find noise: areas of fairly consistent color and texture. It's easy to spot some noise here — nothing drastic, but you might want to take care of this later, after tone mapping.

✔ **Color intensity:** Does the image need more color or less color? Is this need confined to highlights, shadows, or the entire image? Figure 9-9 shows another side of the mural against one end of the main lobby. The colors look nice and saturated, but enhancing contrast will show them off better.

Figure 9-6: Image contrast is lacking.

✔ **Temperature:** Does the image have a blue or reddish color cast to it? If so, this indicates a color temperature problem. Figure 9-10 indicates pretty good temperature in this image. The floor looks gray, the white panels look white, and the black computer monitor looks black.

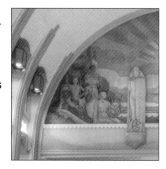

Making and evaluating adjustments

Figure 9-7: Details need more pop.

As you tone map, take the controls and move them one way or another. Go to the extremes so you can see the full effect of the control. You'll quickly see which ones do what and whether you like the effect. Although you can make adjustments in any order, I find approaching things in a regular, methodical way helps to

achieve consistent results. You also avoid setting different controls to have the opposite effect, which makes it very hard to discern what's happening while you tone map the image.

In the following sections, you'll notice that some controls are repeated. This is because effects are often interdependent. After making an adjustment in one area, go back and review other important settings. Refer to Figure 9-3 to compare each change with the baseline.

Figure 9-8: Noise is a common problem with HDR.

Throughout the course of adjusting each setting, constantly evaluate the image. At any time, you can choose elect Save Settings from the Presets list and save the current tone mapping settings in a file that can be stored and accessed later. Name it something that makes sense so you can recall what it is or why you saved it. You can also compare the effect of the tone mapping settings to the original image by selecting Show Original on the Tone Mapping Preview window.

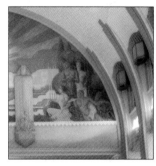

Figure 9-9: Colors add pop and zing if not overdone.

Adjust brightness and contrast

To adjust your image's brightness and contrast, you use the White Point, Black Point, Luminosity, Gamma, and Strength settings. At this point, you're just getting the image into the ballpark and making it possible for you to see where you need to make other changes. Try to keep from blowing out highlights. You'll have plenty of time to finalize brightness and contrast by the time you're done.

Control the overall lightness of the image by raising or lowering the White Point, the Black Point, or Luminosity. White Point and Black Point have strong effects on brightness and contrast. Luminosity acts as a shadow control — raising or lowing the brightness in darker regions.

Figure 9-10: Check the image's temperature.

In the example I use in this chapter, the image is sufficiently bright. The problem is a bit too much brightness around the front door, in reflections

off the floor, and the interior lighting. This is corrected by lowering the White Point to bring the reflections on the floor and other hot spots under control, raising the Black Point to restore contrast, and then raising the Luminosity to lighten the image.

There is a definite balancing act as you change settings. The amount you choose to change settings has a tremendous impact on the overall appearance of the image. You may push things very hard for an artistic look or nudge things very carefully for a more realistic effect. It's your call!

Use Gamma as a last resort to control lightness. Raising Gamma tends to reduce contrast too much, resulting in a washed-out look. Lowering it darkens the image and raises contrast. Strength also affects contrast. If needed, return to Strength and readjust.

Fix the light balance and the overall effect

To adjust the light balance and overall effect in your image, use the Strength and Smoothing settings.

If your baseline settings have been dialed in to the point that you're happy with how your image looks, you might not have to make any significant adjustments to the Strength and Smoothing settings. If that is the case, tweak around the edges to see whether you can improve each particular image. For images that don't look right, it will be obvious. In these situations, adjust Smoothing first, and then take care of the Strength.

−10.0

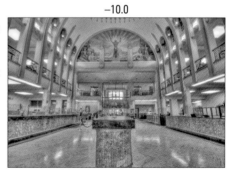

0.0

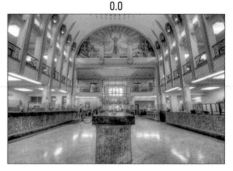

+10.0

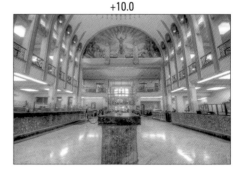

Figure 9-11: Smoothing plays a major role in light balance.

You can easily get carried away with the "HDR effect" and make poor smoothing choices (mostly not enough). Alternate between using the Smoothing slider and selecting the Light Mode check box to compare the results you get from each mode.

Figure 9-11 shows three smoothing strengths: –10.0, 0.0, and +10.0. Each has a different effect on the light balance of the image. Look carefully at the floor versus the low stone walls on the sides. Different settings put them in different balance with each other.

From minimum to maximum, the balance is reversed. With Smoothing set to –10.0, the floor is dark, and the walls are light. As Smoothing increases, they come into a more even balance. By the time Smoothing is at +10.0, they have switched. The floor is light, and the walls are dark. As an aesthetic decision, I choose bright stone walls to emphasize their detail and a darker floor.

Adjust and enhance the color

To adjust and enhance the color in your image, you use the Color Saturation, Saturation Highlights, Saturation Shadows, and Temperature settings.

60

Make color adjustments to suit your taste. You might not need to alter these controls if your baseline settings can be suitably applied to most images. If necessary, start color adjustments with Color Saturation to control the overall intensity of the image. Use Saturation Highlights and Saturation Shadows for special effects or to solve problems in those particular tonal regions.

Figure 9-12 is, in fact, a rejected alternative. Even if you trust your baseline settings, fiddle with them to make sure they look good. In this case, Color Saturation is lowered to 60 (from 80) to see whether the image would look better without as much color intensity. These are the subjective decisions you make while you tone map. I prefer the stronger colors for this image, which can be seen better in the small crop of a colorful area of the wall.

80

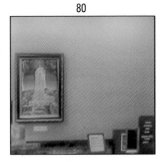

Think details

To tweak the details in your image, you use the Microcontrast and Luminosity settings.

Figure 9-12: Always explore alternative settings — this time, decreased saturation.

Microcontrast is the go-to control for local contrast because it accentuates details. You'll find that Luminosity sometimes needs readjusted after making a strong Microcontrast change. Adjust both until you find the right balance. A strong surge in Microcontrast has the effect of heightening the drama and intensity of an image. If it gets too dark, raise Luminosity to compensate. If necessary, return to White Point or Black Point (which was lowered) to adjust those settings.

Smoothness changes (covered in the next section) reduce local contrast and smooth over details. Consider how you approach the image to avoid setting controls contrary to one another.

Control smoothness

To control the smoothness in your photos, you use the Micro-smoothing, Highlights Smoothness, Shadows Smoothness, and Shadows Clipping settings. You might need to increase smoothness to combat noise or to lower local contrast and smooth out details. Micro-smoothing works globally, and Highlights Smoothness and Shadows Smoothness affects only those tonal areas. Smoothing also has an effect on how smoothly light and dark areas transition to each other.

Smoothing is great, but pay attention to contrast. Small amounts of smoothing go a long way. By increasing the Smoothing level, you can raise the realism, smooth out some noise, smooth out the light a little, and moderate the contrast of the image. As a whole, Smoothing helps cement things together.

Shadows Clipping can often be ignored, but if you have problems with noise in dark areas, raising it can clip it from the image. This setting also has an effect on contrast.

Finishing up

When you're happy with the results, it's time to process and save:

1. **Click the Process button in the Details Enhancer.**

 This applies the tone mapping settings to the HDR image and creates a low dynamic range image for you to save.

 You'll see a progress dialog box. If you're like me, you love watching progress bars.

2. **Choose File⇨Save As.**

 This calls up the Save As (Windows)/Save (Mac) dialog box. The things you want to note are Save As Type (Windows)/File Format (Mac), and the Open Saved Image(s) With check box, as explained in the following list:

- *File Name (Windows)/Save As (Mac):* A name is generated for you based on the original images in the bracket or HDR filename with `_tonemapped` appended. Change as desired.

- *Save As Type (Windows)/File Format (Mac):* Choose 16-bit TIFF for the highest quality (and largest file size), 8-bit TIFF for high quality, and JPEG for the lowest quality (and smallest size).

If you're a quality junkie, don't choose anything but 16-bit TIFF. In reality, the difference between 16-bit and 8-bit TIFF is not that apparent. 8-bit TIFF is a reasonable compromise and will work in image editors that balk at 16-bit images. Choose JPEG only if you don't want to perform further editing.

JPEG is also a great format with which to compare the effects of different tone mapping settings on the same HDR image. Process them separately and save each as a JPEG. This makes the files smaller; they also load much faster if you want to switch back and forth to compare.

- *Save Tone Mapping Settings (Windows only):* Leave this check box selected. You'll have a permanent record of what settings you applied with each tone mapped image. You can recall it and use on other images or, if needed, reprocess the current HDR image and make small changes. The tone mapping settings are saved in an XMP file.

The settings files are a form of XML, which have setting names and values as text. They can be read by a text editor or Web browser, if you're curious.

- *Open Saved Image With (Mac):* Select this check box, and after the image is saved, it will automatically open in the chosen application for further editing.

3. **Close the image, and if desired, close Photomatix Pro.**

The tone mapped image is now ready to be edited further (see Chapters 10 and 11) and published.

Tone Mapping in Photoshop

Tone mapping in Photoshop is much more streamlined than in an application like Photomatix Pro, essentially because you have so few options. Your main decision is to choose one of the four tone mapping methods, two of which don't have any settings.

To tone map an HDR image in Photoshop, follow these steps:

1. **Have your HDR image ready.**

 You can load a previously saved HDR image or continue directly from creating the HDR image.

2. **If necessary, perform adjustments on the HDR image.**

 Photoshop allows you to perform limited adjustments on 32-bit HDR images. Be careful! What you see onscreen is *not* a completely accurate representation of the actual image unless you have a 32-bit-per-channel HDR monitor.

3. **If you're feeling adventurous, choose Image⇨Duplicate.**

 This sets up more than one copy of the HDR image so you can experiment and apply a different conversion setting per duplicate image. You can switch back and forth between images to compare the effects of different methods and settings.

4. **Choose Image⇨Mode⇨8 Bits/Channel or Image⇨Mode⇨16 Bits/Channel to lower the bit depth.**

 This opens the HDR Conversion dialog box, where you select the tone mapping method you want to use.

 Alternatively, you can jump from the Merge to HDR dialog box directly to the HDR Conversion dialog box if you select a lower bit depth than 32 bits-per-channel when merging to HDR.

5. **Choose a tone mapping method from the Method drop-down list and then experiment.**

 Alter settings, switch methods to compare results, and experiment to decide the appropriate method and settings for your image. I discuss these settings in more detail in the following sections.

 You may also load settings from previous sessions (provided that you saved them). If you're working on several HDR images of the same subject (say, an interior), create a master setting to save, and then apply to the additional HDR images of the same scene.

6. **Process the image by clicking OK to apply the tone mapping settings.**

7. **Save the low dynamic range result by choosing File⇨Save.**

 You can continue to edit this file (reducing noise and such). Make sure to save your final results.

Exposure and Gamma

Choose Exposure and Gamma from the Method drop-down list in the HDR Conversion dialog box.

The key with adjusting the Exposure and Gamma sliders is to lower the Exposure setting so you don't have any blown highlights, and then adjust the Gamma setting to get at the right lightness (which can affect contrast). It might not look like a good photo at this point — you'll have to rely on more editing after tone mapping.

In this image (see Figure 9-13), the clouds were on the verge of blowing out until the Exposure was reduced. It wasn't necessary to change the Gamma. Contrast can be enhanced later in editing through Levels or Curves adjustments.

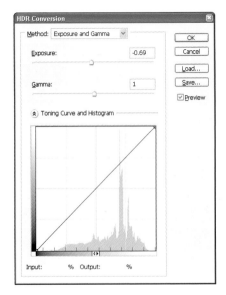

Figure 9-13: Use Exposure and Gamma to protect highlights.

Highlight Compression

Choose Highlight Compression from the Method drop-down list in the HDR Conversion dialog box. Figure 9-14 shows the selection in the dialog box and the effect on the image. In this case, Highlight Compression does a good job of saving the clouds.

Figure 9-14: Use Highlight Compression to squeeze the highlights to fit.

Equalize Histogram

Choose Equalize Histogram from the Method drop-down list in the HDR
Conversion dialog box. Figure 9-15 shows the result of equalizing the histo-
gram. In this case, contrast is enhanced, but details are lost in dark areas of
the building and in the clouds.

Local Adaptation

Choose Local Adaptation from the Method drop-down list in the HDR
Conversion dialog box. Working with the Local Adaptation settings allows
you to control the two sliders (Radius and Threshold) as well as alter the his-
togram. Begin by working on the histogram.

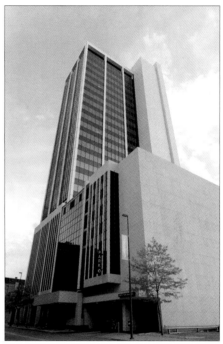

Figure 9-15: Equalizing the histogram squeezes the dynamic range of the image to fit.

When you hover your mouse over the image, as shown in Figure 9-16, the cursor becomes the Eye Dropper tool. Click to see the tone under the Eye Dropper appear on the histogram as a hollow diamond. This lets you sample specific tonal regions and gauge whether to change the histogram for that area.

With that out of the way, see whether a combination of changing the Radius and Threshold settings from the default improves the image. In Figure 9-17, the Radius was increased to emphasize local contrast and the Threshold was decreased to avoid smoothing it over. The result is a bit sharper than the original with good contrast.

Eye Dropper

Figure 9-16: Use the Eye Dropper to examine specific tones on the histogram.

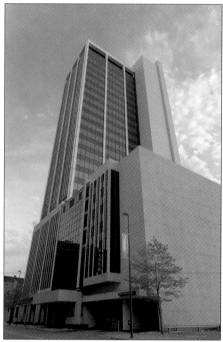

Figure 9-17: Adjusting the Radius and Threshold results in better contrast and sharpness.

An Approach to Comparing Approaches

Individual images often look great. It's when you compare two differently tone mapped versions of the same HDR image, however, that you see flaws you missed or something you like better in one but not the other.

Always save the original HDR image. This way, you can load it into your HDR application each time you want to tone map it. This saves you from having to generate it each time.

To compare different approaches to tone mapping an image, follow this general process:

1. When you reach a point in tone mapping where you like the result, process the image and save the result. Make sure to save the settings as well so you have a record of it.

2. Save the image as a JPEG. No need to get fancy here. You want something that loads quickly in a preview program, which improves your ability to discern nuanced differences as you flip back and forth.

3. Open the original HDR image and make a change to one setting — something you want to see if you can make better. Make single changes at a time. Try changing just the Strength, Color Saturation, Smoothing, Luminosity, or Microcontrast setting. It's harder to gauge the effects of changing multiple settings at once because you don't know which one might have helped and which one didn't.

4. Save the second image. You can work up a third image with still another change to the same setting and have three options to choose from (Baby Bear, Mama Bear, and Papa Bear).

5. Open the images in your editor/organizer (Microsoft Picture and Fax Viewer in Windows/Preview on Mac work best because you can scroll through the images one after another) and look at your versions several times.

Figure 9-18 illustrates three versions of an image tone mapped with different Strength settings. One is at 50, another at 75, and the last is at 100.

Strength=50

Strength=75

Strength=100

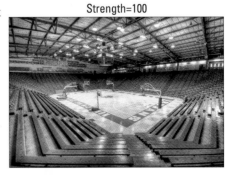

Figure 9-18: Comparing different Strength settings to find the best image.

What you're looking for are subtle (and not so subtle) differences in how you react to each image. All three in this case look good. That isn't the issue. You're after which one you like *best*. Pay special attention to how the tone migrates from the outside toward the center of the photo as the Strength increases. With a setting of 50, the basketball court is fairly light, and the bleachers are dark. At a

Strength of 100, the court has darkened and the seats have lightened. In a completely subjective decision, I prefer the latter.

6. Decide on the best one and use that as the basis to move forward. Open the HDR image in Photomatix Pro, load the settings you just approved, and then make another change.

7. Continue until you're satisfied. When the process is over, you'll know for certain which settings you like best.

8. Save the final version as a 16-bit TIFF for the best quality and continue editing.

Batch-Processing Multiple Files

Be on the lookout for an HDR application that can perform batch processing, like Photomatix Pro. (See Chapter 3 for more information on other software packages.)

Batch processing is a real time and energy saver if you need to process several bracketed sets from the same photo shoot. This is paramount for processing panoramas. Aside from that circumstance, there's no reason to develop different settings for each set of brackets unless you have an over-riding need to treat a particular set differently (perhaps one angle produced a different color cast or the clouds moved out of the way and the scene got much brighter).

Photos shot in basically the same light at the same location might vary only a bit in composition and minor orientation. Using the same tone mapping settings makes sense because the same conditions produce the same basic image elements of lightness, contrast, and detail. Common tone mapping settings also ensure consistency within the same photo shoot. This is especially helpful for interiors where you take different shots in the same room. The room hasn't changed. The lighting hasn't changed. The brackets are probably all shot at the same or very similar exposure settings.

The following steps illustrate how batch-processing multiple files works in Photomatix Pro:

1. Launch Photomatix Pro.

2. Generate the HDR image; choose Process⇨Generate HDR.

Generate an HDR image from a good set of brackets that are representative of the photo shoot.

3. Develop the tone mapping settings to your liking.

See the earlier section, "Tone Mapping with Photomatix Pro," for details.

4. Save the settings and close the tone mapped image.

I like to process the image and save it as a *concept* or *prototype* file in either JPEG or 8-bit TIFF format. I can then open the image in an editor and check to see its potential or problems (color cast, noise, and so on). I don't spend a lot of time developing it because I'm just trying to get a sense of where the image is going.

You may forgo this step and simply save the settings in Photomatix, which doesn't require processing the tone mapped image.

The important part is finalizing the tone mapping settings and saving the settings file for use in batch processing.

5. Click the Batch Processing button from the Workflow Shortcuts window, which appears when you launch Photomatix Pro.

The Batch Processing of Differently Exposed Images dialog box appears (see Figure 9-19), which has a number of options for you to choose from. Notice that it's a pretty blank slate to work from the first time you run it.

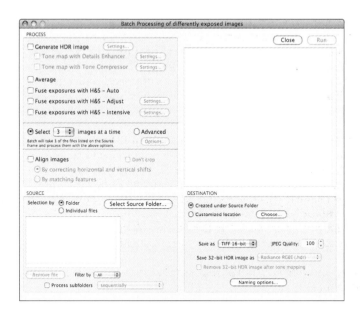

Figure 9-19: Preparing to set up a batch session.

6. Select the Generate HDR Image check box to work with HDR (the other options allow you to fuse and blend exposures), click the Settings button beside the check box to access the HDR options, and then click OK.

See Chapter 7 for more details on the HDR settings options.

Clicking the Settings button opens another dialog box, as shown in Figure 9-20. There are a few differences in this dialog box compared with the routing to generate HDR. You can select the Force Exposure Value Spacing To check box and enter an amount, which can ensure the computer doesn't make a mistake. You can also select the Process Strip by Strip check box if you want to avoid memory problems.

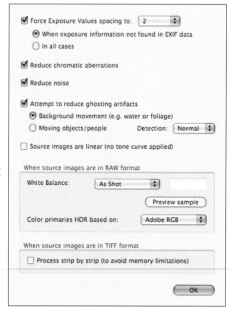

7. **Choose tone mapping options and settings as described earlier in this chapter, and then click OK.**

Check the Details Enhancer and/or Tone Compressor. In this case, the Details Enhancer is being used, and the settings are entered in the dialog box shown in Figure 9-21. You may enter the settings manually (as here) or load the settings file of the sample HDR image you tone mapped in Step 4.

Figure 9-20: Selecting HDR settings.

8. **Back in the Batch Processing of Differently Exposed Images dialog box, select the image-selection criteria by entering the number of images in the Select Images at a Time text box.**

You can identify the number of images to select for each bracketed set, or select the Advanced radio button, which lets you apply more advanced rules for selecting the images.

It helps to have the same number of brackets in each bracketed step and have them be in the same folder on your hard drive (or each set in its own folder in a collective container folder). If you have three images in some sets and five images in others, select Advanced. In the dialog box that appears (as shown in Figure 9-22), select either the Automatically Detect Number of Bracketed Frames or the Select Only Part of the Frames in the Bracketed Set radio button.

9. **Select the desired alignment and cropping options.**

Select the Align Images check box to align your images, or leave it deselected if you don't want Photomatix to align them. Select the Don't Crop check box to preserve your images. Choose whether to save the aligned output. These options are similar to the standard options you encounter when generating HDR.

10. **Choose the source images by selecting the Folder or the Individual Files radio button; click the Select Source Folder or Select Source Files button to browse to the desired folder on your hard drive.**

You can select a folder or individual files. After you have files selected, you can remove files and filter them by selecting the files in the preview box and clicking the Remove File button or selecting an option from the Filter By drop-down list, which allows you to select certain types (such as JPEG). You may also select the Process Subfolders check box, which helps if your brackets are stored in their own folders within a container folder.

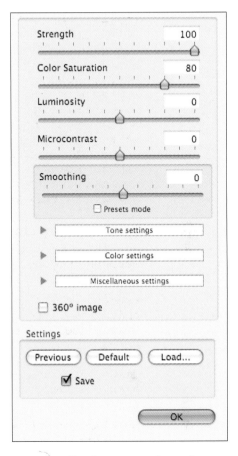

Figure 9-21: Entering tone mapping settings.

11. **Select the Created under Source Folder radio button to save your batch-processed files in the source folder; or select the Customized Location radio button and then click the Choose button to specify a different destination for the files.**

12. **Select the file format to save from the Save As drop-down list, adjust the JPEG Quality setting if desired, and choose an option for HDR image format from the Save 32-Bit HDR Image As drop-down list.**

If you're saving the 32-bit HDR image, select the Remove 32-Bit HDR Image After Tone Mapping check box if you want to delete the HDR image after tone mapping.

13. **(Optional) Click the Naming Options button to select your own naming options for the processed files, as shown in Figure 9-23.**

 Notice that you have a few options to start with and that you can append a word or phrase to the end. Starting with the processed set is a good choice if you want the results organized by set number, while selecting the Start with Filename of First Image in the Set radio button is good if you want to organize by the image file names.

14. **Finally, click the Run button.**

 This starts the process. You see interim progress reports show up in the dialog box as Photomatix Pro works its way through all the images. When it's done, you're notified. Close the dialog box.

Figure 9-22: If your brackets are complicated, select from Advanced options.

Batch-Processing Single Files

It's an added bonus if your HDR application performs batch pro-cessing on single files, as does Photomatix Pro. You might think the whole concept stinks of oxymoronic

Figure 9-23: Selecting naming options.

malfeasance, but it makes sense when you face north, close your left eye, and hum "Happy Birthday." You'll realize that *single files* (an oxymoron in and of itself) refers to a collection of single Raw images converted to pseudo-HDR or a collection of HDR images (not the brackets). In other words, say you have several single-exposure Raw images that you want processed with the same tone mapping settings. You can't use normal batch processing because that requires multiple bracketed exposures. You have to batch-process single files.

The other scenario where you might want to use this technique is when you already created a bunch of HDR images (possibly through batch processing) and want to apply the same tone mapping settings to them. You don't need to re-create the HDR images — all you need to do is feed the single HDR images collectively into the batch process single files hopper.

The same general prep work for bracketed exposure batch processing applies here (see the previous section), and the steps are similar. Follow Steps 1–5 in the "Batch-Processing Multiple Files" section, and then follow these steps for processing batches of single files:

1. Select a conversion type and method:

- *If you're working with single Raw images:* Select the Convert Raw Files into Pseudo-HDR Images check box, and then select the tone mapping options you want to employ.

- *If you're tone mapping existing HDR images (pseudo or not):* Select the Tone Map HDR Image Files or Psuedo-HDR Images With check box, as shown in Figure 9-24.

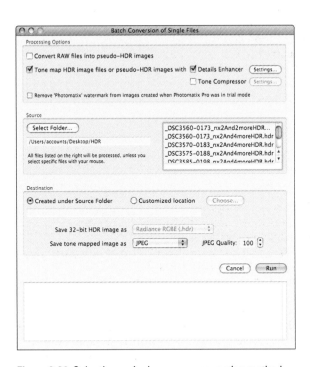

Figure 9-24: Selecting a single source conversion method.

2. **Click the Settings button and enter your tone mapping settings manually or with a preset.**

3. **Click the Select Folder button and browse to the source folder.**

 Identify the folder that contains the single Raw images to convert and tone map, or existing HDR images to tone map.

4. **Select a destination and format by selecting the Created under Source Folder or the Customized Location radio button.**

 If you select the Customized Location radio button, click the Choose button to choose to have the results saved in a subfolder within the source folder or in a new location.

5. **If you're simply converting single Raw exposures to pseudo-HDR, choose a format from the Save 32-Bit HDR Image As drop-down list. You can also choose the final tone mapped image format from the Save Tone Mapped Image As drop-down list.**

6. **Click the Run button and close the dialog box when Photomatix is done with the batch process.**

 Photomatix processes the images according to your wishes, and gives you status reports along the way.

10

Layers, Process, and Blending

In This Chapter
▷ Understanding layers and big league layer management
▷ Optimizing your workflow
▷ Blending, blending, and more blending

A chapter in an HDR photography book on layers, process, and blending? Yup. Layers, process, and blending are important topics when it comes to editing a tone mapped HDR image. Layers make a lot of things — like blending — possible. You can use layers to make different adjustments and changes, track changes, evaluate different approaches, and undo your work to various points in the process to start fresh.

Managing layers is part of an overall process where you try to work in a fairly structured way to achieve specific goals rather than work randomly or haphazardly. That's not to say that randomness isn't fun, but when you try and re-create or remember something you've done in an earlier image, you'll appreciate a bit of order.

Blending, which relies on manipulating layers, enables you to make things look more or less realistic, correct specific problems within your images, and accentuate or protect positive aspects from other edits. (For example, noise reduction notoriously degrades your images.) You can selectively edit and control how things appear in the final image.

In the end, it's up to you to decide how and when to use layers and blending, and to use the processes and workflow that makes the most sense to you. However, the information in this chapter can make post-HDR editing much more productive and rewarding for you.

Taking the Layers Refresher Course

Layers are indispensible tools to use if you want professional editing results. It's that simple. They assist you while you edit your tone mapped HDR images and make certain techniques — such as blending — possible. If you don't use layers often, spend time in this chapter coming to grips with what they are and how they work.

The lasagna of layers

Photoshop Elements 8 (like virtually all dedicated graphics applications today) can store image elements — such as copies of the image with different effects and adjustments applied independently — on layers. It's like stacking different images on top of each other. Each layer is unique, but in the same file. Layers combine to create what you see.

If you've ever eaten lasagna, you know what I'm talking about. Each layer of pasta, cheese, and sauce builds on the one below it and they all work together to make the dish. Layers. Lasagna.

Unlike the layers you'll find in lasagna, though, image layers are separate and can be selected, moved, deleted, and edited independently. They don't congeal or otherwise stick together (unless you link them, but no need to get into that here). There is, however, a pecking order to what you can and can't see. A layer on the bottom is normally invisible — covered up by layers above it. There are exceptions to this, which spices things up — and makes blending possible.

The exceptions are

- **Transparency:** Pixels and layers can be deleted (or not painted). When this happens, what's there is a *transparent* pixel or layer. It still exists, but it has no content. It's like a transparent sheet that allows everything beneath it to show through.

 Transparent areas allow you to blend the contents of different layers together as if they were one solid image. This is very helpful if you want to sharpen one area of an image but not the rest. You would put the sharpened layer above one without extra sharpening and delete pixels from the sharper layer that you don't want to appear sharpened.

 Figure 10-1 illustrates replacement clouds in an image. The rest of the layer has been deleted. You can see the transparent areas as a checkerboard, which allows whatever is underneath this layer to be seen. The bottom layer, which has the building and the rest of the scene, is hidden at the moment. When it is turned on, the clouds blend right in.

Figure 10-1: Transparent pixels are see-through.

✏ **Semi-transparency (also known as *opacity*):** Pixels and layers can be partially transparent. This means they haven't been completely deleted. They're only mostly deleted (like in *The Princess Bride*). This allows content below to show through, but only partially.

Opacity is a great way to blend parts of layers or entire layers together. Overlaying a realistic semi-transparent layer on top of a less realistic version of the image increases the apparent realism of the image.

Figure 10-2 shows the effects of a partially transparent layer on top of the background. The nontransparent pixels in the clouds layer have been selected so you can see their extent. The layer's visibility has been reduced to 49% to blend.

✏ **Blending modes:** This is when you get to change the rules. Normally, opacity is king, which means that layers are blended — or blocked — based on what layers on top are opaque. You can change this behavior to include blending based on lightness, color, differences, and so forth. Refer to Chapter 13 for more about using the Color blending mode to tint images.

✔ **Masking:** Masking is a form of transparency and semi-transparency, but it's not available in Photoshop Elements (except when you're working with panoramas). When you mask something, you're telling Photoshop to hide it, which allows content below to shine through. See Chapter 12 for more on using masks.

If you have Photoshop Elements, you can duplicate the effect of masks by erasing parts of layers. You won't be able to alter the area after it's deleted (which is one of the best things about a mask), but the blending works the same way.

Figure 10-2: Layers can be semi-transparent, too.

Managing layers

Being able to manage your layers is important, especially if you're using them to perform complex image blending. Here are some of the more important layer commands you should be familiar with in Photoshop Elements 8:

✔ **Select a layer.** Click the layer thumbnail or name to select it. This makes the layer active. Just about everything you do (paint, erase, apply adjustments, alter layer opacity, and so on) happens to the selected layer.

✓ **Duplicate a layer.** This creates a copy of the layer you selected and puts it above the original. You have a chance to rename the copy as you create it. I use this all the time in my methodology (which I show you in a bit). To duplicate a layer, right-click (Windows) or Control-click (Mac) the layer in the Layers palette and choose Duplicate Layer.

✓ **Rename a layer.** Being able to rename any layer is helpful to keep track of what you're doing. Rename the layers according to what you're doing with them. For example, you could rename a layer to *Sharpen*, indicating you sharpened it. To rename a layer, double-click its name in the Layers palette. Type in a new name and click elsewhere to complete the operation.

✓ **Drag and drop layers.** Click to drag and then release to drop a layer to change its order in the Layers palette, as shown in Figure 10-3. I don't normally need to move a bunch of layers around, but you can duplicate your Background layer and move it to the top to quickly compare the final versus original image by hiding and showing the new top layer.

Click, drag, and release to reorder a layer.

Click the Eye icon to show/hide a layer.

Figure 10-3: Moving a layer.

✓ **Hide a layer.** Poke the eyeball next to the layer thumbnail (as seen in Figure 10-3) to turn off the layer. Poke the empty box where it was to turn the layer back on.

✓ **Change the opacity.** Use the arrow shown in Figure 10-4 to access the Opacity slider. Move it back and forth to change the opacity of the layer you have chosen. Remember, this affects the selected layer. Make sure you have the correct layer selected before altering the opacity. You can also select the opacity percentage and enter a new value from your keyboard.

Blending Mode drop-down list

Opacity slider

Figure 10-4: Changing layer opacity.

✓ **Use a blending mode.** Select the Blending Mode drop-down list (refer to Figure 10-4) to access the long list of blending modes (discussed in a bit).

✓ **The rest:** Of course, you can delete layers, link layers, merge layers, and so forth, but these commands are beyond what I want to show you. (For more information on these topics, you can pick up *Photoshop Elements 8 For Dummies* by Barbara Obermeier and Ted Padova [Wiley].) The more you study layers, the more you will open up the commands and options. As you do so, you will continue to enhance your ability to edit HDR images.

Mama Mia Methodologia

While I'm talking about layers and how to manage them, this seems like a good place to show you my strategy of how you can use layers effectively in HDR, which boils down to using layers to track your edits — locking them in the file via layers. This allows you to be more consistent, experiment with different approaches to the same image, and go back to any stage in the process to try something new without having to start over from scratch. Following those general principles, you see my detailed workflow. This takes the basic strategy and turns it into a practical series of steps to follow.

Editing with layers

There are pros and cons to the methodology and workflow I use — and you certainly don't have to copy it exactly. I developed this workflow over the years working with photo retouching and restoration, image manipulation, graphics and Web development, and HDR.

To wit, here are the principles, starting with a tone mapped HDR image:

- ✔ **Save as PSD.** Open up your tone mapped HDR image and immediately save it as a Photoshop (PSD) file. This preserves the original tone mapped file. Also, any layers you add will be preserved and editable the next time you open the PSD file.

 The PSD file is, therefore, your highest quality, uncropped, unresized working file. You work with the PSD file until it's finalized and you're ready to publish the image. (For example, if you want to put the image on the Web, you need to reduce the image size and save it as a JPEG to make it small enough that it doesn't choke people's Internet connections.)

- ✔ **Preserve the Background layer.** Preserve the Background layer (as shown in Figure 10-5) as the inviolable source image by duplicating the layer and never making any edits to the Background layer. In this case, it is your tone mapped HDR image that you open up to create the Photoshop file. Keeping the Background layer safe makes it possible to compare your work with the tone mapped original, which in turn makes it possible to evaluate whether your changes look better or worse.

- ✔ **Merge layers.** *Merged layers* are special layers where I combine the results of blended and semi-transparent layers into one opaque working layer. I can show/hide the merged layer by clicking the Eye icon to compare the merged layer against any other layer in the file. This makes it easy to evaluate your progress, and also provides a firm foundation to make more edits on.

 To create a merged layer, select the top, visible layer and then choose Select⇨All. (Should you have any layers above where you want to copy, click the Eye icon to hide them.) Next, choose Edit⇨Copy Merged. Finally, paste the merged layer at the top of the Layers palette and rename it.

 Figure 10-5 shows what this looks like on the Layers palette. The Background layer is untouched and provides the blending base. Noise reduction has been applied to the sky and water, but erased from the trees and bridge. The merged layer rests on top, making the bottom two layers irrelevant except for situational awareness and backtracking purposes.

- ✔ **Duplicate and do:** Duplicate a layer, rename it, and then apply one adjustment to it: one — *and only one* — change. Keeping this simple makes it easy to track your changes, compare results, and backtrack if you need to.

Some people prefer to work with Adjustment layers, but I don't use them. (Adjustment layers are essentially overlays that contain lighting, color, and other edits that affect the layers beneath them — but do not imprint the changes on the layers themselves.) My experience is they create a large file, slowing down my work too much, and make it harder to manage multiple changes. They do, however, preserve the settings better than standard layers do. You can, however, write the settings down for later use.

Lock the Background layer.

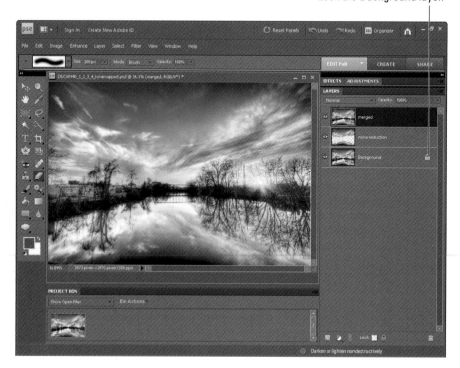

Figure 10-5: Merged layers lock blending layers into a single solid layer.

Depending on the image (follow along with Figure 10-6), I might have the following layers (from top to bottom, as you would see it in the Layers palette):

- **Final:** The final image that I use to save as the final full-sized image or as a new file to continue working. It's the same as the last layer or a merged copy of semi-transparent layers beneath it, but I like having one named Final so I can see it immediately.

- **Transform:** A layer where I had to rotate, reposition, or remove lens distortion.

- **Merged:** Combines the Saturation and Contrast layers, resulting in a solid layer with all the changes.

- **Saturation:** Contains a saturation adjustment. Areas I don't want oversaturated are erased.

- **Contrast:** Contains a contrast adjustment. Areas where I want less contrast are erased.

- **Clone:** Contains the results of cloning out dust or other distractions.

✓ **Merged:** Combines the results of noise reduction with the previous merged layer.

✓ **Noise reduction:** Contains noise reduction, with areas I want left alone either erased or masked out.

✓ **Background:** The original image.

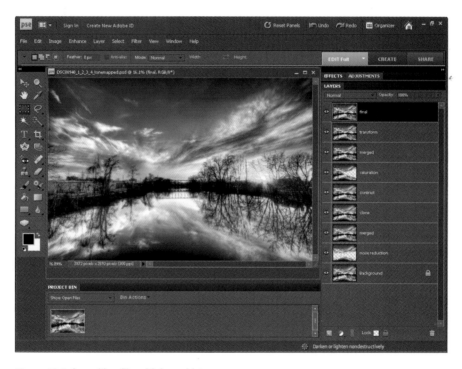

Figure 10-6: A working file with layer history.

If you're new to working with layers, you may feel a little overwhelmed. If that's the case, pay close attention to the screen shots in the next few chapters. You'll see the layers arranged as I've presented here. This approach also represents my workflow, which is coming up next.

The workflow (cue reveal music)

To get to this point, you took bracketed photos, created and tone mapped the HDR image, and then saved the tone mapped image as a JPEG or TIFF. Although you could publish that version to the Web, you'll have a better looking image if you correct problems like noise and make other enhancements like sharpening and contrast adjustments to the tone mapped image before you publish or print it.

The following sections describe my post–tone mapping workflow and why I use it.

Save the image as a PSD

The first step in my workflow is to save the tone mapped image as a PSD as follows:

1. **Open your tone mapped file in Photoshop Elements.**

2. **Choose File➪Save As and save the file in the Photoshop (.psd) format.**

 This ensures you don't overwrite the tone mapped file.

3. **Choose Image➪Mode➪8 Bits/Channel to convert the file to 8 bits.**

If necessary, convert an 16 bits-per-channel tone mapped image to an 8 bits-per-channel image first. Photoshop Elements provides limited support for 16 bits-per-channel images. For example, you can't duplicate the Background layer of a 16 bits-per-channel image in Elements, you can't use the Enhance➪Convert to Black and White command, nor can you use the Filter➪Correct Camera Distortion command to correct lens distortions. However, when I work in Photoshop (which is most of the time), I don't convert my images to 8 bits-per-channel. Photoshop has more mojo on tap to work with 16 bits-per-channel images.

Look for places to blend material from alternate sources

Be on the lookout for areas where you may need to blend material in from alternate sources. For example, if part of the sky is blown out, you might want to replace the blown-out sky with a version that has been tone mapped differently so the sky looks better (what often happens is the rest of the photo stinks, but that's why you're looking to blend the sky in and not a complete image). See the later section, "And Now, Blending in 3-D," to find the details of how to accomplish this.

It's not easy to say in every instance at what point blending should take place. Sometimes, it's best to do this as soon as possible — before sharpening, noise reduction, and so forth. However, you might have to wait and blend later in the process, depending on the tonality of the images you're blending.

Figure 10-7 shows two areas that use alternate sources to blend with the tone mapped background. The sky was a bit blown out, and the lighting in and out of the garage looked bad in this version. The red layer (named helper) is so you can identify the extent of the new material and is not part of the image as I would edit it.

Duplicate the Background layer and sharpen

(Remember, you want to preserve the Background layer so you have the original tone mapped image within this file.)

Figure 10-7: Replacing material immediately in this case.

Create a duplicate of the Background layer, or create a merged copy if you already have several layers. Make sure you rename the layer in the Layers palette. (See the earlier section, "Managing layers," for instructions on duplicating and renaming layers.)

If necessary, sharpen the image (make sure your new duplicate layer is selected first) by choosing Enhance⇨Adjust Sharpness or Enhance⇨ Unsharp Mask. The Adjust Sharpness dialog box appears, as shown in Figure 10-8, where I'm sharpening the building. The sign is a good guide to see the effects. If necessary, use the blending techniques shown in the "And Now, Blending in 3-D" section to isolate what you want sharpened and blend that in with the rest of the image.

From this point on, I assume you get the point about duplicating layers and why I do this. You'll want to keep at it, renaming as you go along. If you have semi-transparent blended layers, duplicating isn't enough. You have to select the entire canvas, perform a merged copy, and then paste that as a new layer. (See the earlier section, "Editing with layers," for instructions.)

Perform noise reduction

Reducing noise is similar to sharpening. Create a duplicate layer, and then choose Filter➪Noise➪ Reduce Noise. Figure 10-9 shows the Reduce Noise dialog box open with the default settings being applied to the sky.

Figure 10-8: Sharpen the duplicate layer.

I perform sharpening and noise reduction first from trial and error. I used to wait to sharpen and remove noise until after I made other adjustments (contrast, levels, color, saturation, and so on). However, I invariably ran into an unfortunate side effect: Sharpening and noise removal altered the look of the image so much that I needed to go back and perform many of the same tasks again. I therefore decided to sharpen and perform noise reduction first and ask questions later.

Figure 10-9: Reduce noise.

Clone away dust and other problems

I tackle dust and other distractions before I make other changes so everything is in place for the tone and brightness changes coming up. To clean up an imperfection, select the Clone Stamp tool, Alt-click (Windows) or Option-click (Mac) a "good" area near the imperfection, and then click the marred spot. I wait until after sharpening/noise reduction because those operations increase or reduce edge contrast, and I prefer not to give them any additional material to alter that isn't in the original.

Check color (that is, white) balance and brightness

Choose Enhance⇨Adjust Lighting⇨ Levels to open the Levels dialog box (as shown in Figure 10-10). Click the Auto button to see whether you like the change. After this, look at the histogram. Then select the individual color channels and examine their histograms.

Sometimes, a correction is necessary; sometimes, it isn't. You can alter an image's contrast through the Levels dialog box, but I prefer to use the Curves dialog box for that.

Figure 10-10: Correct levels.

Correct obnoxious color problems

There's a difference between tweaking color to enhance (which I do later) and solving color problems (which I do here). Sometimes, you'll have an image with too much of a single color. You can control this from the Hue/Saturation dialog box (choose Enhance⇨Adjust Color⇨Adjust Hue/Saturation).

Enhance brightness and contrast

I use the Adjust Color Curves dialog box to enhance the brightness and contrast. Choose Enhance⇨Adjust Color⇨ Adjust Color Curves to open this dialog box, as shown in Figure 10-11.

Detailed info on how to tweak brightness/contrast and many other tasks can be found in this and the following two chapters. Don't worry. Here, I'm talking you through the workflow.

Figure 10-11: Enhance contrast.

You can also choose Enhance⇨Adjust Lighting ⇨Brightness/Contrast or even Enhance⇨Adjust Lighting⇨Shadows/Highlights.

Make creative saturation adjustments

Saturation adjustments can be varied. In general, I look to increase saturation to add some pop. You can also reduce saturation to make the photo look a bit aged. Choose Adjustments⇨Adjust Color⇨Hue/ Saturation to open the Hue/ Saturation dialog box, as shown in Figure 10-12.

Figure 10-12: Increasing color intensity.

Dodge and burn

Use the Dodge or Burn tools to add highlights and shadows where you want them. (The Dodge tool lightens the area you paint, while the Burn tool darkens the area.) When well done, this adds to the overall impact of the photo. Clouds look great when you add tone this way (a smidge of both), as do trees and other greenery. (I normally lighten the highlights of trees.)

(Optional) Convert to black and white

I cover converting images to black and white in Chapter 13. Although it looks like I wait a long time for this step, remember that you don't have to apply every adjustment to every image. For images I know I want to be in black and white, I might skip a lot of the color adjustments unless I think they will add to how the black-and-white image is converted.

Correct distortions and straighten

Correct any lens distortions and straighten the image by choosing Filter⇨Correct Camera Distortion to open the Correct Camera Distortion dialog box, as shown in Figure 10-13. Remember that you're working on a duplicate layer built up from all the previous steps, and you could be up to eight or ten layers by now.

Figure 10-13: Correcting distortion in the image.

I wait until I'm almost done to correct distortion and straighten an image because these corrections (and the following one) change what pixels are visible onscreen. If I want to come back and alter how I corrected the distortion or recomposed the image, I don't have to start everything over from scratch. I simply pick up at the last layer, duplicate it again, choose Filter➪Correct Camera Distortion, and change the settings I used earlier.

You can sometimes combine this and the next step if you don't have any distortion to fix.

Recompose

I save recomposing for last, for the same reason I wait to correct lens distortion next-to-last.

I transform images by enlarging this layer (see Figure 10-14) rather than cropping the entire image. You can see the drag handles and border outside of the image frame — this area is the actual extent of the image and is effectively cropped from view by this technique. There are some drawbacks to this — mainly that it takes up a lot of memory and can make performance sluggish. If your computer can handle it, however, this method preserves all the layers underneath in their uncropped state.

Figure 10-14: Recomposing the image.

If your computer is getting sluggish because your image file is too big and bulky (hence the overall memory load is getting larger and larger), save the file, and then simplify your layer structure by deleting everything but your uppermost working layer and background. Save the image as a new working version with a new filename. Continue working in the new, slimmer file — starting where you left off.

You can also choose Select➪All and then Image➪Crop to erase everything outside the image boundaries. This deletes all the super-sized extra stuff.

Publish

Your original tone mapped file was either a JPEG or TIFF. You should be working with a Photoshop Elements (PSD) file when you're editing to enhance the image. When you publish your final image, save a new version of the PSD as a JPEG (for Web use) or a TIFF (for archive and printing).

And Now, Blending in 3-D

Clearly, some edits don't require blending. Say the image looks great. A little sharpening across the image is fine. There is no need for noise reduction. You don't see any reason (creative or otherwise) to blend different changes together. Cool. That happens. And when it does, don't mess it up by over-working the image.

On the other hand, sometimes it's not so simple. You might want to sharpen one part of the image more than the rest, or add a touch of realism to the entire image. You can do these things, and more, if you blend results from different adjustments on different layers.

Blending enables you to think and edit in three dimensions.

Blending with opacity

One of the simplest ways to blend two or more layers is to lower the opacity of the upper layers. I often use opacity blending to add a touch of realism back into a tone mapped image, especially with people.

I use this technique all the time. Say you want to make a contrast adjustment but decide to tone it down some — just follow these steps:

1. **Duplicate the layer on which you want to make the adjustment.**

 This is another reason to work with different layers: It opens up a number of blending opportunities.

2. **Make the adjustment.**

 The contrast adjustment is good, but a little too strong. (See the left side of Figure 10-15.) Rather than continually undoing and redoing, it's simpler to blend the right strength by altering opacity on the contrast layer. See the right side of Figure 10-15.

3. **Create a merged layer, as described in the earlier section, "Editing with layers." (See Figure 10-16.)**

4. **Continue working.**

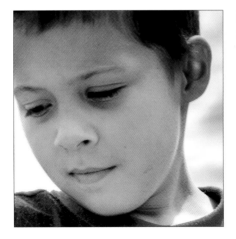
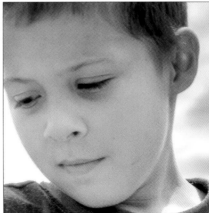

Figure 10-15: Blending just the right amount.

Photoshop has an Edit⇨Fade command that essentially works the same way as opacity blending. Make the adjustment you wish, and then immediately fade it by a certain percentage. I prefer to use layers because you can fiddle with it later, but you might find Fade worth your time.

You can stack a number of layers on top of each other, each having their own opacity, to create a very complex blend. As described in Chapter 13, this is an effective way of colorizing or tinting an image.

Figure 10-16: Locking in the blend.

Blending select areas

Unfortunately, Photoshop Elements doesn't allow you to create and edit masks. Masks make the selective application of changes to an image pretty easy — and you can edit the mask after you create it.

You can duplicate the effects of masking with the good old-fashioned Eraser, though. Here's how.

1. **Duplicate the layer on which you want to make the adjustment.**

 In this case (see Figure 10-17), I duplicated the Background layer twice — once for a sharpening adjustment and another to reduce noise. This is an alternate method that splits sharpening and noise reduction. Instead of performing one adjustment on top of the other, they will be completely independent and blended after the fact.

Figure 10-17: Create duplicate layers to work with.

2. **Make the adjustments.**

 In this example, I'm sharpening the foreground and reducing noise in the sky on two separate layers. Figure 10-18 shows the Layers palette after the adjustments have been made and the layers renamed. They're ready to blend.

3. **Select the Eraser tool and erase what you don't want sharpened on the sharpen layer.**

 Because this isn't a mask, you have to be careful and erase only what you don't want to see sharpened. Don't be afraid to undo. Change brush sizes and hardness to make erasing easier. You want to blend the edges, so stay away from hard brushes.

Figure 10-18: Ready to blend.

I'm erasing the sky in Figure 10-19 because it doesn't need to be sharpened. In fact, if you sharpen skies with too much noise, you end up with sharp noise that's even harder to remove than the traditional variety. Notice that the other layers are hidden. This ensures you are working on the right layer and are erasing only what you want to.

In Figure 10-20, I switched to the noise reduction layer and am erasing the cityscape, which needs no noise reduction. Again, I turned off the other layers so I can tell exactly what I'm doing.

TIP

If you want to get really creative, combine this technique with altering layer opacity. In other words, reduce the strength of your noise reduction and sharpening layers to blend them with the background. The blending possibilities are astounding.

Figure 10-19: Erase areas to leave unsharpened.

4. Create a merged layer to lock in your changes to one layer, as described in the "Editing with layers" section.

It helps to leave the Background layer (or another one underneath the operation) on when you copy the merged layers. This makes sure you have no transparent or semi-transparent pixels in the mix. Figure 10-21 shows the blended and merged copy layer, resting atop the work layers. If everything blended together nicely, this is your new Background layer.

5. Continue working.

The great thing about this technique is that you can use it with any number of layers. If you want a lot of noise reduction in the sky, some on the buildings, a little in the water, and none in the trees, create three duplicate layers, adjust them differently, and then erase the areas you don't need. They will blend together (along with the base layer, which remained unchanged) to form a completely customized and blended result.

If you're using Photoshop or another application that supports masks, use masks instead. They have the advantage of being flexible — you can edit what is hidden and what is exposed.

Figure 10-20: Erase areas to ignore noise reduction.

Photoshop versus Photoshop Elements

Yes, Photoshop has even more powerful and creative ways to blend layers together than its little brother Photoshop Elements. What would you expect from the leading photo editing application? There are a few differences between Photoshop and Elements that you might find interesting.

Layers in Photoshop have blending options based on a tonal range you define. Aside from selecting a blend mode and opacity, you can specify advanced blending parameters and set blending conditions on the tonality of the current layer or that below. To access these features,

right-click the layer in the Layers palette and choose Blending Options.

The other major difference is the fact that Photoshop supports (and that's an understatement) masks. Elements does not, except when you open a Photoshop file with masks in it, create a panorama, or use clipping masks (which is a type of mask, but not comparable to the classic mask). Masks are wonderful tools to use: like erasing part of the layer without erasing it because you can always go back and refine the mask.

Figure 10-21: Merging the results.

Using blending modes

Blending modes are powerful ways to control — yes, you guessed it — blending. The default blending mode in Photoshop Elements is called Normal, which is based on opacity. A number of blending modes are available in Photoshop Elements, and some are more useful than others. Table 10-1 shows how they are grouped into different sections on the menu.

Table 10-1	**Photoshop Elements Blending Modes**	
Mode	*Use*	*Types*
Normal	Blends based on opacity	Normal and Dissolve
Darken	Darken the image	Includes Darken, Multiply, Color Burn, Linear Burn, and Darker Color
Lighten	Lighten the image	Includes Lighten, Screen, Color Dodge, Linear Dodge (Add), and Lighter Color

(continued)

Table 10-1 *(continued)*

Mode	Use	Types
Contrast	In general, alters the contrast of the image	Includes Overlay, Soft Light, Hard Light, Vivid Light, Pin Light, and Hard Mix
Compare	Look for similarities or differences between the layers	Includes Difference and Exclusion
Color	Compares the hue, saturation, color, or luminosity of the layers to create a blend.	Includes Hue, Saturation, Color, and Luminosity

To use blending modes, follow these steps:

1. **Duplicate the layer you want to make the adjustment to.**

2. **(Optional) Make adjustments.**

 In this example, I made two creative decisions. First, I turned the duplicate layer into a gradient map by choosing Filter⬦Adjustments⬦ Gradient Map (see Figure 10-22).

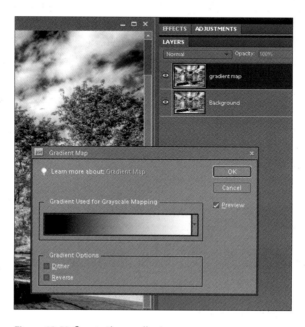

Figure 10-22: Create the gradient map.

Next, I colorized the gradient map layer by choosing Enhance⇨Adjust Color⇨Hue Saturation. The dialog box is shown in Figure 10-23.

You don't actually have to make adjustments — changing the blending mode doesn't require you to. However, this is a creative way to show you another way to colorize an image.

3. **Select a mode from the Blending Mode drop-down list.**

In this case, I selected Hue. The effects are shown in Figure 10-24.

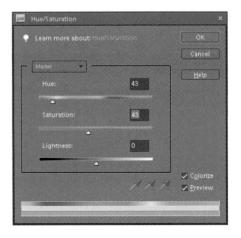

Figure 10-23: Colorizing the gradient map layer.

Figure 10-24: Change the blend mode.

4. **Create a merged layer, as described earlier in the "Editing with layers" section.**

5. **Continue working.**

Of course, you can stack layers, each with a different blending mode, for complex results. Most often, however, you'll use a single layer above another.

Cleaning Up Your Photos

In This Chapter

▶ Reducing noise

▶ Removing distractions

▶ Resolving distortion

▶ Reworking color and saturation

▶ Re-leveling lightness

▶ Re-something-or-other to do with smoothing

▶ Publishing your HDR photos on the Web or printing them

*T*one mapped images don't always come out of your favorite HDR application looking perfect. In fact, most of the time, they need further editing before they're "perfect." Some images have too much noise (a common problem with HDR) in general, or they may need different levels of noise reduction in different areas. Some have dust, moving objects, or other distracting things that are best removed. Many images have lens distortion, which wide angle lenses tend to accentuate. At times, you'll see color problems — too much, too little, too much of a single color, or the wrong color. And on top of all this, artifacts can appear in tone mapped images that are the result of movement in the scene.

This chapter shows you common problems that plague HDR images and gives you solid techniques to combat them. I show you how to reduce noise and blend that reduction in with the rest of the image, and I show you a few different ways to remove distractions, such as dust and other objects.

This chapter won't show you how to correct every image problem in the known universe in every possible way — but you won't run into many problems that aren't here or in the other chapters. (This chapter is organized by types of problems and doesn't reflect the contents of the entire editing workflow. For workflow information, see Chapter 10.)

Hey! Keep the Noise Down in There!

Noise, as I mention several times throughout this book, is problematic for HDR. Although you can attempt to reduce noise in other parts of the HDR process, you have the most control over where, how, and how much to remove in post-tone mapping editing.

The thing to remember with noise is that you are always on the horns of a dilemma (see Figure 11-1):

- ✔ **Too little:** If you're not firm enough, you'll leave unwanted noise in your image.

- ✔ **Too much:** If you're too aggressive, you can destroy lines and detail in your images, resulting in something without sharpness — a soft image. (Chapter 15 holds other examples of too much noise reduction.)

Well, the point of noise reduction is to reduce noise, right? If you don't go far enough, you leave in noise — but if you go too far, you can hurt the image. What's a person to do?

 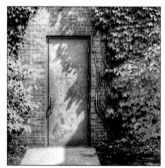 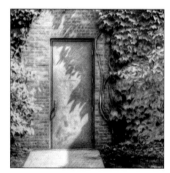

Figure 11-1: Noise reduction: too little (left), just right (middle), too much (right).

Global noise smackdown

You can always apply noise reduction to the entire layer you're working on. This is the massive retaliation option. See it. Smack it. Smell the burn.

It's pretty easy to do, too, which is a bonus. (See *Photoshop Elements 8 For Dummies* by Barbara Obermeier and Ted Padova [Wiley] for plenty of details about using Elements.)

Here's how to apply noise reduction in Photoshop Elements:

1. **Duplicate the layer you want to make the adjustment on.**

 See Chapter 10 for my rationale on working with different layers.

 You can't duplicate the Background layer in Photoshop Elements if you haven't converted the image to 8 Bits/Channel.

 Figure 11-2 illustrates a working *noise reduction* layer above the background. Apply noise reduction to this layer, and then duplicate it and continue working. You end up with a file with layers stacked on each other — each with a different adjustment.

Figure 11-2: Preparing the working layer first.

2. **Choose Filter⇨Noise⇨Reduce Noise to start the process.**

3. **In the Reduce Noise dialog box that opens (see Figure 11-3), choose from**

Figure 11-3: Reducing noise.

- *Strength (0–10):* Determine how strongly you want to seek out and destroy noise. The catch is that Strength targets noise (the random, mottled specks of random pixels) that's gray, black, or white — *luminance noise.*

- *Preserve Details (0–100%):* Set how much you want to try to protect edge details in the image. This basically allows you to set a high Strength and have Elements remove noise in larger areas but not overdo it when it comes to lines and edges.

- *Reduce Color Noise (0–100%):* Set this strength setting for noise that shows up in the image as variations in color.

- *Remove JPEG Artifact:* If you see JPEG compression artifacts, selecting this check box tries to take them out. This shouldn't be much of a problem for your HDR images.

4. **Select OK to apply noise reduction.**

5. **Continue working.**

Although you can use other methods for noise reduction in Photoshop Elements, Reduce Noise is the most applicable to HDR images because it works well to reduce noise without as much blurring, and happens to be more customizable than alternate methods. Try the other methods (accessible from the Filters⇨Noise menu), though, to see whether they work for you in certain circumstances:

✓ **Despeckle:** This filter blurs everything except edges and produces a much softer image, which is fine in theory, or when you have a lot of speckles. You have no control over the strength, though, but you can blend. See the before and after in Figure 11-4.

✔ **Dust & Scratches:** Don't confuse this filter as having anything to do with removing sensor dust spots (which are normally much larger). It basically blends pixels together that contrast. Not a bad solution for actual dust and scratches on scanned prints, but even a light application renders a tone mapped image pretty blurry. See the before and after in Figure 11-5.

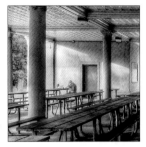

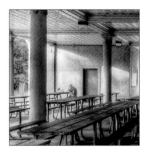

Figure 11-4: Despeckle before and after.

✔ **Median:** The Median filter is sort of an averaging method that replaces pixels with the median value of pixels that surround them. This area can be large (resulting in a ton of blurring) or small (which still results in blurring, but not so much that you want to hurl). See the before and after in Figure 11-6.

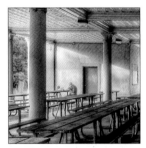

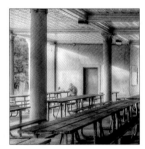

Figure 11-5: Dust & Scratches before and after.

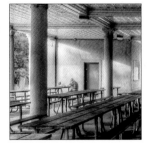

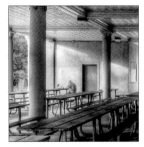

Figure 11-6: Median before and after.

Select and reduce

Applying noise reduction to an entire layer has its strengths and weaknesses. One big weakness is the fact that you might not need the same level of noise reduction across the image. This is definitely a factor for photos that contain a lot of texture and detail — trees, concrete, rocks, hair, and so forth. One method to get around this is to select the noisy areas first and then apply noise reduction to those specific areas. The drawback to this is that selecting complex areas with any metaphysical degree of certitude is often very hard, which means you'll end up with compromises, or it will take forever.

Figure 11-7 shows an image taken from a bridge. The iron latticework makes for a tough selection. I've tried to select areas I want to reduce noise in with the Magic Wand, and the result is poor.

On the other hand, there's not much difference between selecting areas versus erasing them in Elements (as part of blending) or using a mask in Photoshop. The supreme advantage to a mask, of course, is being able to change the masked area after the fact. After all, after you delete something, it's gone.

For me, the tiebreaker comes down to a desire to keep noise reduction isolated to separate layers, and blending the results afterward.

Figure 11-7: Selecting complex areas first is fraught with difficulties.

Masked reduction

The next step up the ladder of sophistication is masked (or erased) noise reduction. This works very well for landscape shots with a good deal of sky and possibly water. Here's how:

1. **Duplicate the layer you want to make the adjustment on.**

2. **Choose Filter⇨Noise⇨Reduce Noise.**

3. **From the Reduce Noise dialog box, choose the noise reduction options you want (refer to the earlier section, "Global noise smackdown") and then click OK.**

4. **Make sure the reduce noise layer is active, and then erase the areas you don't want noise reduction applied to.**

 You can choose a few different methods to erase areas from the noise reduction layer. This blends the reduction in with layers below that have no noise reduction applied.

 • *Select and delete.* Switch to your favorite selection method, select areas to erase, and then delete them.

- *Select, invert, and delete.* Sometimes it's easier to select the opposite areas. For example, the sky tends to benefit from noise reduction much more than trees and the ground. In this scenario, using the Magic Wand to select areas to delete (trees and the ground) is almost impossible because those areas have too much texture and variability. It's far easier to use the Magic Wand to select the sky, invert the selection (choose Selection⇨Inverse), and delete.

- *Erase.* Switch to the Eraser and erase the areas of the layer you don't want to see.

 Elements offers a few different erasers. The standard Eraser is manual mode. There are also the Background Eraser and the Magic Eraser. The Background Eraser erases material similar to where you first click and erase in the image — it assumes you are erasing the background. The Magic Eraser acts like the Magic Wand. Click an area you want to delete, and presto! — it's gone!

- *Opt for the combo platter.* I normally switch to the Lasso and quickly outline areas I want to delete, as shown in Figure 11-8. The trees and buildings in this scene I'm selecting don't need noise reduction, so they can be deleted from this layer. The layer beneath — the Background in this case — shows through and preserves their sharpness. This is a rough selection. No need to spend an inordinate amount of time on it.

I then use the Eraser in Brush mode to fine-tune the border, as shown in Figure 11-9, changing brushes to suit the conditions. Don't let yourself get too wrapped up in precision here. It's important not to be sloppy, but the border doesn't need to be exact. That's the beauty of blending. I go over the lines a bit into the sky to make sure the edges of the trees aren't softened, and I just don't worry about the part of the sky that gets erased.

Figure 11-8: Quickly selecting areas to delete.

Figure 11-9: Cleaning up the border.

One big (and negative) difference between Elements and Photoshop rears its head when you try to figure out how to alter a brush's hardness

in Elements. You can't (for most, that is — the Background Eraser and Healing Brush are two exceptions).

Change hardness for the normal Eraser in Elements by selecting different brushes or switching the Eraser mode from Brush to Pencil or Block.

5. Perform a merged copy (see Chapter 10) and continue working.

This consolidates the effects of the blend into one solid layer.

Multiple masked reduction

The pinnacle of noise reduction methodology is to apply tailored noise reduction levels to specific areas of the image by using multiple layers and masks (or the Eraser, in the case of Elements). Although that sounds complicated, I think you'll find the most you'll ever practically need is two levels of noise reduction, possibly three. If you see other parts of the image you want to try different levels of noise reduction on, duplicate the last un-noise-reduced layer you have and apply a different amount of noise reduction to the newly duplicated layer.

Figure 11-10 shows three noise reduction layers being finished. Apply the noise reduction first; then delete what you don't need out of each layer. Remember, the three layers have different noise reduction strength. More for the ceiling, less for the walls, and just a bit for the floor.

Figure 11-10: Erasing unneeded areas.

Arrange the noise reduction layers so the areas you have applied the noise reduction to are visible and don't conflict with each other. In Figure 11-11, the three areas don't overlap. Notice that when all the noise reduction layers are on, there is still quite a bit of transparent areas. That's because those areas have no noise reduction at all.

Figure 11-11: Arranged and visible — noise reduction layers blend together.

After you get your noise reduction layers finalized, turn on the Background layer (or the next layer underneath) and create a merged copy to lock the adjustments onto one layer.

We Have the Technology: Cloning

Cloning is one of the most important techniques you should master if you want total control over your HDR images. I realize that makes it sound like you're some sort of evil super-genius bent on taking over the world. It isn't that scary. Basically, it means you're not held hostage by dust and other distractions.

Ye olde feather duster

Dust, while not always a problem, is certainly an irritant with dSLRs. The problem is caused by constantly removing and reattaching lenses. Without the lens on, dust floats through the hole where it was mounted and gets on the sensor. Even if you never take off the lens, the cameras aren't air-tight.

Dust, which shows up as big blobs on photos, is most noticeable in the sky or other light, evenly toned areas. You might not see it (hence, it won't be a problem) in more complex areas of your image, such as in trees and grass.

I use the Spot Healing Brush as my feather duster in most situations:

1. **Duplicate the layer you want to make the adjustment on.**

2. **Select the Spot Healing Brush and set the size large enough to cover the dust.**

3. **Paint over the dust spot with a circular motion.**

Wax on, wax off, as shown in Figure 11-12. Notice that I'm brushing just enough to cover the spot. When you release the mouse button, the new material is applied. Make sure to check that it's okay. There is another dust spot (you can see them most clearly in the sky) to the left of the one I am removing.

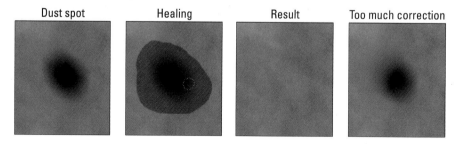

| Dust spot | Healing | Result | Too much correction |

Figure 11-12: Dusting with the Spot Healing Brush.

Sometimes the Spot Healing Brush mangles the texture of an area or pulls in unwanted material to cover the spot (see the final panel of Figure 11-12). It should be obvious. When this happens, undo and repeat. Or, if you need more control, switch to the Healing Brush or use the Clone Stamp tool.

Removing distractions

Dust isn't the only thing you'll want to remove from your photos. Other distracting objects can take attention away from the subject or make the scene less than desirable. Notice the large shadow to the left in Figure 11-13? Nuke it.

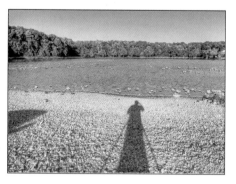

Figure 11-13: The shadow to the left distracts.

The Spot Healing Brush is too large and unwieldy to use. After all, it's not a spot. Switch to the Clone Stamp tool — but that's not all. Create a new, empty layer and name it *clone*. Use this layer to apply the new material to. This is yet another way to blend. If you don't like the job, you're not stuck. You can switch to the Eraser and erase the changes you just made, and then start over.

Change the size of the Clone Stamp tool to cover a reasonable amount of space. You don't want it too small, or it will take forever. Nor do you want it too large — that makes your fixes easier to spot. Nor do you want it too hard —

that makes the edges too easy to spot. You want it juuust right.

Select the Sample All Layers check box (on the toolbar) and make sure that the empty clone layer is active. This is the layer you want to paint on. Alt-click (Windows)/Option-click (Mac) to set the source location, and then paint over the destination; see this in action in Figure 11-14.

Figure 11-14: Clone away a distracting shadow.

Select a new source area regularly. Mix it up, but pay attention. If the texture and tones don't match, the replacement will be visible for all to see. You want it to be hidden (see the result in Figure 11-15). In addition, you don't want features to repeat. In this case, if you can see the same rocks over and over, start over.

Not everything is as complicated as a shadow on rocks. The left panel of Figure 11-16 shows an irritating yellow-green light in a line of trees at dusk. Using the Clone Stamp tool, select an area beside the source and then paint over the light (the right panel of the figure). It gets pretty easy with practice.

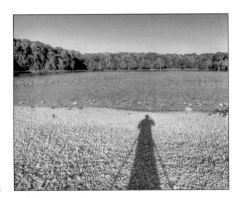

Figure 11-15: Watch that tones match and nothing obvious repeats.

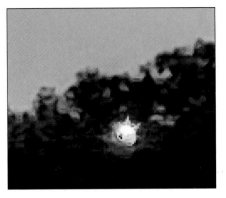

Figure 11-16: Clone away a ghost light.

Not all cloning is cosmetic. The left panel of Figure 11-17 shows an area on a building that has color bleed from a banner to the building surface. This is a tone mapping oddity. To remove it, select the Clone Stamp tool and move into an unaffected area (one building block down in the image) to select the source area. See the result on the right side of the figure.

Figure 11-17: Cloning sometimes solves tone mapping problems.

Fixing Lens Distortions

Look at something with straight lines. It could be your computer monitor, tiles on your bathroom wall, bricks, a fence, or graph paper taped to your wall. Are the lines straight? They should be. Now take a photograph of the same scene and examine whether the lines are straight in the photo or not. Most likely, they won't be — even if you're using a very expensive lens and camera. You're seeing distortion in action.

Distortion happens when something that should be straight appears curved in your photographs. There are three types of lens distortion, as well as two types of distortion caused by how you hold the camera:

✔ **Lens**

 • *Barrel:* The center of the image bulges out. (See Figure 11–18.)

Barrel

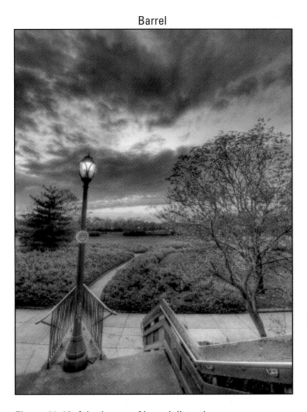

Figure 11-18: A bad case of barrel distortion.

- *Pincushion:* The center of the image is pinched inward.
- *Combination:* Uneven distortion of either type (barrel or pincushion) that generally looks worse in the center but tapers off to almost straight by the edges of the image.

✔ **Camera position**

- *Vertical:* When vertical lines aren't straight, you have vertical distortion. This happens when you point the camera up or down, which causes vertical lines to either fall away or toward you, respectively. See examples of vertical distortion in Figure 11-19.
- *Horizontal:* When horizontal lines aren't parallel to the ground, you have horizontal distortion. This happens when you point the camera left or right of the lines, which causes horizontal lines to cant one way or the other.

Figure 11-19: Vertical distortion.

To fix lens distortion, choose Filter⇨Correct Camera Distortion. In the Correct Camera Distortion dialog box that opens, as shown in Figure 11-20, there are several convenient options to choose:

- ✔ **Remove Distortion:** Repairs barrel (positive values correct bulging by pushing the center in) or pincushion (negative values correct pinching by pulling the center out) distortion. Notice the fairly large positive value I'm using here: This helps straighten out the lamppost (compared against the left panel of Figure 11-18).

 Use the grid lines (select the Show Grid check box at the bottom of the dialog box) to line things up (as shown in Figure 11-20), or turn the grid off to see the image better. You can change the color of the grid, plus zoom in and out.

- ✔ **Vignette:** Lightens (positive values) or darkens (negative values) the corners of the image. Use to correct or cause vignetting. Adjust the Midpoint slider to change how little or how much the vignetting extends into the image.

Figure 11-20: Correcting camera distortion.

✔ **Vertical Perspective:** Adjust to make vertical lines vertical. Notice the large value in this example. This was necessary to make the lamppost vertical.

✔ **Horizontal Perspective:** Adjust to make horizontal lines horizontal.

✔ **Angle:** Straightens the image.

✔ **Scale:** Enlarges the image. The one caveat here is that unlike transforming the image in the main window, you lose whatever extends beyond the dialog box preview window. In other words, it crops after it enlarges. For this reason, I never use Scale. (I show it in this example, however, so you can compare with the previous image and see the overall effect of the transformation.)

To illustrate the effect, Figure 11-21 shows what happens when you add vignetting. If your images come out of tone mapping like this, correct it here. Not all vignetting is bad — some can look artistic. Notice, too, barrel and vertical distortion are corrected, the grid lines are off, and the image was scaled upward a bit to make it appear full-screen.

Figure 11-21: Vignetting.

Solving Color and Saturation Problems

When you shoot color photographs, it stands to reason that you'll occasionally run into color problems — in fact, a lot of the time. I can't discuss all the different ways to address color in Photoshop Elements (and other programs) here. However, I want to show a few common problems and possible solutions (note the terminology — you can often use one of several techniques successfully).

Oversaturation

Oversaturation means having too much color. It's too intense. Most often, you'll see this reflected in a general hue, such as purple or red. The left panel of Figure 11-22 illustrates the base of a lamppost at sunset. It's got far too much red in it.

Adjust oversaturation by choosing Enhance⇨Adjust Color⇨Adjust Hue/Saturation. From the Hue/Saturation dialog box, choose the problem color from the drop-down list (it defaults to Master) and then reduce the saturation until the color looks right, as shown in the right panel of Figure 11-22.

Did you notice that the sunset doesn't look as good after the desaturation? Use the blending techniques to isolate the desaturated area to the lamppost.

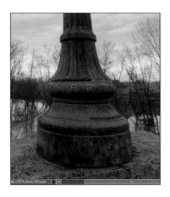

Figure 11-22: Selective desaturation solves the problem.

Color casts

Color cast is a type of color problem that happens a lot, and you might not even be aware of it. There are several ways to combat the problem: Levels (to adjust white balance), removing color cast, and photo filters.

The left panel of Figure 11-23 shows a tile wall where the color is off — the whites are too warm. Use Levels to correct the white balance. Choose Enhance➪Adjust Lighting➪Levels. In the Levels dialog box, as shown in the right panel of Figure 11-23, click the right-most eyedropper and click something in the image that should be white. What was not white automatically becomes white (theoretically, it's a little like playing the lottery sometimes).

Figure 11-23: Correcting white balance with Levels.

That one was obvious. The next example (Figure 11-24) isn't. In the top-left panel of the figure, the ceiling should be white. It isn't. In this case, try Enhance⇨Adjust Color⇨Remove Color Cast. From the dialog box that opens, click to select a black, gray, or white object in the photo.

That part takes a bit of trial and error. Try clicking different places of the image until you get the right color. You can see the result in the top-right panel of the figure here.

The next example shows the power of photo filters. You can use them to cool or warm an image. The left panel in Figure 11-25 (all these are tone mapped HDR images, by the way) is too warm. In other words, it looks too yellow-red. As a fix, choose Filter⇨Adjustments⇨Photo Filter to try out photo filters. The options in the Photo Filter dialog box (the right panel of the figure) are pretty intuitive: Choose a filter type based on the description or a solid color and then choose a density to apply to the filter. In this case, I applied a cooling filter (visually, blues cool and reds warm an image) and tinkered with the density to get the right strength. The result looks pretty good.

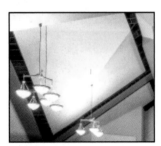 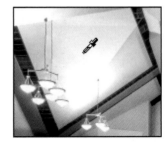

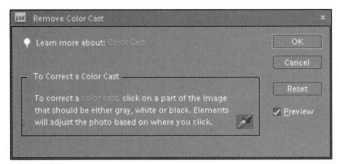

Figure 11-24: Automatically remove the color cast.

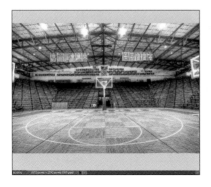 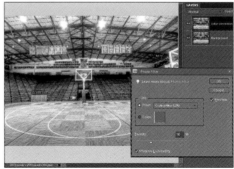

Figure 11-25: Using photo filters.

Levels and Lightness

If you have brightness problems, use Levels as a good way to brighten or darken an image. Figure 11-26 shows a scene that came out of tone mapping a bit too dark. Not to worry. You don't have to fret over problems like this in tone mapping because you have a good chance of fixing them in editing.

Choose Enhance⇨Adjust Lighting⇨ Levels to open the Levels dialog box, as shown in Figure 11-27. To lighten an image, drag the white triangle under the main histogram (the graph) to the left, as shown. To darken an image, drag the black triangle to the right. Drag the gray triangle to move midtones up (darkens) or down (lightens).

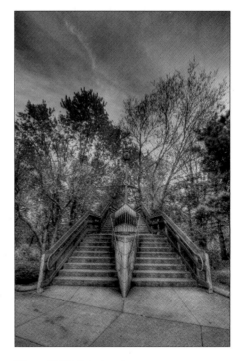

Figure 11-26: A dark stairway.

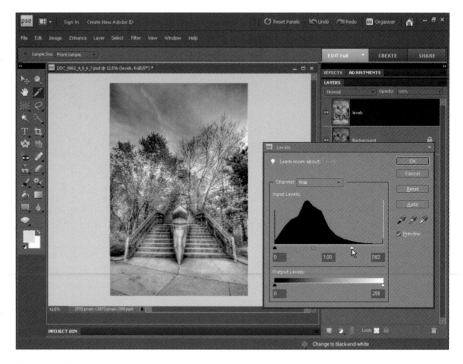

Figure 11-27: Brightening with Levels.

You can achieve very similar results by using a simpler method of adjusting brightness and contrast from the Brightness/Contrast dialog box (Enhance⇨Adjust Lighting⇨Brightness and Contrast). Just use the two sliders there, as shown in Figure 11-28. The downside of this approach is that it lightens or darkens every pixel, which may or may not be what you want.

Figure 11-28: Brighten and add contrast.

Smoothing Rough Spots

Rough spots (see Figure 11-29) happen in tone mapping when you have motion that oscillates. This is most obvious in plants, trees, and water, where subtle back-and-forth movement is captured by bracketed exposures.

You can't correct rough spots while you generate the HDR image or during tone mapping. I find the best solution is to smooth these areas as I edit. I do this at the point in my workflow where I would otherwise clone.

Here's how to smooth these spots to make them less distracting:

Figure 11-29: Rough tone mapping spots.

1. **Duplicate the layer you want to make the adjustment on.**

 See Chapter 10 for my rationale on working with different layers.

2. **Zoom in to see the problem closely.**

3. **Select the Blur tool.**

 This tool looks like a water droplet and is located with the Sharpen and Smudge tools, near the bottom of the toolbar.

4. **Adjust tool characteristics.**

 Set the size and strength to fit the nature of the problem.

5. **Brush the problem area.**

 Use the Blur tool to brush the edges of the rough spot to blend it in with the surroundings.

6. **Continue working with your image.**

Turning Your Images Loose: Publishing

Publishing or printing your photo is the final step in the HDR process. Snap on your chinstrap, fire up Elements, and get going:

1. **(Optional) Enter file info by choosing File➪File Info and entering any file and copyright information you wish. Then save the final working copy as a Photoshop Elements (.psd) file.**

2. **Choose File➪Duplicate to create an identical copy of the Photoshop file, and then close the original.**

 This step is for safety so that you don't accidentally save and overwrite the layered Photoshop file and lose all your work.

3. **Make sure the right layers are visible, and then choose Layer➪ Flatten Image.**

4. **Save the image as a high-resolution TIFF by choosing File➪Save As.**

 For archival and printing purposes, save the image as a high-resolution (that is, unresized) TIFF. I always append the term `-final` to these TIFFs so that I can differentiate them from the tone mapped images that come from Photomatix Pro. Accept the default save settings unless you have reasons for changing them.

 If you want to print your image, send this TIFF to a commercial photo printer or print the image on your own home printer.

5. **If you want to create a JPEG to post on the Web, resize the image by choosing Image➪Resize➪Image Size.**

 Although you can jump ahead to Step 11 and choose File➪Save for Web, that routine is not optimized for large files, and you will get a warning to that effect. I find it best if I resize at this point.

6. **In the Image Size dialog box (shown in Figure 11-30), select the Resample Image check box if it isn't already checked.**

7. **Select a resampling method from the drop-down list at the bottom of the dialog box:**

 Figure 11-30: Preparing to resize.

 - *Nearest Neighbor:* Preserves hard edges. This definitely does what it says. Pay careful attention when you use this method. Examine the edges at 100% magnification to look for any jaggedness from the sharp edges.

 - *Bilinear:* A good method. The colors are good, and the image is smooth. You lose a bit of sharpness, however.

 - *Bicubic:* Best for smooth gradients. Similar results to Bilinear but a bit sharper.

 - *Bicubic Smoother:* Best if you're enlarging the image. When reducing, this method looks almost indistinguishable from plain 'ol Bicubic.

 - *Bicubic Sharper:* Best if you're reducing the image size. Distinctly sharper than all the other methods. Use this method or sharpen after you reduce the image to its final size to preserve the effects.

8. **In the Pixel Dimensions section, select Pixels from the Width and Height drop-down lists, and enter new pixel dimensions in the Width text box. Then click OK.**

 If the Constrain Proportions check box is selected, you need to enter only one dimension, and the other will automatically be calculated and set by Elements.

 For moderately sized Web galleries, 800 pixels is a good width to start with. If you want something larger, head on up toward 1024 pixels wide. (If your photo is in portrait orientation, enter the dimension in the Height text box instead.)

9. **(Optional) Add a text or graphic watermark.**

 If you have a watermark to copyright your work, add it as a layer now. I put my name in the bottom-right corner of the image. I set up a helper file that has my name already entered, complete with a green block to help me align it (see Figure 11-31). I open this image and drag the layers (they are linked) to the HDR image, as shown in the figure. I then close the helper file and reposition the name to the corner. I then hide or delete the green block (green so I can see that it's there very easily) later. If you want your watermark to be less obvious, reduce its opacity.

Figure 11-31: Add a watermark as a layer.

Elements doesn't let you create embedded watermarks unless you use the File⇨Process Multiple Files workaround.

Do not apply a watermark to your high-resolution final TIFF (created in Step 4). Save watermarking as one of the last steps before publishing so you can customize the size of the mark to your final output size.

10. (Optional) Add a frame or other decorative elements.

An easy way to add a border is to choose Image⇨Resize⇨Canvas Size. In the Canvas Size dialog box, select the Relative check box, enter how much to extend the canvas in the New Size section (each side is increased by half the number you enter, totaling the full amount), and then select a color from the Canvas Extension Color drop-down list. Click OK. I do this step twice — first, I add a 4 pixel (px) increase with white, and then a 2px increase in black.

11. Choose File⇨Save for Web.

If you want all the EXIF data preserved, choose File⇨Save As, choose the JPEG file format, and then click Save. At the next dialog box, enter the quality you want (you can probably leave the other options alone) and click OK.

In the Save for Web dialog box (shown in Figure 11-32), follow these steps:

a. *Select JPEG High from the Preset drop-down list.*

b. *Select a percentage from the Quality drop-down list.* A lower percentage makes the file smaller (see the preview window for the estimated size given the current settings) but at the cost of quality. Select a higher percentage for, you guessed it, higher quality. The cost is a larger file size.

c. *Zoom in (use the Zoom drop-down list in the bottom-left corner) to see whether the quality you chose works.* I find that 80 is a good compromise. If you want no compromises, select 100.

d. *Select the ICC Profile check box to save the image with the color profile embedded.* This is preferred because it gives a Web browser or other application the information it needs to accurately render the colors contained in the image.

12. When you're ready, click OK. Choose a location and name; then click Save.

13. Close the TIFF without saving it.

This is important. *Do not* to save the TIFF. After all, you resized it. If you make a mistake and overwrite it, you can go back to your Photoshop Elements file and re-create the TIFF. I'm a backup-to-the-backup kind of guy.

Figure 11-32: This JPEG was made for savin'.

Part IV
Having Fun with HDR Images

The 5th Wave By Rich Tennant

"You should see the HDR photo of this area.
It's like we're standing right there.

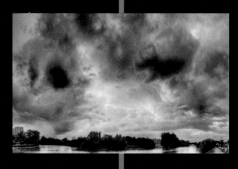

In this part . . .

Brackets? Check. HDR? Check. Tone mapping?
Check. Are you done? Not quite. This part is
about having some extra fun with your HDR
images.

Chapter 12 shows you how to work around the
limitations of your camera and create ultra-wide
panoramas in HDR. You find out how to break the
scene up into pieces, photograph them, then turn
the separate shots into bona-fide HDR images and
stitch them together to create a seamless compos-
ite. Chapter 13 shows you several ways to turn a
color image into black and white. Although it
might sound goofy — taking color photos with a
digital camera to turn into HDR images only to
take the color out — it's actually a great way to
showcase some of your photos and create power-
ful, dramatic shots. You also see how to colorize a
black-and-white image to make it look old, odd, or
just awesome.

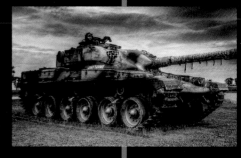

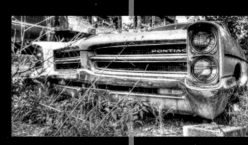

12

Creating Panor-Ahhh-Mas

In This Chapter

▷ Photographing HDR panoramas

▷ Processing the darned things

▷ Sewing the frames together in Elements

*F*ind some room to move around. This chapter starts out a bit like an aerobics class.

Look straight ahead and stretch your arms straight in front of you. Keeping them straight, pull your arms back (like opening a double door) until you can't see them anymore. Still looking straight ahead, bring your arms back forward until they just come back into your field of vision. Keeping your arms in position, look to the left and right to see where they are. This exercise (pun intended) shows you what human eyes see panoramically, which is a pretty wide angle of view — about 120 degrees or so, including peripheral vision. However, unless you're working with a wide or ultra-wide angle lens, this isn't what camera sees, so photos don't come close to this.

So how can you create panoramas? No need for fancy equipment. With any lens you have in your kit (even compact digital or super-zoom cameras work well for panoramas, as long as you can use them for HDR), you can create a single wide-angle image by merging multiple frames. Akin to HDR, you take more than one photo of a scene to create a single final image. Panoramas and HDR go well together: Panorama techniques extend your angle of view, and HDR captures a greater dynamic range of the scene. And this chapter is dedicated to helping you create exciting HDR panoramas, whether indoors or out.

Shooting Panoramas in HDR

Shooting a panorama in HDR is the same as shooting a traditional panorama except that you take three to five times the number of photos. This takes into account brackets for each section of the panorama. You process the results as HDR images and then tone map them before you stitch the whole thing together as a panoramic view.

The best way to start is to start:

1. **Select a scene and configure your camera to shoot brackets for HDR.**

 Have a look at Chapters 4 and 5 for more information or if your memory needs refreshed.

 Use whatever bracketing method your camera supports and that you're comfortable with. You might not be able to use certain auto modes, depending on your camera. (See the next step.)

 You could conceivably shoot single-exposure HDR, but if you're going to the trouble to set up a tripod (which you should) to shoot a panorama, you might as well go the whole mile and shoot the brackets, too. The exception to this might be scenes with moving subjects.

2. **Tweak specific settings for panoramas.**

 Ideally, you want your camera in completely manual mode (so white balance, focus, and the center exposure for the brackets don't change willy-nilly), but this isn't always possible. At a minimum, try these tweaks:

 - *White balance:* Take white balance off Auto and set it to the conditions (sunlight, cloudy, and so on). This way, it won't change from one frame to another even if the lighting is different. You want consistency across the entire panorama.

 - *Focus:* Switch to manual focus to maintain a consistent depth of field (the focal point won't move to and fro within the scene). Using auto focus can easily change from one frame of the panorama to the next; that's bad.

3. **Mount and level your camera on a tripod.**

Don't skip the leveling. You want your camera to rotate about an axis that is as true to vertical as you can get it. Rotate your camera and check that it stays level when you point it in a different direction.

4. Determine your framing strategy.

Most people rush this step and just start shooting photos. Relax and take a few minutes to plan this. At a minimum, try for three frames. Center the subject of the panorama in the center frame, making sure to always have good overlap. If you need more than three frames and have a strong subject, center the subject as best you can in one frame and shoot the same number of frames on each side, balancing the panorama. Overlap shouldn't be a problem with this scenario — you'll have plenty.

As you can see from Figure 12-1, the number of frames you need depends on the angle of view of your lens and the scene at hand. Wide and ultra-wide angle lenses require fewer shots to capture the same scene compared with lenses of longer focal lengths. In my example, the magic number of frames is four.

Important: Try to overlap each frame by about one-third, as seen in Figure 12-2. Overlap helps the panorama program *stitch* (assemble) the frames by providing good reference points. The more reference points, the greater the possibility of a successful stitch in your assembly software.

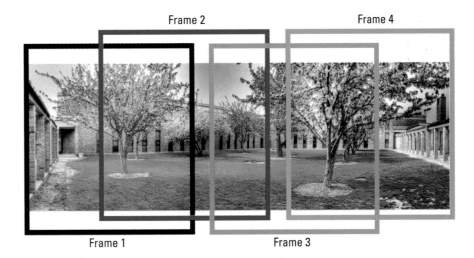

Figure 12-1: Envisioning a framing strategy.

Frame overlap

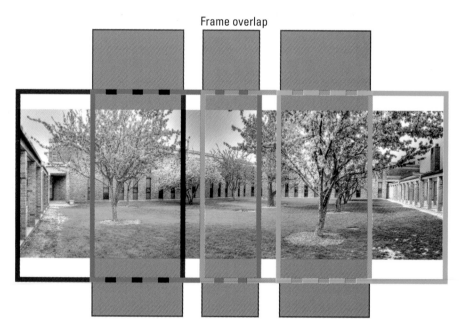

Figure 12-2: Plan for plenty of overlap.

5. Check the alignment of each shot.

This can be a dry run where you don't take the photos, or you can go ahead and shoot them. Doesn't really matter. The important part is checking out landmarks that help you identify the boundaries of your frames and how much overlap you'll get.

As you can see from Figure 12-3, trees make outstanding landmarks. In fact, anything that stands out from the background — and vertical objects seem to work best — serves as a landmark.

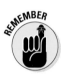

If you have a tripod with a compass, you can make a note of the reading for the center point of each frame.

Take a few meter readings along the way to see whether exposure varies from one side of the panorama to the other. HDR is more forgiving than single-exposure panoramas because of the brackets (the point of HDR, really).

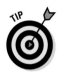

Make sure you capture as much dynamic range of the scene as possible while not blowing out any highlights. Decide on a final exposure. If in extreme doubt, shoot a bracketed panorama with one central exposure (the 0.0 EV point); then capture another with different settings.

6. **Pan to the right-most frame and double-check the exposure.**

Landmarks

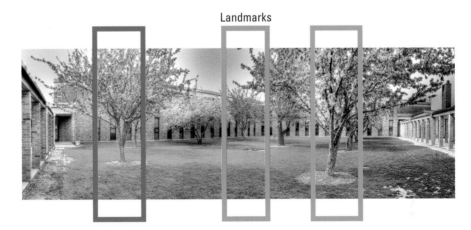

Figure 12-3: Look for landmarks to identify frame boundaries.

Sure, you can start on the left if you want. There is no technical reason to shoot one way over another except personal preference. You can try to shoot the center frame first and then move left and right, but it's more natural to shoot left-to-right or right-to-left.

Make sure the exposure you decided on is dialed in and set.

I recommend shooting in Manual mode so the camera can't change the exposure. If you're in a semi-auto or automatic mode, the camera can change settings every time you check exposure.

7. **Shoot the first bracketed set (see Figure 12-4).**

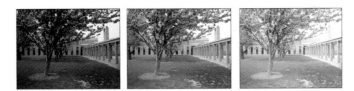

Figure 12-4: The first bracketed panorama frame.

8. Pan to the next frame and shoot another bracketed set (see Figure 12-5).

 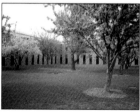 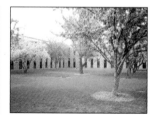

Figure 12-5: The second bracketed panorama frame.

9. Pan to the next frame and shoot another bracketed set (see Figure 12-6).

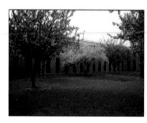 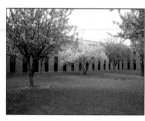 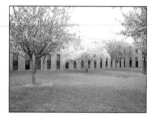

Figure 12-6: The third bracketed panorama frame.

10. If necessary, continue shooting frames to complete the panorama.

Figure 12-7 shows the fourth and final set of brackets for this panorama.

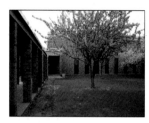 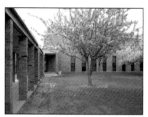

Figure 12-7: The final bracketed panorama frame.

Figure 12-8 shows the final, tone mapped panorama.

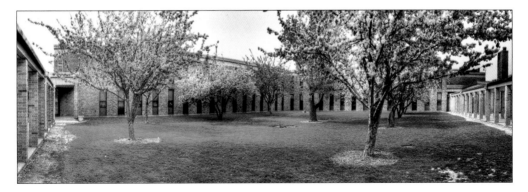

Figure 12-8: The completed panorama.

Going the extra mile

Shooting panoramas is a whole 'nother world with its own set of specialized gear and techniques. If you're not shooting professionally, you don't really need to worry about the differences between casual and professional panoramas. If you want the most professional results and the highest quality images, however, here are a few things you should do to up your game.

First, buy a dedicated panorama tripod head, which moves the axis of rotation from somewhere in the camera body (where the screw goes in using a normal tripod head) to a point that is the optical center of the lens. There is confusion about what this point is called: the no-parallax point, the entrance pupil, or the nodal point.

Shooting frames that revolve around the no-parallax point reduces or eliminates *parallax* (a visual side effect where nearby objects move in relation to far objects between frames, like your finger moves against the background when you look at it with one eye, and then the other). You have to dial in this point by taking test shots and moving the camera forward or backward in the panorama head mount.

You can also change the orientation of your camera to vertical (portrait). This is easier to do on some tripod heads than others, but it's a breeze if you have a panorama head. The benefit of shooting portrait panoramas is having more photo to use after you stitch the images. You will be sure to capture enough area so that when you crop the final image, you won't be forced to make incredibly painful decisions on what to lose. The downside is that you'll have to shoot more frames from left to right, but that's easier than shooting two rows or wider frames to capture the same area.

Processing Panoramas As HDR

Taking the photos is only the first part of creating a panorama. Now you need to process your shots as HDR images.

You can, of course, do this the hard way — prepare and tone map all your brackets manually. Depending on how many frames and brackets you have, that might take some time. Conservatively, you should have three frames of three brackets each (nine images). As a time-saver, take advantage of as much automated processing as possible.

Developing Raw photos in bulk

Not every Raw editor can process Raw photos automatically: Sony Image Data Converter, for example. Some, like Adobe Camera Raw, enable you to open all the images into the interface at once and apply one setting to every image. Much better.

If you use Adobe Lightroom or Apple Aperture (see Figure 12-9, where I have selected three random photos of hash browns to illustrate this concept), you can select multiple Raw files and export them as TIFFs, or use the Quick Develop tool in Lightroom as a pseudo-batch processor before you export.

Figure 12-9: Exporting hash browns for breakfast.

Other applications, like Nikon Capture NX 2, have full-featured batch routines that make it possible to process every exposure in an HDR panorama without opening them all up. Batch-processing Raw images is also addressed in Chapter 9.

To ease the processing burden on your computer, convert Raw photos to 8-bit TIFFs or JPEGs. Yes, you'll suffer a bit of a quality hit, but if the photos are well taken, it won't be noticeable with the 8-bit TIFF — and JPEGs might look fine, too.

Creating an HDR master frame

The most efficient way to proceed with HDR is to create a master, tone mapped frame and use that as the template to process the other frames of the panorama in HDR. (HDR and tone mapping information is more fully covered in Chapters 7–9.) After you create the master frame, you have the settings you need to plug into your HDR application's batch routine. This also ensures consistency across the panorama. You don't want to use one set of HDR options and tone mapping settings for one frame of the panorama and a completely different set for the next.

Thankfully, creating a master frame is exactly like generating an HDR image from normal brackets and tone mapping it in your HDR application. Figure 12-10 illustrates creating the master frame HDR image. This is used to tone map the master frame — which can then be discarded. The only reason to do this is to get the settings you want in a file.

Next, tone map the master frame. This is necessary to find what settings you want applied to the entire panorama. Then save the settings.

Mac users: Save your tone mapping settings when you save the file. This takes an extra step. Windows users can check a box on the Save As dialog box and have Photomatix Pro always save the settings with the file (very handy, that is).

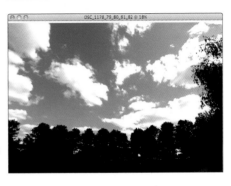

Figure 12-10: Create the HDR master frame image.

Batch-processing the rest

With your master frame completed, batch-process the rest of the panorama. Here's how in Photomatix Pro, after you process your Raw images (if necessary; discussed earlier) and then create and tone map the master frame (as shown earlier and in Chapters 7–9). Your goal is a settings file that can be used during batch processing. You don't even need to save the tone mapped image.

1. **Organize the source images in a new folder.**

 You can use JPEGs, 8-bit TIFFS, or 16-bit TIFFs. It's up to you. I find it easiest to identify an entire folder to perform batch processing on. This keeps things separate so you're assured of processing the images you want and not others. And I always keep original Raw photos in a safe place, well away from Raw editors and HDR applications.

2. **Create a destination folder.**

3. **In Photomatix Pro in the Workflow Shortcuts window (this window should automatically appear when you run Photomatix Pro), click the Batch Processing button.**

 You use the Batch Processing of Differently Exposed Images dialog box to enter all the information required to automatically create the HDR and tone map all the images for your panorama. Pretty cool.

 See Chapter 9 for detailed steps to batch-process the images for your panorama.

4. **Select the Tone Map with Details Enhancer check box and then click the Settings button.**

 You're presented with a tone mapping settings dialog box.

5. **Although you can enter the settings manually, click the Load button; in the Load Tone Mapping Settings from and XMP File dialog box, select the master frame tone mapping settings XMP file, and then click the Load button, as shown in Figure 12-11.**

Figure 12-11: Select the saved master frame tone mapping settings.

This is where creating the master frame tone mapping settings file pays off.

The rest of the steps to batch-process images are identical to those given in Chapter 9.

Figure 12-12 shows the final panorama, edited and cropped. You can see from this figure how important it is to have the same settings applied to each frame of the panorama. Otherwise, you would easily be able to tell where one frame ends and the other begins. Your goal, after all, is seamlessness.

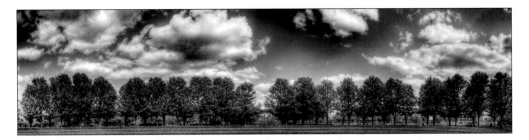

Figure 12-12: This nice line of trees is actually in a semi-circle.

Stitching the Elements Together

Time to stitch the tone mapped images. Panoramas don't just merge themselves, you know. You need to use specialized software algorithingamajigs to combine separate images into a cohesive whole. Photoshop Elements offers Photomerge, and Photoshop has a very similar capability (coincidentally, also called Photomerge — maybe the lawyers should look into that).

Stitching in Photoshop Elements

Stitching panoramas together in Photoshop Elements isn't that hard. You might need a few run-throughs before you get totally comfortable with it, but it's mostly automated.

Elements is a little goofy when it comes to working with 16-bit images. If you open tone mapped files that are 16 bits per channel, Elements prompts you to convert the bit depth before you begin. However, Photomerge gets stuck after the first image and refuses to continue opening and stitching images together (no matter how many times you curse at it), so it's rather pointless. Instead, open 16-bit images in Elements and convert them to 8 bits (when you save them, consider renaming the files if you want to preserve the 16-bit images for some other purpose), or save the tone mapped images as 8-bit JPEGs or TIFFs directly from your HDR application.

After you have all the brackets you want to stitch together into a panorama saved as 8-bit images, follow these steps:

1. **Open Photoshop Elements and start Photomerge by choosing File➪ New➪Photomerge Panorama.**

 As Figure 12-13 shows, the Photomerge dialog box appears, beckoning you toward panoramic greatness.

Figure 12-13: The Photomerge dialog box.

2. **Click the Browse button, and in the Open dialog box that appears, browse to the folder containing the tone mapped frames of the panorama, select them, and then click OK.**

 The Open dialog box closes, and the selected files appear in a new, untitled image document as a stitched panorama.

3. **Choose a layout by selecting one of the radio buttons in the Layout section of the Photomerge dialog box.**

 • *Auto:* You're telling Elements to go for it, allowing it to choose between Perspective and Cylindrical layouts.

 • *Perspective:* The center of the panorama remains unchanged, and the outer areas are distorted so that horizontal lines parallel to the ground remain parallel to the ground.

The major side effect of this layout is the "bow-tie effect," in which the center of the panorama looks normal, but the corners are heavily distorted. You lose this area when you crop the final image. Figure 12-14 shows what happens when perspective goes bad. This is how you know to choose another method. Elements can't properly configure this panorama as a perspective.

Figure 12-14: Won't you take me to (daah, da dat) (wait for it) Funky Town?

- *Cylindrical:* This projection eliminates the bow-tie effect on the corners and results in a panorama where the corners aren't distorted up and out. In fact, the corners are allowed to do the opposite — that is, creep in. Figure 12-15 shows that the sky can balloon up. Everything that isn't a nice, tidy rectangle gets cropped out at the end.

- *Reposition Only:* This layout aligns each frame (based again on matching reference points) but does not transform them in any way.

This option, contrary to what you might think (we often fall prey to the notion that correcting for perspective is always better), can produce very good-looking panoramas that do not suffer from undue amounts of distortion. Figure 12-16 illustrates this layout in action. Overall, it looks good, but the horizon looks too wavy to me. I favor Cylindrical for this panorama.

Figure 12-15: Ah, that's better.

Figure 12-16: Repo-sition, man.

- *Interactive Layout:* This is the do-it-yourself option, as shown in Figure 12-17. Elements opens a lightbox with your panorama stitched for you (the images it can do so automatically, at any rate), and gives you the control to override the existing layout.

 You can zoom in and out, click and drag frames to reposition them, rotate individual frames, and change the settings from Reposition

Only to Perspective. If you select the Perspective radio button, you can even set the Vanishing Point of the image.

Figure 12-17: Laying it out in the lightbox.

4. **Click OK.**

 Elements aligns and processes the images and eventually creates the panorama as a new image. Each frame occupies a separate layer, with portions *masked* (hidden) to blend together well. ***Note:*** This is one of the few times Elements allows you to work with masks.

5. **Save your panorama!**

 I find it best to save the raw panorama as a Photoshop file (`.psd`) now for future reference before I tweak frame blending and make other adjustments. Then I save the finalized panorama image as a separate file.

Blending the frames with layer masks

Blending allows you to tweak how Elements masked the different layers and then stitched them to create the composite image. This process is useful if something looks better on one frame of the panorama but that spot has been masked by Elements in favor of the same spot in another frame that doesn't look as good. This requires some playing around.

Masks in Photoshop Elements (and other image editors) make certain pixels transparent on a layer, allowing what's on the next layer down to show through. Look ahead to Figure 12-18 and check out the Layers palette — the black and white blobs are the masks on those layers. The black parts are

transparent (so you see through to the layer underneath), and the white parts are "solid." The great thing about masks is that you can use grays to make the corresponding parts of that layer partially transparent, which for this chapter means that you can create smooth blending of the transitions between frames of the panorama. (Chapter 10 goes into more detail about using masks and layers for blending in HDR images.)

If you see a strong border where there is a mask, soften it by smoothing the mask edge. Or, if you like something on a layer that's masked (a tree looks better in one frame than another, for example), unmask the better tree and mask over the tree in the other frames. It takes some practice to get the hang of it because you're working in three dimensions. Where layers overlap each other, you can choose which layer you want to see by virtue of layer order and masking — just follow these steps:

1. **Find the areas that don't look quite right, and click the Eye icon to show and hide the layers to see where the borders are.**

 Hint: You can erase or paint black or white onto the mask to enlarge, shrink, or soften it.

 Figure 12-18 shows a border that looks like trouble. You can see the edge between one frame and the next. This is a prime candidate for blending.

 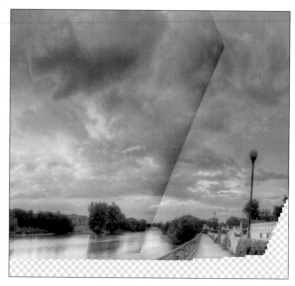

 Figure 12-18: This border needs a-blending.

2. **Click the layer mask you want to work with in the Layers palette.**

 Make sure you select the mask — not the image. The mask has a white highlight around it when you secure it, as shown in Figure 12-19.

3. **Click the small white-over-black box under the main color swatches to select the default foreground and background colors — then switch them by clicking the color-swap arrows above the background color swatch.**

Oddly enough, Elements 8 swapped these so that the default foreground is black and background is white. Ugh.

This sets the foreground color to white and the background color to black — colors you'll see when you start painting or erasing.

4. **Select a tool (such as the Brush tool) to paint the mask. Paint with black (making those parts transparent) or white (making those parts solid).**

You can also use the Eraser tool

Figure 12-19: Selecting the top layer mask.

if you don't like switching between black and white. In Figure 12-20, I'm using the Eraser tool with a soft brush tip selected (which is important to keep the edges from being too harsh) to better blend it with the layer beneath. You might find it helpful to reduce the Opacity setting to 50% or so to avoid abrupt changes in tone.

Figure 12-20: Smooth a border by adjusting the mask.

Cropping the finalized image

Cropping is a final step in creating your panorama, so you want to make sure you finish other edits first: Blend the transitions, sharpen, correct the color, improve contrast, reduce noise, and so on.

This workflow preserves your options longer. If you crop first, you're stuck with it. If you want to go back and crop the panorama in a different way, you have to perform all the edits again to get back to the same place. So I recommend that you first make all your edits, and then save the panorama as a working Photoshop Elements file. After you crop, save the image again (with a new name and type) as a final file to publish: for example, as a JPEG if you want to publish the image on the Web, or as a TIFF if you want to print it.

To crop your panorama, follow these steps:

1. **Zoom out to see the entire panorama.**

2. **Select the Crop tool, and drag a border around the area you want to keep.**

 Figure 12-21 shows the crop box positioned over the bottom part of the panorama. Unfortunately, there's not much that can be done to rescue transparent areas. Cropping panoramas is a fact of life.

3. **Zoom in to see more precisely and then adjust the crop borders to weed out any transparent pixels.**

Figure 12-21: Positioning the crop box.

Figure 12-22 shows the bottom-left corner of the panorama at high magnification. The light areas show where the rough crop box was. I am moving it into the image so the crop box won't have any transparent pixels.

4. **Click the check mark (refer to Figure 12-21) to apply the crop.**

Figure 12-23 shows the finished, cropped, panorama.

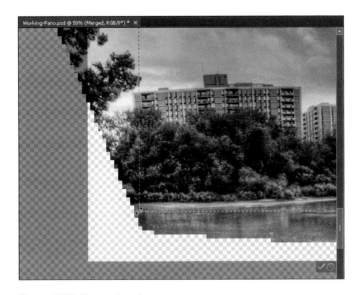

Figure 12-22: Fine-tuning the crop.

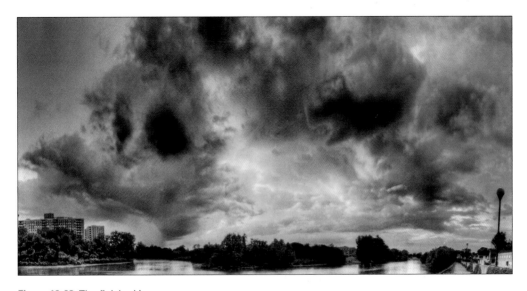

Figure 12-23: The finished image.

Love panoramas? Check out PTGui!

PTGui (www.ptgui.com; $120 for the more basic version and $200 for PTGui Pro) is a powerful all-in-one panorama application, dedicated to supporting specialized panorama features, such as customizable control points and significantly more projection types as Photoshop Elements. (See the following figure.) If you want to control just about every conceivable part of the panorama process and are considering displaying or selling your panoramas professionally, PTGui is for you. PTGui allows you to enter information about the camera and lens, and enables you to edit the stitched-together frames in the Panorama Editor. PTGui gives you lots of options on controlling how the panorama looks, how the frames fit together, and how they're aligned.

PTGui has a developed following and robust support system on the Web. If you're serious about creating HDR panoramas, download either or both trial versions and have a closer look for yourself. The Pro version even has its own HDR and tone mapping features.

13

Going Old School with Black-and-White HDR

*H*DR in *black and white*? I can hear the exclamations from here. Why go to all that trouble to photograph multiple brackets of a scene, lovingly tone map it, and then throw away all that hard-earned color data? Why, for heaven's sake, take a modern digital camera with more computing power in it than the Apollo moon program and go so freakishly retro? Why? You're just fooling yourself! You take the photo in color, generate the HDR in color, tone map it in color, and then pretend to create a black-and-white "photograph." It's all nonsense!

Yes. Yes. Yes, and yes. It is.

Black-and-white HDR photography is a lot like love. Yes, love. You can rarely explain it, and it's hardly logical. I love thee, because thou satisfiest the rational in me. Pshaw. Black-and-white HDR photography satisfies the creative artist bent on love in all of us. We love it because it is, and that's what this chapter is about: describing it a bit, and then showing you how to turn your HDR photos into spectacular black and white.

Seeing That Special Something

In general, you should convert an HDR photo to black and white for the same reasons you would convert any other photo. Those reasons boil down to aesthetics (it looks cool and makes a statement in black and white) or solving color problems (color has problems, so maybe black and white looks better). The difference is how the HDR tone mapping process gives you more to work with from the outset. You'll have more contrast, more tone — more of everything — leaving you with a more interesting and powerful black-and-white image.

Analyze the photos in this section and see whether you agree with me that these images work as black and white as well or better than as color HDR. Hopefully, you'll see why you should even bother because converting photos to black and white is another step to incorporate into your workflow.

Emphasizing contrast

HDR photography excels at emphasizing contrast — and not just in color but in black and white, too. Black-and-white photos are beautiful studies in contrast. With color removed from the photo, your eyes tune in to differences between black and white or light and dark much more readily. The result is a new and pleasing perspective.

Figure 13-1 is just such a case. The color photo, an interesting study in HDR, has a number of elements that pull your eyes away from the study of contrast: the inside, outside, the man sitting at the far end of the pavilion, picnic tables, and green of the trees versus the browns and grays inside. However, the same photo converted to black and white is a concentrated study in contrast. HDR accentuates details that make contrast more interesting, but the black-and-white conversion removes distractions.

Six degrees of black and white

Of the many ways to create black-and-white HDR, whatever method you choose and when you employ it depends on the applications you use and how much effort you want to put into it. Having said that, you can create pretty good results quickly and easily in most programs. So, all the fuss in this chapter comes down to degree.

In general, you'll achieve the best results (and the greatest power to control the outcome) if you use Photoshop, Lightroom, or another application that allows you to individually tweak the black and white tones.

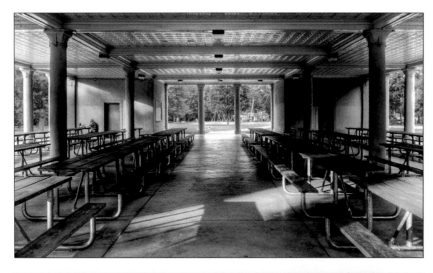

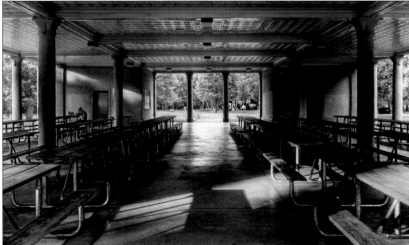

Figure 13-1: The black-and-white version tells the story of contrast.

Reveling in tone

Some people live in a world of color. Things are azul, rojo, amarillo, anaranjado, morado, or verde (a little Spanish there for ya). Tone isn't that black and white. Tone, in fact, is a world with nuanced shades of gray. Figure 13-2 is a tough one. The color version of this shot is good with the chrome, the blue sky, and rusty dump truck. The part of this photo is boring (the color of the car) and lost in a sea of other details.

Figure 13-2: Tones rock black-and-white photos.

In black and white, however, the story gels and becomes much more concentrated. It's not about color anymore, but about the different levels of tone. These different components that make up the scene are no longer disjointed — thrown together by circumstance. They fit in a cohesive whole in black and white and tell a singular story.

Solving color problems

Sometimes color HDR photos just don't look good. For whatever reason, Figure 13-3, a single-exposure HDR image, is such a case. The color version, as you can see, just isn't that interesting, even in HDR. The objects that draw your eyes are the line of green trees and the color markings on the Mustang. The clouds and tarmac aren't captivating, and the aircraft itself is unremarkable.

In black and white, though, the photo explodes with interesting tones. The clouds and concrete are more interesting, and the silver of the plane has a gorgeous tone that was hidden in color. The color was removed, therefore, and replaced with shades of gray. The difference is astounding.

Figure 13-3: Black and white can solve color issues.

Focusing on the subject

Black-and-white photos sometimes have the effect of bringing you closer to the subject of the photo. Depending on how you process it, you can accentuate certain elements by lightening them, or reduce their importance by darkening them. In Figure 13-4, the color HDR image suffers from an overly busy background that pulls attention off the subject (the tree and park bench). In the black-and-white version, though, the sky is darker and areas of the tree lighter. This pulls attention to the front-center of the photo and allows your eyes to explore the simple setting. Now the background is more appropriately background.

Figure 13-4: This subject stands out better in black and white.

Converting Early in the HDR Process

One option to create black-and-white HDR images is to convert your color photos to black and white before using them to generate the HDR image. You have two options to choose from if this is the direction you want to go in:

- Convert during Raw conversion.
- Convert during tone mapping.

Marching orders

If you're wondering what order to do things in — you know, should you convert to black and white before or after you sharpen? Before or after you increase contrast? Before or after you transform, resize, reshape? — here's my strategy. I tend to create the best color image I can, complete with sharpening, noise reduction, cloning, and any other adjustments I want to make. It's done. Then I move to black and white. This way, if I decide I don't like how the

black-and-white image turned out, I don't have to do everything all over again. I just pick up the finished color image and go back to the black-and-white drawing board.

Your mileage may vary, but I have to think that all the obsession over creating the perfect workflow is often overrated from a quality perspective. Use the workflow that preserves quality, but also time.

Using a Raw editor

If you convert during Raw conversion, you must shoot your images and brackets in Raw and be prepared to convert them to black and white in your favorite Raw converter. Depending on the strength of the application you use, you can have more or less control over the process.

If you shoot using JPEGs only, these methods (as they pertain to Raw photos) are not applicable to you.

Here are a few examples of the options you might have:

- **Desaturation:** This method certainly works, but you have no control over toning. Photoshop Elements (via Adobe Camera Raw) and certain Raw editors (such as the Sony Image Data Converter) offer this option. Sometimes, the only way to convert a photo to black and white is to completely desaturate it (in addition to altering its contrast, sharpness, and so forth).

- **Cameraesque presets:** Nikon's Capture NX 2 has handy presets that enable you to convert a color photo to black and white. Choose a camera preset with filter (green, red, and so in) from the Color Mode drop-down list in the Picture Control palette, as shown in Figure 13-5. You can also convert Raw photos using New Additional Adjustments in NX 2 (at the bottom of the Edit List panel).

 Apple Aperture works the same way but also allows for a level of custom control.

Figure 13-5: Choosing black and white presets.

✓ **Robust black-and-white toning:** Applications such as Photoshop and
Adobe Lightroom both contain extensive black-and-white conversion
routines. These are covered more fully later in the chapter, but you can
see the Lightroom interface active in Figure 13-6. I am using the Develop
tab to convert a Nikon Raw image to black and white.

Figure 13-6: More controls for a custom conversion.

If you want to convert your bracketed photos to black and white before processing them as HDR, apply the exact same settings to all images. This ensures a consistent conversion.

Desaturating while you tone map

You may also (depending on the options of your HDR application) convert an HDR image to black and white while you tone map. Conversion using a standard color saturation control is very simple. Reduce it to 0 and you're done, as shown in Figure 13-7. Photomatix Pro has a few saturation options (different controls for highlights and shadows), but overall color intensity is controlled by the Color Saturation setting. Setting it to 0 turns the image to grayscale.

Figure 13-7: Desaturating in the HDR application.

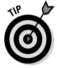

Try tone mapping the color image until you reach the effect you're after, and then reduce saturation to 0 to convert it to black and white. Alternatively, reduce Color Saturation to 0 first; then manipulate the other settings to achieve the best look for the image.

The downside to converting color HDR images to black and white at this stage is generally a loss of control. Color saturation settings are simple, and you have very few, if any, options to manage the tones you want.

Converting a Tone Mapped HDR Image

There are a number of methods to convert a color, tone mapped image to black and white after the HDR process. Use your favorite image editor (in this case, I use Photoshop Elements and Photoshop).

Weighing in on the grayscale

Converting an image to grayscale is a very simple procedure. That's the upside. The downside is that you have no control over the process. Contrary to what you may think, there is no appreciable difference between the total number of shades of gray in a grayscale image and one converted to black and white using the other methods in this chapter, as long as you're comparing images at 8 bits per channel. If you convert a 16-bit image to grayscale, the total number of shades rises to 32,768. (As an aside, *grayscale* is the technically correct term for black and white photography. The photos and images are made up of shades of gray. A true black-and-white image has only two colors — black and white.)

In Photoshop Elements, choose Image⇨Mode⇨ Grayscale. When prompted to throw the image's color information away, click OK.

Desaturayayayayshun

Another simple technique to get a fast black-and-white image is by desaturation. You can accomplish this in Elements by choosing Enhance⇨Adjust Color⇨Adjust Hue/Saturation and then reducing Saturation to 0 in the dialog box, as shown in Figure 13-8.

Using Convert to Black and White

Photoshop Elements has a handy Convert to Black and White feature that gives you some creative control over the process. It's probably the most popular method to convert a color image to black and white in Elements.

Figure 13-8: Desaturating an image.

Finish editing the image. This includes noise reduction, contrast enhancements, sharpening, and all other applicable steps shown in the workflow presented in Chapter 10. You should have a layer ready to convert to black and white.

Duplicating the background

I like duplicating the Background layer before I make any changes. This preserves the original, tone mapped image in the file and allows me to go back and start over if I need to. In Photoshop or Photoshop Elements, right-click the background layer and choose Duplicate Layer. Rename the new layer and continue.

To use the Convert to Black and White feature in Photoshop Elements, follow these steps:

1. **Choose Enhance⇨Convert to Black and White.**

 The Convert to Black and White dialog box (see Figure 13-9) has the following sections:

Figure 13-9: Converting to black and white in Photoshop Elements.

- *Preview:* In the Before and After windows, see the effects of the settings you choose.

- *Select a Style:* From this handy list of presets, choose from styles that blend color information (intensity, not hue) from the three color channels. See a comparison in Figure 13-10.

- *Adjustment Intensity:* Use these sliders to adjust the percentage of each color channel (Red, Green, and Blue) used in the conversion. Ideally, they should add up to 100%, but you have some creative latitude. You can also alter contrast using the Contrast slider.

2. **Make adjustments to the conversion by moving the Red, Green, Blue, and Contrast sliders. If you don't like the results, click the Undo button. If you really mess up, click the Reset button to remove all your changes and start over.**

Figure 13-10: The different presets in action.

A little change goes a long way here. Too much, and the image will be white (too much intensity coming from one or all channels). Too little, and the image will be black. Over-accentuating contrast tends to poster-ize the image, although that can sometimes be a cool artistic effect.

3. **When you're finished and want to approve the conversion, click OK.**

 The image is converted and appears in the Elements workspace, as shown in Figure 13-11.

Figure 13-11: Ready for more editing.

This isn't the last stage of image processing. You'll want to save your work, most likely as a Photoshop (.psd) file and continue editing. In particular, black-and-white images benefit from further contrast enhancements as well as dodging and burning. For more information on additional editing tech-niques, see Chapters 10 and 11.

Using a gradient map

Most people don't think of using gradient maps to convert images to black and white, but the results are very good. I happened across it quite by acci-dent one day. The thought occurred to me, "If I ever write a book called *High*

Dynamic Range Digital Photography For Dummies and am working on a chapter entitled 'Going Old School with Black-and-White HDR,' then I need to use this!"

In Photoshop Elements, follow these steps:

1. **Choose Layer⇨New Adjustment Layer⇨Gradient Map to create an adjustment layer.**

 This calls up the New Layer dialog box, as shown in Figure 13-12. Click OK to continue.

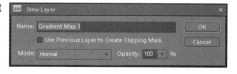

Figure 13-12: Creating a gradient layer.

2. **If necessary, select a gradient from the Adjustments panel.**

 If the gradient (you can see it in the Adjustments panel in Figure 13-13) runs from black to white, you don't need to change it.

 If it's something else, select Black, White from the Gradient Map drop-down list. (See Figure 13-14.)

3. **Click OK to close the dialog box and apply the gradient map as an adjustment layer, as shown in Figure 13-15.**

 If you don't want the hassle of an adjustment layer, right-click the layers in the Layers palette and choose Merge Visible. This combines the layers into one. If you do want the hassle (say you want to come back and edit the adjustment), remember to make a merged copy to lock in the effect before you continue.

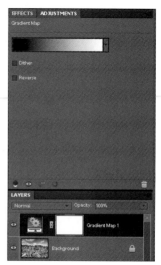

Figure 13-13: Find the details in the Adjustments panel.

A Gradient Map is nothing more than a mask that turns everything beneath it to grayscale. You can create part color and part black-and-white images in Photoshop Elements by erasing areas of a Grayscale Map mask. Select the Eraser and make sure your background color is black (black areas of the mask allow the lower layer to show through unaffected). Click the mask to select it, and then erase areas on the image you want to remain in color. Make a mistake? Switch to the Brush with white as the foreground color, and paint white in the mask to reapply the black and white adjustment.

Figure 13-14: Select a black and white gradient map.

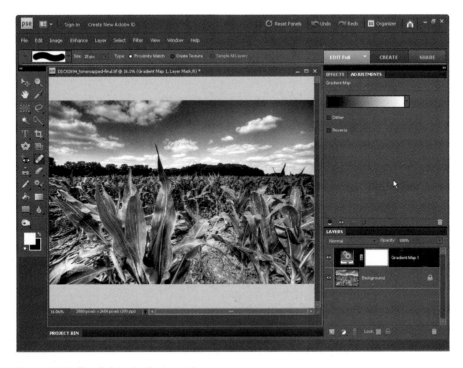

Figure 13-15: The finished adjustment layer.

Working with Photoshop

Not surprisingly, Photoshop has a very powerful tool to convert color images to black and white. This is what I use because it gives me a significant degree of control over how the final image looks. You can turn blue skies dark, green grass light, red features gray, and so forth. It gives you a lot of creative freedom, and I'm all over that. You can also use Photoshop (and Elements) to colorize (tint) a black-and-white image at the end of conversion. Sweet. You can read about different ways to colorize later in the chapter in the "Using Elements to colorize" section.

To use it, ride this escalator:

1. **Choose Image⇨Adjustments⇨Black & White.**

 In the Black and White dialog box that opens, there are many more options than in the Photoshop Elements method, but they work similarly.

2. **(Optional) Select a preconfigured preset from the Preset drop-down list.**

 Options include choices such as Darker, High Contrast Red Filter, and Yellow Filter. Scroll through the list, as seen in Figure 13-16, and find one you like.

Figure 13-16: The effects of a few presets.

3. **Use the color sliders to alter color percentages.**

 These six colors create the tonal mixture of the black and white. For example, increasing the amount with the Blues slider increases the intensity of the blue channel during conversion, which lightens the resulting grayscale image. This makes skies, water, and other blue objects lighter.

 You can, therefore, lighten or darken specific areas of the black-and-white image by increasing or decreasing the color percentage of one of the six colors. Choose the color that is dominant in the area you're working in. (Make sure to select the Preview check box to see your changes in real time.) See an example in Figure 13-17 — the preset is High Contrast Red Filter, and I adjusted the Yellows slider.

4. **(Optional) You may also click in the image (see Figure 13-18) and then drag left or right to decrease or increase the color percentage based on the source color of the area you clicked.**

 This is a fast and effective way to modify the black-and-white image's tones.

 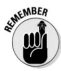

 You're not colorizing the image when you make changes to the color sliders. Rather, you're adjusting the gray tone of the specific color you choose. This lets you make blues dark gray and reds light gray, for example.

Yellows=+120 Yellows=−100 Yellows=0 Yellows=+300

Figure 13-17: Altering individual color ranges.

5. **(Optional) Click the Auto button to let Photoshop assign color percentages based on its own best judgment.**

6. **When you're happy with the results, click OK.**

Click and drag

Color Picker

Figure 13-18: Click and drag left or right to alter the tonality.

If you want to now colorize the image, select the Tint check box (refer to Figure 13-18) and then click the Color Picker to select a tone to colorize with. Alternatively, control the color by modifying the Hue. Control strength with Saturation. Then click OK.

Quick and dirty edits

Photoshop Elements has three editing modes: Full (which I'm using in this chapter), Quick, and Guided:

✔ **Quick:** Includes a saturation control you can use to desaturate the image.

✔ **Guided Edit:** Has two options you might want to try: Enhance Colors (leads to desaturation) and Old Fashioned Photo (guides you through converting a photo to black and white, and then colorizing it).

Colorizing Black-and-White Images

Colorizing (often called *tinting* or *toning*) black-and-white images overlays one, two, or more colors over the black-and-white image, resulting in an aged or other creative effect. For example, sepia-toned images that have the appearance of aging are created this way (well, aside from photos that aged naturally, of course).

There are several ways to approach colorizing images, depending on the application you use to edit your images. Although you can experiment and use these methods prior to creating the HDR image (much like converting brackets to black-and-white before generating the HDR image and tone mapping it), my examples here use a completed tone mapped image.

Using Elements to colorize

Photoshop Elements has a few interesting ways to colorize images. They are easy to use although limited. For example, you can't colorize while you convert the image to black and white or use the Duotone mode like in Photoshop. Most of the time, you convert color images to black and white by choosing Enhance⇨Convert to Black and White. You can't colorize while doing that. However, if you convert to black and white by desaturating the image by choosing Enhance⇨Adjust Color⇨Adjust Hue/Saturation (that there's a mouth full), you can colorize. This disclaimer has been brought to you by Photoshop Elements 8.

Colorizing using the Hue/Saturation dialog box

The easiest solution is to first convert the image to black and white, as described in the earlier section, "Using Convert to Black and White." Then choose Enhance⇨Adjust Color⇨Adjust Hue/Saturation.

Select the Colorize check box and then adjust the Hue and Saturation sliders accordingly. Hue controls the color, and Saturation controls intensity. You can also modify the overall brightness of the image with the Lightness slider. When finished, click OK. See the effects on a tone mapped photo in Figure 13-19 where I'm creating an old, blown-out look.

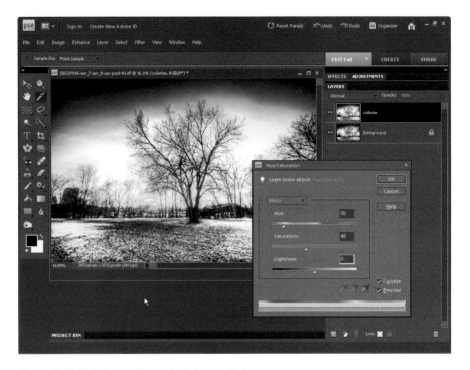

Figure 13-19: Colorize applies a single hue to the image.

Applying color layers

An alternate approach is to use color layers, which allows you to blend more than one color, and even erase and blend the colors in creative ways. You could have blue-tinted shadows and gold-tinted highlights, for example. To use color layers, follow these steps on an image already converted to black and white:

1. **Create a color fill layer by choosing Layer➪New Fill Layer➪Solid Color.**

2. **In the New Layer dialog box that appears (see Figure 13-20), click OK.**

Figure 13-20: Creating a new fill layer.

3. **Choose a color from the Color Picker (as shown in Figure 13-21), and then click OK.**

Figure 13-21: Choose a colorizing color.

You can choose a basic color from the vertical rainbow and then select a specific hue (light or dark, intense or muted) from the large color box in the middle. Or, you can enter color values in the HSB, RGB, or Web color boxes. I opt for a gold color in Figure 13-21.

4. **From the Layers palette, open the drop-down list to change the blending mode from Normal to Color; see Figure 13-22.**

Blending modes affect whether and how layers on top allow other layers to show through. Normally, they don't allow other layers to show through because they're opaque. You can change this behavior, which is what you're counting on to colorize the image.

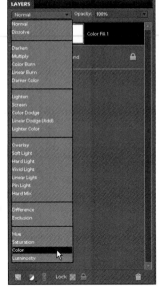

5. **Lower the color layer opacity to blend by using the Opacity slider on the Layers palette.**

The Opacity slider controls the color intensity, as shown in Figure 13-23. The black-and-white image should show through even at 100% because you changed the blend mode to color.

If you have more than one color layer, all except the very bottom one must have an opacity less than 100% to allow the bottom ones to show through.

Figure 13-22: Change blending to color.

6. **Add more color layers if desired.**

7. **Blend by erasing areas you don't want colorized.**

This allows you to isolate colors from different layers and have them apply to specific areas of the image. For more about blending, see Chapter 10.

Opacity slider

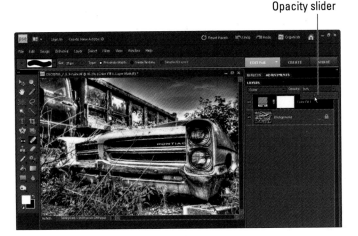

Figure 13-23: Blending with opacity.

Using the Color Variations dialog box

Elements offers another colorizing tool — Color Variations. Several controls are available here with which you can increase or decrease colors in specific tonal regions. In other words, if you want to increase green in the shadows, you can. The downside is that you have only three color options: Red, Green, and Blue.

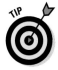

All is not lost, however, because a side effect of decreasing any of the three primary colors is increasing another color. Red and cyan are thus linked, as are green and magenta, and blue and yellow. Therefore, to increase cyan, decrease red. Although this is an easy method, it's sometimes hard to exercise fine control over the process, and the preview window is tiny.

Adjustment layers

Many layer adjustments can be applied directly to the layer you're working on (the method I use in this chapter) or through *adjustment layers,* which are layers that make changes to the layers below them without altering the original layer's content. For example, you can colorize a black-and-white layer by using the Adjust Hue/Saturation dialog box and apply the changes to that layer, or create an hue/saturation adjustment layer and achieve the same effect.

In general, adjustment layers take up more memory and make the application run slower. However, they have the benefit of preserving your original material. So, I encourage you to experiment with adjustment layers and see what you think. Many feel that the extra RAM usage is worth being able to save your original image, open and re-edit the layer, or hide it and add a new one to take a different direction. Your call.

To colorize a black-and-white image in Elements using the Color Variations dialog box, follow these steps:

1. **Modify brightness and contrast as desired by selecting an option from either the Enhance⇔Adjust Lighting menu or the Enhance⇔Adjust Color⇔Adjust Color Curves menu.**

 Increase contrast for a nice, dramatic effect. You can also alter shadows, midtones, and highlight brightness as well as midtone contrast.

2. **Choose Enhance⇔Adjust Color⇔Color Variations.**

 The Color Variations dialog box appears, as shown in Figure 13-24.

3. **Increase and decrease colors by selecting a radio button (Midtones, Shadows, Highlights, or Saturation), and then adjusting the Amount slider.**

4. **Choose a color to increase or decrease by clicking the appropriate button (Increase Red, Decrease Red, and so on). To lighten or darken the image as a whole, click the Lighten or Darken button.**

5. **(Optional) Click the Undo button if you don't like a change; click the Reset Image button to revert to the original and start over.**

6. **When you're satisfied with the results, click OK.**

Figure 13-24: Making color variations.

Cross-processing in Elements

A good way to use the Color Variations dialog box in Elements is for *cross-processing,* which is a technique used to develop film in chemical solutions meant for another type of film. The result is an oddly colorized image, often heavy in greens and yellows.

Using Photoshop to colorize

Photoshop has many of the same features as Elements (Colorizing, Color Variations, and Color Layers), so I won't repeat them here. As you'd expect, Photoshop offers more power-user features that give you greater control over colorizing.

Duotoning

The Photoshop color mode Duotone automatically applies colored tints in various proportions. Duotone is easy and powerful, and has a lot of options. You can choose the number of colors, specific toning curves for each color, and the colors themselves. (CMYK is available as well.) However, your image must be converted to grayscale, which is 8 bits per channel.

Although the name of this tool is Duotone (two colors), you can have one color (Monotone) or more: three (Tritone) or four (Quadtone).

To apply a duotone, start with an image already converted to black and white using your favorite method. It can still be a 8 Bits/Channel or 16 Bits/Channel RGB image at this point (that is, a black-and-white image in a color space). The point is for you to have a chance to control the black and white tonality. If you want to quickly colorize an image and not spend a whole lot of time converting it to black and white first, jump right into the following steps.

Follow these steps to apply a duotone:

1. **Convert your image to 8 bits per channel by choosing Image➪Mode➪ 8 Bits/Channel.**

2. **Convert your image to grayscale by choosing Image➪Mode➪ Grayscale.**

 You need to have an 8 bits/channel image converted to grayscale to use duotone — it won't work with any other format.

3. **Convert your image to Duotone by choosing Image➪Mode➪Duotone.**

 The Duotone Options dialog box shows a monotone to begin with initially, or the settings from your last application.

4. In the Duotone Options dialog box, choose a preset from the Preset drop-down list.

You might prefer to find some presets you like and possibly modify and save them as your own. (Configure the settings you like, and then select the small drop-down list tucked between the Preset menu and the OK button — within this list are the Save and Load Preset options.) Figure 13-25 shows a preset loaded in the dialog box and the image visible onscreen. I selected the BMY Sepia 4 option in the Preset drop-down list, chose Tritone from the Type drop-down list, and tweaked other details.

Figure 13-25: Viewing the effects of a tritone preset.

To create your own colorized image, use these options:

- *Type:* Select Monotone, Duotone, Tritone, or Quadtone.

- *Duotone Curve:* Click the little graph beside each color to control how the tones are applied. Make them darker, lighter, increase the contrast, and so on. The process is similar to adding points on a histogram to brighten or darken, but you are limited to specific ink percentages.

- *Ink:* Click the color swatch to open the Color Picker and choose a new color.

- *Color name:* If you're using a preset, the preset color name appears. If you selected a color from the Color Picker, you can name the color whatever you want.

- *Overprint Colors:* Click the Overprint Colors button to open a dialog box where you can specify in what order the colors are printed. For example, the result of printing red over blue can look different than printing blue over red.

5. **Click OK.**

That's it. I recommend saving the colorized image as a separate file because it's now an 8 bit-per-channel duotone image.

Cross-processing

There is no direct way to cross-process in Elements, but cross-processing in Photoshop is easy. *Cross-processing* is a technique used to develop film in chemical solutions meant for another type of film. The result is an oddly colorized image, often heavy in greens and yellows.

Because this is a chapter on black-and-white HDR, I tell you to start with a tone mapped image that you've already converted to black and white. However, you can cross-process color images as well — I encourage you to experiment and see if you like the results. To cross-process a black-and-white image in Photoshop, follow these steps:

1. **Choose Image⇨Adjustments⇨Curves.**

 The Curves dialog box appears. Photoshop uses curves to alter the in-to-out ratio of each color channel to create contrasted greens and yellows.

2. **Select the Cross Process (RGB) preset from the Preset drop-down list.**

 Figure 13-26 illustrates a tone mapped photo with the Curves dialog box open and the Cross Process (RGB) preset loaded. Notice the otherworldly green tones applied to the image. That's the beauty of cross-processing.

3. **Alter if desired by adjusting the RGB curve or selecting specific channels (R, G, or B) and adjusting those curves individually.**

 You can completely customize the strength and balance of colors this way.

4. **Click OK.**

 You're free to continue editing or publish your image.

Figure 13-26: Cross-processing produces some interesting results.

Part V
The Part of Tens

The 5th Wave By Rich Tennant

Dad creates an HDR image of a campfire
that's better than the real thing.

In this part . . .

The Part of Tens concludes every *For Dummies* book — and for good reason: It's a fun way to finish. Despite being fun, I tried to make this as practical and helpful as possible.

Chapter 14 starts off with ten ways to shoot better photos for HDR, ranging from being patient while your family waits in the van to looking around for additional angles and shots at the same scene. Chapter 15 reverses this and shows you ten ways to ruin a good HDR image. These are things *not to do*. They range from overprocessing and over-sharpening to overreacting.

(More Than) Ten Ways to Shoot Better Photos for HDR

*T*aking better photos for HDR involves two things: taking better photos in general, and effectively using the particular techniques of HDR. If you aren't taking good photos, whether you employ HDR techniques (like using a tripod or AEB) is irrelevant. Likewise, you diminish the effect of shooting wonderfully contrasted clouds at sunset in a five-shot bracketed set if you fail to understand how to set up and compose the shot.

This chapter, therefore, provides helpful hints, reminders, and showcase showdown images to help steer you in the right direction. There are certainly more than ten ways to shoot better photos for HDR, but here is a good cross-section of HDR-specific information and general photography pointers.

Getting a Good Tripod

Get a good tripod. Cheap tripods are, well, cheap. They aren't stable, don't allow you to change heads, break easily, and mark you as an amateur. Good tripods are worth the investment. I have never regretted — not for a minute — spending extra for my Manfrotto tripod (the legs), heads (one ball and one pan-tilt), and a good bag. This was after going through several cheaper versions. You don't have to run out and buy a Manfrotto (distributed by Bogen, by the way). Shop around and find something that suits you. Try Gitzo, Induro, Slik, or Calumet. A good tripod makes aligning HDR brackets easier in software. Your overall HDR image will be sharper as a result. And, a good tripod is especially a great investment if you have thousands

of dollars of camera and lenses to protect. These tripods have very strong *mounting plates* (the thing you attach your camera to that mounts it on the tripod) and don't tip over or collapse easily.

Being Patient

Photo shoots are often exciting. The scenery is beautiful, and you're pumped to get good shots. It's easy to be swept up by the fun and start rushing yourself, but don't. Be patient and enjoy yourself.

Going fast often results in errors. You may forget to change a camera setting (I have), leave the camera in the wrong shooting mode (I have), forget where you are in your shoot — "How many brackets are left?" — (I have), and end up ruining the shoot (I have). Patience is also a strong factor in how you compose a scene. If you take your time, you can analyze scenes and purposefully compose better shots. It isn't a race.

Becoming a Cloud Watcher

HDR photography happens outside a good portion of the time, which is (conveniently) where clouds tend to congregate. Go figure. So pay attention to the clouds: how they move and in what direction. And also pay attention to their position in the sky in relation to the sun and what time it is. Early evening (the "golden hour"), the sky can look completely boring one minute and light up in a fantastic display the next. The sun strikes them from the side, and then underneath as it sets.

In the morning, play this scene in reverse — the horizon will glow, then the sun will peek up and light the bottoms of clouds, then the sides, then the tops.

Figure 14-1 illustrates several cloud formations at different times during the day and in different conditions. You can see there is a lot of variety. When you start paying attention to clouds you will start seeing more and more detail. When you start seeing this, you will start shooting better clouds (and skies, and scenes) more on purpose. Then your HDR photos will get better.

Figure 14-1: Clouds come in many sizes and shapes, and are lit with different colors.

Taking Your Camera with You

It really helps to have your camera with you almost everywhere you go because, you know, you can't take a photograph without your camera. So toss your camera bag in the back seat or the trunk. That way, if you spot something on the way or the light that evening looks marvelous, you can stop and take a picture.

Figure 14-2: You can be spontaneous if you have your camera (and tripod) with you.

Figure 14-2 is a shot taken in the restroom at a local fast food establishment. The tiles fascinate me. I love the way they look like pools of blue liquid. After a while, I woke me up to the fact that I never had my camera with me to take a picture of them. The next time I was there, I took several bracketed sets and later processed them into HDR.

Loving HDR Photography

As odd as it sounds, you will take better HDR photos if you love doing it. If it's a chore, a hassle, a distraction, or an otherwise dreary means to an end, you will end up holding back and mechanically executing your craft without much of a personal stake in it.

Loving what I do helps me keep trying, even when it's hard. It fuels my persistence and motivates me to learn and practice. It also makes it easier to digest the (sometimes dry) aspects of exposure, cameras, gear, specifications, software, and so forth.

Paying Attention to Light and Time

As you traipse around looking for good HDR shots, you will undoubtedly run into the same phenomena I have regarding light and time:

- ✔ **Not all light is good.** I used to love to go out at noon and take photographs because I thought the light was better. It certainly was stronger, but better?

 In general, no. Midday light causes lots of problems, actually — more than it solves. The first and greatest problem is the sun is so intense, shadows are very harsh. It's like holding a flashlight directly over someone's head as you take a photograph, only a thousand times worse.

- ✔ **Not every time is good.** This is intimately related to the first point because when shooting outdoors, time and light are closely related.

 As I mention earlier, the best time to shoot outdoors is during the golden hour — the hour or so before sunset and after sunrise. Dusk (a short period after sunset and before sunrise) can also be magical.

 When you start to think of light in terms of time, and vice versa, you are on your way to taking better photographs.

When you realize how important light and time are to the photograph, you'll start taking better pictures. This is true even for HDR. Just because you can capture a broader range of light doesn't mean every situation will produce an award-winning photo.

Pay attention to how your scenes (landscapes, buildings, and so on) are oriented toward the setting or rising sun. Decide where you want the light to be for the best photograph; then see whether you can take that photo without obstructions or distractions.

Knowing Your Camera

Today's brands of cameras rely extensively on auto this and auto that. One of the consequences of this is that many amateur photographers don't learn how to use their cameras like they should.

Don't be one of them. You'll enjoy yourself more and take better pictures if you learn how to use your camera. Think of yourself as an engineer operating a complex piece of equipment — because you are. Take any dSLR camera and look at all the buttons, displays, knobs, and ports. More likely than not, that camera has a plethora of handy controls that are totally useless to you as a photographer if you don't know how to use them.

The best way to learn what all the buttons and controls are and what they do is to read the manual. (Wiley Publishing offers a number of well-illustrated books on a variety of dSLR models as well.) Learn every mode, switch, menu option, knob, and button. Learn how to use everything, and make sure to practice.

Read the manual in chunks. Don't try to go from front to back in one sitting and expect to remember everything. Get the basics down and start adding bit by bit. Before you know it, you'll have it!

Looking for Contrast

Although HDR specializes in capturing scenes with a high dynamic range of light, you can use other sources of contrast besides light. As you look at several examples of contrast here, keep these thoughts in mind:

- **Light and dark:** This is HDR's specialty. Photograph scenes with a wide range of light and dark for best results.

- **Colors:** Colors can contrast as well. Blue-gray clouds floating in a blue sky across a fiery red sunset. Green trees sit along a gray road with white clouds in a blue sky. Red rust on a blue truck with chrome details.

 Interior spaces look much better if they are filled with contrasting colors. Monotone rooms and spaces are relatively booooorrrring.

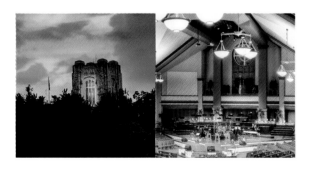

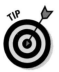

- **Textures and materials:** Textures often contain details that can be accentuated in HDR. Brick, wood, stone, grass, rocks, and other rough surfaces are especially pleasing in HDR.

Returning to the Scene

Returning to a particular scene is a great way to learn and grow. You become familiar with the scene and see new things you missed during previous shoots. All the shots in Figure 14-3 are of the same walkway under construction at a local university. They were shot with different cameras, at different times, in different weather, and with different results. All are of the same subject, and all are in HDR.

Figure 14-3: Compelling scenes provide many great opportunities for HDR.

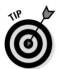

Scout out locations ahead of time — take some practice shots and evaluate them with the expectation of going back. You might end up using some of these shots.

Experiment with different times, angles, and bracketing solutions. Process the photos in your computer and study them to see how you can improve your photography. You will get better at it.

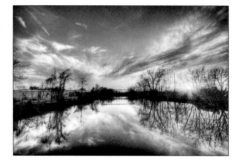

Looking Around

If you go to shoot a scene, look up, down, and sideways at other possible shots at that location. Turn around and see what's behind you.

Figure 14-14 illustrates the point of shooting from different angles of the same location, in contrast to the previous section, where the same subject was photographed throughout. Notice that from one vantage point on a bridge, the sun set in a beautiful glow of color to the west, the city was bathed in golden hour light to the south, and the east had a magical presence to it as well. All the photos capture the amazing clouds that were present that evening.

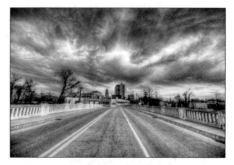

Always be on the lookout for opportunities to make your current trip pay off more than expected. If you go looking for one scene, come back with three. If you go to shoot a sunset, shoot what's behind and beside you, too.

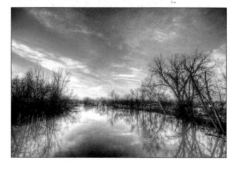

Figure 14-4: There's always something behind and beside you.

Using AEB

Although you can shoot HDR photography with many types of cameras of varying abilities, using auto exposure bracketing (AEB) really rocks. It takes away much of your workload, which allows you to concentrate on setup and composition.

If you have a fast camera, you can use AEB to shoot scenes that are impossible otherwise. The result in Figure 14-5 comprises five bracketed photos shot without a tripod. The only thing that makes this possible (I was just standing there — you could lean against a car or a pole, or brace the camera against your body for additional support) is using AEB, having enough ambient light, and a camera with a fast shutter speed. It's HDR on the go, so to speak.

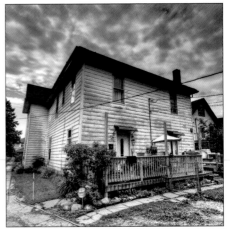

 Moving clouds are particularly hard to shoot manually. Even those that don't appear to be moving fast can look horrible once you process them in software.

Figure 14-5: HDR from five hand-held exposures taken with AEB.

Shuttering with a Purpose

Try this simple rule when composing a scene. It will have a profound impact on how you compose it. Take a picture of *something*. Not anything. Not nothing. Take it of a thing you can point to and say, "This is why I took the picture." It could be a person, a tree, the sunset, a shadow, a horse, or a building. Landscape shots of "nothing" will challenge you on this.

For example, the HDR image of a soybean field in Figure 14-6 isn't terribly bad, but it lacks purpose. Anyone could have walked out into this field and taken this shot. That's part of the problem. There is nothing to set it apart. Here's my point: HDR can't make a bad photo good all the time. Don't think that all you need to do is fire up the HDR application and turn anything into an amazing photo. Doesn't work that way, and this shows it.

Figure 14-6: This shot lacks a strong purpose.

There are many ways to make these types of shots better. Figure 14-7 shows a better composition, this time of a corn field. The tripod is lower, resulting in the corn plant in the foreground becoming the true subject of the scene. The rest of the field recedes into the background, and the field takes up more space in the shot than the sky, which itself is more attractive. The clouds are puffy and interesting. Even though they're nice, they're not the main element of the shot: It's about that one corn plant. This photo has purpose and interest, which is then accentuated by HDR.

Figure 14-7: Corn takes center stage: a photo with a purpose.

Ten Ways to Ruin a Good HDR Image

You know, there are a lot of ways to ruin a harmless HDR image. I've done it myself more than I would like to admit. (Thankfully, you can pick up the original images any time and start over.) You might ruin images from a little over-eager-beaverness (closely related to overkillitis) to make it look HDR, or by being too timid.

This chapter, then, is a study in contradictions. For example, I tell you to crank up the contrast but then not to overdo the drama. And I warn you about losing your imagination but then say you're going too far with HDR.

This chapter focuses on software ruination — not bracketing or other photography mistakes. Most people are likely to get into trouble while they tone map and edit HDR images — proactively ruining an image — rather than failing to capture it properly. With that encouraging thought in mind, after seeing and learning about these pitfalls, you'll be armed to the teeth to prevent them.

Halos, Halos, Everywhere!

The number one way to ruin a good HDR image is the dreaded halo. Your photos might be perfect, but they don't need halos to prove it. Figure 15-1 illustrates a nice view off an old walking bridge on the river below with a nice sky and clouds above. What do you see in the ruined image (left)? Halos. Halos around the structure of the bridge and the tree line.

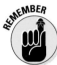

What typically happens is that you're focused on achieving a certain look in other areas of the photo that you either miss or ignore the fact that you're ruining the entire thing by leaving in halos.

The image on the right side of Figure 15-1 shows an alternative — tone mapped and processed to create a similar look without the halos. Much better! There are certain compromises, of course. The sky is brighter and the structure darker. It looks closer to a realistic scene, but still not without drama. If you wanted to bump that up a notch, you could further increase contrast and do some dodging and burning in post-HDR editing.

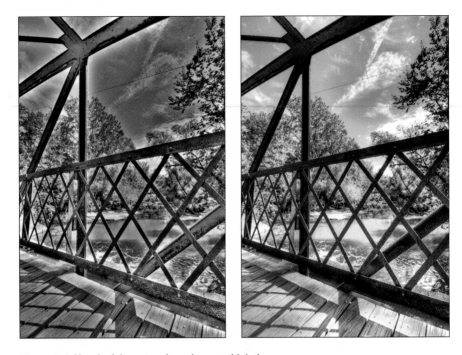

Figure 15-1: You don't have to ruin an image with halos.

Wimping Out on Contrast

HDR images thrive in contrast: That's the point. You're capturing loads of contrast when you go to the trouble of shooting brackets. Don't settle for images, then, that are too mushy in the contrast department. Live it. Love it.

The top image in Figure 15-2 shows a *potentially* gorgeous sunset with powerful colors and interesting details. The problem is that there is no contrast. The colors look muted, and details are not accentuated. Sometimes we get

scared of blowing out highlights or making something look too bold. It might not be possible to achieve the level of contrast you want as you tone map. In this case (see the bottom image in Figure 15-2), additional contrast was added after the tone mapped image was saved. Additional burning made the clouds and shadows on the water darker.

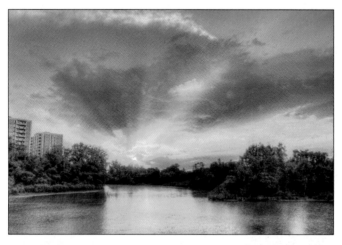

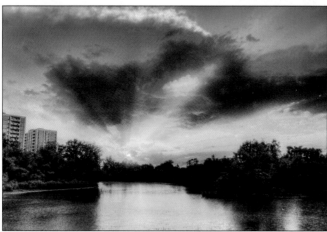

Figure 15-2: Contrast is Cing.

Believe it or not, that is why the colors look so much better: contrast. Contrast sharpens the details of the clouds and sky, creates bold colors, and makes for a much more interesting photo.

Imagination Smackdown

Imagination is a powerful thing, a fact that is made more obvious when you see the result of not using it versus using it. It's an Imagination Smackdown. The top image in Figure 15-3 is an HDR image of a local diner during the "golden hour" — that late time of day when the sun is low, and objects are more sun-lit from the side and bottom (there's one in the morning too). The problem is that the lens I was using (and have since returned) had horrific distortion characteristics. Nothing looks right in this image. I tried and tried to do something that I like with this photo, and have come up short each time. The windows, though, have always caught my attention. So, I decided to focus on them.

Rather than leave anything else in the image, I cropped and transformed so that the windows took center stage. I moved the right window to the left a bit to cover the sign and cloned to blend it in. The end result (see the bottom of Figure 15-3) is something really powerful. It's colorful, interesting, completely unexpected — it's imagination.

When your images show imagination, people will be far more interested in looking at your work — it will be worth their time and effort to seek you out.

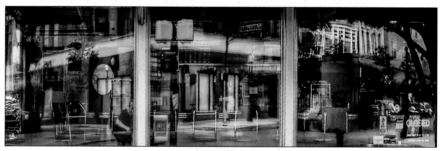

Figure 15-3: Imagination wins every time.

This Isn't Casper, The Friendly Ghost

If something is moving in your image and creates ghosting artifacts to the point of becoming a distraction, take it out or mask it. Don't let it dominate the final image.

The top image in Figure 15-4 was cropped from a scene with traffic moving up the road. It's an interesting scene, but it has ghosts galore. (If you're into math and physics, it is a good illustration of speed, time, shutter speed, and frame rate.)

Had this been at night or had the ghosting been more "river like" (with a constant stream of cars instead of a stop-start-stop appearance) it would probably be worth leaving the ghosting in.

Figure 15-4: B'bye, ghosts.

The version without ghosting is also shown on the bottom of Figure 15-4. The truck is solid and contributes to the image. This was achieved when creating the HDR (ghosting options) and also by overlaying solid traffic over the ghosts (masking and blending).

Sharpening From Dusk 'Til Dawn

Much like the mania with noise reduction, photographers are sometimes obsessed with sharpness. They want everything to be pixelly perfectly sharp from the nose of the camera to infinity, no matter what lens, aperture, ISO, or shutter speed they use. If you get caught up in that, you're primed to over-sharpen your HDR images.

Figure 15-5 shows the results of over-sharpening (and then a proper amount) on a close-up of Dale Earnhardt's #3 car at the Kruse Automotive and Carriage Museum. Over-sharpening introduced artifacts, noise, and imperfections in the top image (which is a bit overdone, to try to show you the result in this book). Alternatively, when you go easy, as in the bottom image, you're left with a much clearer image with less noise and no edge artifacts.

Here's a trick. Don't over-magnify when you're editing images. They'll always look bad at 1600% — much like you would look like under a microscope. Back away from the magnifying glass. In fact, get into the habit of zooming out and looking at the image as if it were printed normally to gauge what is discernible for the average print or not. If the image is 300 dots per inch (dpi), 25% magnification is a good representation; if at 72 dpi, then 100%.

Too Much Noise Reduction Going On

It's tempting to try and squash every little bit of noise from a tone mapped HDR image the moment you see it. I think everyone is slowly being programmed to expect perfection because of computers and digital logic. No work of art, photograph, or man-made *anything* has reached the lofty goal of perfection.

So, get used to noise. Don't overdo the noise reduction. You'll end up with a featureless blob with no sharpness and soft details. It's okay. You can even embrace noise at times and use it to good effect.

Figure 15-5: Over-sharpening adds noise and crud to your images.

Figure 15-6 shows part of a tall building with too much noise reduction (left) and just the right amount (right).The window looks soft and fuzzy, the reflections of the trees turn into a green blob, and the concrete looks too smooth.

Figure 15-6: Too much noise reduction softens an image and kills details.

Putting a Square Peg into a Round Hole

When you run into a situation and it seems like nothing is working — the settings don't look good, the image feels wrong, the effects are all bad — relax and take a break. The image is telling you something. That something is sometimes related to forcing a solution to an image. These are the times it pays to realize you're trying to put a square peg in a round hole.

I have bracketed sets that I took a year ago, and after an initial round of processing and tone mapping, I concluded that there wasn't much I could do with them. Instead of trying to force it to happen, I left them alone and kept shooting new sets. In the process, I learned a lot.

Figure 15-7 shows a ruined photo of a tulip (top) compared with something more reasonable (bottom).

Figure 15-7: Letting go of preconceived notions of HDR.

The top image is the result of my impatience and stubbornness. I was shooting bracketed HDR and wanted this flower to look dramatic. I wanted to use the same settings on this image that I have been using on others. The problem was that the flower wasn't cooperating. When this happens, pay attention. Tell yourself, "Self, I may be trying to put a square peg in a round hole." Stop. Relax. Come back later with a different mindset. The results can be very good if you do!

Timidity on the Coloroidity

In general, bold, contrasting color is interesting to look at. It's powerful and striking. It reaches out, grabs you, and pulls you toward it. It gets your attention.

The problem is that color is a fickle beast. Sometimes it rewards you. Sometimes it punishes you. I think this (with perhaps some peer pressure of some photographers who insist on mildness) results in many photographers being too timid when editing images.

Figure 15-8 is a comparison of being a little too timid (top) versus being bold with color (bottom). The timid version doesn't look bad, mind you. I did not desaturate or damage it so you would look at it and say, "Oh, that's the bad one!" However, compare it with the bottom image. It's striking. The bolder version really works. It makes a statement. Go back and look at some of your images in your editor and see if you tend to be timid or not. Increase the saturation by 10% to 30% and see how it looks.

Too Much HDR

Sometimes too much of a good thing can be a bad thing. I remember when I first started working with HDR. I would generate an HDR image and then tone map it with the most absurdly unrealistic and impractical settings possible. I loved the *otherworldliness* of it. It was HDR. Well, it wasn't too long until I realized that maybe I was overdoing it a bit. I started pulling back on some settings and allowing myself to increase the Light Smoothing in Photomatix Pro. The result was a bit more realism and a lot more satisfaction in the long run.

Figure 15-8: Bold color gets attention.

Figure 15-9 shows a comparison of how this looks in practice. The scene is the New Castle (Indiana) Chrysler High School Fieldhouse ("The Largest and Finest High School Fieldhouse in the World"). The top version shows too much HDR. I have to admit — it calls to me. It really does. However, in most cases (see, I can barely bring myself to say it), it's just too much HDR. The light balance is funky, and there are too many details. Compare it with the more realistic version (bottom). This is a great picture. This is what it looks like in person, and the version that uses HDR to achieve a good balance of drama versus realism.

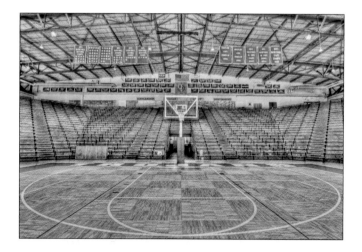

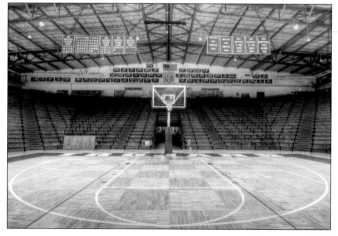

Figure 15-9: You can have too much HDR sometimes.

Overreacting to Criticism

The bottom line is this: Your HDR images are *yours*. Ultimately, what you create should appeal to you on some level. Start there. Be comfortable with that (but don't let it go to your head).

Figure 15-10 illustrates two different interpretations of the same scene. I love this scene. A guy (out of the frame) and his dad were eating in this pavilion at the park when I brought my family over for some photography and fun. The kids played in the playground (you can see it in the background), while I walked around with my gear and shot brackets. I timed the shots so the older gentleman wasn't moving.

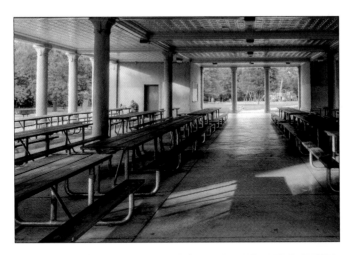

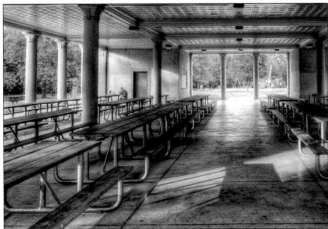

Figure 15-10: One scene — two different interpretations.

So, which version works? Which one doesn't? Both. Neither. It depends on who you're asking. If that person hates overdramatized HDR, he will vote for the realistic version. If that person loves the way HDR makes a photo look like art, then she will shun the realistic version and say if you want that, just go take a single picture.

Always recognize who your audience is and who is giving you feedback. They are not always the same group. Make sure you're responding to criticism for the right reasons. Is it to improve your work? Is it to reach your audience better? Is it to make people like you?

Index

• V •

vertical distortion, 233, 234
Vertical Perspective option (Photoshop Elements), 235
viewfinders, 31
Vignette option (Photoshop Elements), 234, 235–236
Vivid Landscapes style (Photoshop Elements), 280

• W •

watermarks, adding to images, 243–244
Web sites
 Adobe Lightroom, 63
 Adobe Photoshop, 63
 Adobe Photoshop Elements, 63
 Adorama Camera, 44, 45, 48
 Amazon.com, 44, 48
 Artizen HDR, 58
 Corel Paint Shop Pro Photo, 63
 creating JPEGs to post on, 242–245
 Dynamic Photo HDR, 59
 easyHDR, 59
 FDRTools, 60
 file formats, 136
 Hydra HDR plug-in for Aperture 2.1, 61
 Photomatix Pro, 61
 Qtpfsgui, 62
 software, 64
 third-party Raw editors, 57
WhiBal (white balance aid), 49

white balance
 aids for, 49
 fixing, 138
 for panoramas, 250
White Balance drop-down list (Photomatix Pro), 145
White Point setting (Photomatix Pro)
 description of, 160
 tone mapping and, 179
wide angle lenses, 39–40
wide-angle capability
 compact digital cameras and, 38
 of super-zoom lenses, 39
wireless shutter releases, 48
workflow. *See also* post-tone mapping workflow
 converting Raw photos and, 137
 converting to black and white, 275
 defining, 26
 editing with layers, 203
 phases of, and types of software, 51–52
 post-tone mapping, 206–212
 for single-exposure HDR, 119–123
 steps in, 11, 13
Workflow Shortcuts dialog box (Photomatix Pro)
 Generate HDR image option, 143
 options, 155

• Z •

zoom capability, and compact digital cameras, 38